ANTONIO ALL CORREGGIO

FROM THE GERMAN OF DR. JULIUS MEYER

DIRECTOR OF THE ROYAL GALLERY, BERLIN.

EDITED, AND WITH AN INTRODUCTION,

BY MRS CHARLES HEATON,

AUTHOR OF " THE HISTORY OF THE LIFE OF ALBRECHT DÜRER," ETC.

London and New York

MACMILLAN AND CO.

1876.

CHISWICK PRESS:—PRINTED BY WHITTINGHAM AND WILKINS,
TOOKS COURT, CHANCERY LANE.

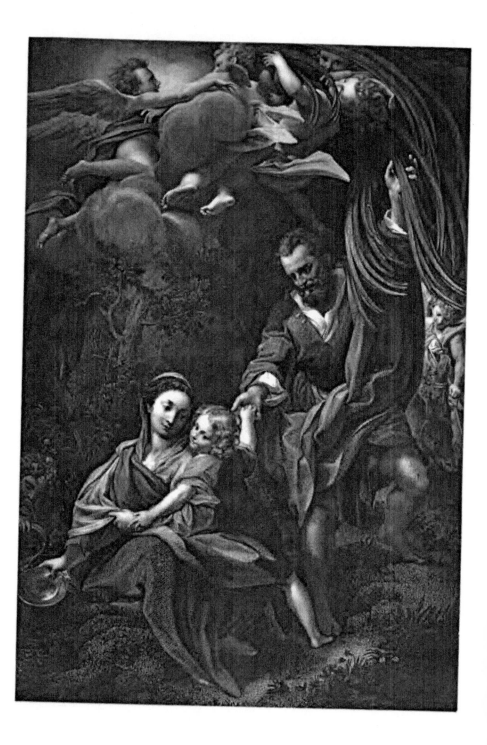

PREFACE.

THE present work originally appeared in 1870 in the "Allgemeines Künstler-lexicon," of which comprehensive but tardy publication Dr. Julius Meyer was then the editor. It was, however, immediately republished in a separate form, with some additions and alterations, and it is from the reprinted volume, and not from the dictionary, that the English translation has been made. Miss Spencer, the translator, has found it necessary in some places to condense the text, but has always endeavoured to preserve the character of the original German as closely as possible.

Since the appearance of Dr. Meyer's work, which thoroughly exhausted the knowledge gained upon the subject up to that time, two or three contributions to Correggio literature have been made. Of these, the most important are the second edition of Pietro Martini's "Il Correggio," Parma, 1871, and Cav. Quirino Bigi's "Notizie di Antonio Allegri," etc., Modena, 1873. Unfortunately, neither of these authors has added much to the very scanty amount of information we possess concerning Allegri's

life. Cav. Bigi seems, indeed, to have written without any acquaintance with Dr. Meyer's previous researches, so that his book is behind rather than in advance of our knowledge of the subject. It deals, however, chiefly with the minor artists of Correggio, none of whom have much more than a local celebrity. The few new facts and theories relating to Allegri and Antonio Bartolotti that are contained in it, I have found no difficulty in inserting in foot-notes. For these notes, the introductory chapter, and the appendices, which are compilations rather than literal translations from Dr. Meyer's larger catalogues, I am responsible. I trust they may prove useful to English readers.

M. M. H.

Lessness Heath, Kent.

CONTENTS.

CHAPTER IV.

CORREGGIO'S FIRST MASTER-WORKS AND THE CALL TO PARMA.

CHAPTER V.

MARRIAGE. CORREGGIO'S WORKS ANTECEDENT TO THE FRESCO PAINTINGS IN S. GIOVANNI (1519—1521).

CHAPTER VI.

THE PAINTINGS IN SAN GIOVANNI IN PARMA.

CHAPTER VII.

THE DOME OF THE CATHEDRAL IN PARMA. CORREGGIO AS SCULPTOR AND ARCHITECT.

CHAPTER VIII.

ALTAR-PIECES OF THE PERIOD WHEN CORREGGIO'S ART HAD ATTAINED
ITS HIGHEST DEVELOPMENT.

CHAPTER IX.

RETURN HOME AND RENEWED INDUSTRY.

CHAPTER X.

MYTHOLOGICAL PAINTINGS.

CHAPTER XI.

CORREGGIO'S DEATH.

CHAPTER XII.

THE CHARACTER AND SIGNIFICANCE OF CORREGGIO'S ART.

APPENDICES.

LIST OF ILLUSTRATIONS.

LIFE OF CORREGGIO.

By Mary ... Kintore, ... ;

INTRODUCTION.

THE little town of Correggio, lying about half way between Reggio and Novellara, in the pleasant duchy of Modena, is so unimportant at the present day that it is not even mentioned in Murray's handbooks. Very few travellers ever think of turning aside from their route to visit it, for almost the only claim that it has upon their notice is that it was the birth-place of Antonio Allegri, who derives the name of Correggio by which he is usually called from this circumstance.

But this quiet, insignificant little city had formerly a distinct individuality and power of its own. It had its own lords, who governed it rightly or wrongly, according to their ability, and who, living in their strong fortified castle, if sometimes they plundered the inhabitants themselves, at all events protected them from foreign marauders.

It is uncertain when Correggio was first inhabited, but its old Latin name, *Corregium*, shows that it existed in Roman times. The first mention of it in mediæval history occurs in a

charter of the year 945, in which the following passage occurs : " Alfri qui et Bonizo filio bone memorie exambit de Corregia."[1] It is certain that the castle must have existed not long after this date, for a charter of the year 1009 is dated, " Actum in Castro Coregia."[2]

This castle served the lords of Correggio both as a palace and a fortress. Its outer walls and bastions, the ruins of which the visitor still sees, were built by a certain Guido di Azzo da Correggio, who, in 1372, with the troops of the Visconti, drove out the then Castellan Giberto da Correggio, his uncle, and assumed the government of the town. It was these fortifications that enabled the town to sustain the two years' siege that it afterwards underwent in 1554.[3]

In the fifteenth and sixteenth centuries the lords of Correggio, like the other rulers of that time all over Italy, were ambitious of being considered the patrons of literature and art. They do not, however, seem to have attracted any men of distinguished ability to their town, not having perhaps any great seductions to hold forth, until the celebrated Veronica Gambara, second wife of Giberto da Correggio, who ruled Correggio at the beginning of the sixteenth century, founded an academy in her palace, and invited scholars and scientific men from all parts of Italy to come and teach in it.

Veronica Gambara is characterized by Pungileoni as " a lady of excellent virtue and great purity of blood."[4] She was in truth

[1] Zedler, " Universal Lexicon."

[2] Rampoldi, " Corographia dell' Italia."

[3] Tiraboschi.

[4] The Count Pompeo Gherardi, also, in his epitaphs on Distinguished Italian Writers that have lately appeared in Il Raffaello, calls her " cultrice distinta delle buone lettere, poetessa di merito non comune, buona moglie, madre esemplare, nel governo di Correggio temperante—caritatevole—savia."

one of those noble, gracious, and highly cultivated women who move dimly in the Italian history of this period, and who evidently exercised a considerable influence over the society and culture of their time. In several respects Veronica Gambara may be compared with the noble princess Vittoria Colonna, whose friendship cheered the gloomy age of the great Titan of Italian art. Both ladies had that indescribable charm of manner that subjugated men's hearts to their service; both were left inconsolable widows at an early age; and both found expression for their feeling in graceful pensive verse, for Veronica was a poet as well as Vittoria. Her poems[1] were much admired in literary circles beyond the little court of Correggio, and they brought the writer into communication with several men of note, especially with the lively Pietro Bembo, with whom for some time she kept up an active correspondence.[2]

Such a woman, ever prompt to recognize and pay honour to genius, was not likely to have overlooked the merits of Allegri, even although it is the proverbial fate of a genius, no less than a prophet, to find little honour in his own country. It is evident, indeed, that she highly esteemed him, for in a letter to her friend Beatrice d'Este, the Duchess of Mantua, she writes, " Come and see the *chef d'œuvre* of the Magdalen in the desert, just finished by the Messer Antonio Allegri; it astonishes all who behold it."[3]

This was of course written at a time when his fame was fully established (the letter is dated Sept. 3, 1528); but it goes far to prove previous relations with our master; indeed Dr. Meyer, who is so careful of admitting anything not thoroughly substantiated,

[1] They were first collected and published in 1759, with some of her letters.

[2] Bigi, " Dicorso di Veronica Gambara." Mantua, 1859.

[3] " Venite a videre il capo d' opera della Maddalene nel deserto fatto ora da Messer Antonio Allegri, che fa stupore a chi la mira."

owns that Allegri most probably owed his introduction to the court at Mantua, and also perhaps to the great Emperor Charles V., who was at one time a guest in Veronica's palace in Correggio, to her kindly offices.

Unfortunately, as is the case with everything relating to Allegri, beyond this little passage in a letter, and the fact that he was present as a witness at the marriage of the lady Clara of Correggio with her cousin Ippolito Gambara, the son of Veronica, in 1534, there is nothing to tell us what relations existed between the lady and the painter. It would be pleasant to have some little anecdote, some stray letter or even chance word that passed between them, but of such gossip history, so bountiful to us in respect to Michel Angelo, vouchsafes no record.

But Veronica's favour, if it ever cheered the path of our master, could only have been bestowed towards the latter part of his life, or at all events after his reputation was fully established. There is nothing to show that he had even this encouragement at the outset of his career, nor that the small court of Correggio, at that time held by Manfredo, the father of Giberto, was in the least aware of the genius who had been born within its jurisdiction, and who, more than all the strong lords and gracious ladies who moved in its circles, was destined to shed glory on its obscure little town.

The fact, indeed, that one of the great masters of Italian painting should have arisen in this poor place, remote from all the favouring influences that had developed the growth of art in Florence, Venice, and Siena, seems to militate strongly against Taine's well-known theory that art is to a great extent the product of the circumstances, *le milieu*, in which the artist is placed.[1]

[1] " Loi de la production des œuvres d'art. L'œuvre d'art est déterminée par un ensemble qui est l'état général de l'esprit et des mœurs environnants."

Although we may not believe in the phenomenon that Vasari presents to us of a heaven-born genius suddenly acquiring a complete knowledge of art, and carrying the "new manner" (as he calls the freer style of painting adopted by the great artists of the fifteenth century) to perfection, yet it is certain that Allegri's natural talents must have developed to a certain extent under unfavourable conditions.

In the other schools of Italy we find a direct succession of artists, each one carrying on the principles of art a step farther than the other, and following a certain law of development until perfection is reached, after which an apparently inevitable time of decline and decay has always followed. Thus in Florence we have Giotto, Orcagna, Masaccio, Ghirlandaio, Luca Signorelli, and other artists of progress before we get to Michel Angelo, who suddenly, as it were, achieves all that his predecessors had been striving after for centuries. Raphael's art, again, is but the flower of the religious art of Siena and Umbria grafted on the bolder stock of Florence; and the same with the Venetian school. Its gorgeous blooms are the natural expansions of the lovely buds put forth in the time of the Vivarini and the Bellini. But it is not so with Allegri. It is impossible, from what we know of the influences under which he worked, to regard the wonderful perfection of his art as the outgrowth of any particular mode of cultivation.

"If," says Hermann Grimm, "we were to imagine streams issuing from the minds of Raphael, Michel Angelo, Leonardo, and Titian meeting together to form a new mind, Correggio would be produced;" and yet it is tolerably certain that he never came under the direct influence of any one of these great painters. Leonardo is the one to whom he is most nearly allied, and no doubt he was well acquainted with some of Leonardo's works; but even his influence is not paramount, for the subtle intellectual

c

qualities of the great Milanese master disappear in Allegri, while the sensuous are exaggerated.

In spite, therefore, of all the criticism that has been brought to bear upon his art, Allegri remains, even to this day, the " pittore singularissimo" that Vasari calls him ; one of those rare geniuses whom Nature now and then produces in contradiction to her general rule, and as if to show her superabundant power under unexpected, and, as it seems to us, unpropitious circumstances, at all events not in obedience to Taine's " Loi de la production."

Of course it must not be supposed that Allegri's sudden development was entirely spontaneous. He had teachers certainly ; one of these, a master named Bartolotti, was no doubt a better artist than was formerly thought. Bigi proves that he was at the head of an Academy of painting in Correggio, and was highly esteemed for his drawing, harmonious colour, and impasto. Unfortunately very few of this master's works are known, only one indeed is thoroughly authenticated, so that it is extremely difficult to judge of his merits or of the influence he had over his great pupil, but it is quite possible that some of the supposed early works of Allegri were really executed by Bartolotti or in his school. This was the case, we know, with regard to Raphael, whose so-called early works are often only paintings done in Perugino's school by forgotten artists, who like Raphael had caught their master's peculiar manner. Later on, the study of Mantegna's works at Mantua taught Allegri much concerning the principles of art, but it is scarcely likely to have had, as Dr. Meyer supposes, any formative influence over his style, for nothing can well be more dissimilar than Allegri's cheerful grace and Mantegna's sternly classic spirit. The one master delighted in colour and life, whilst the figures of the other have often the coldness and rigidity of marble. Allegri would give life to a statue, but Mantegna would turn even Venus herself to stone.

Much more probable is it that Allegri, like so many artists of his time, caught inspiration from the gracious Leonardo da Vinci, whose spirit was diffused more widely perhaps than that of any other master of his time. If Allegri had ever been a pupil in the great Milan school, the "Academia Leonardi Vinci," as the inscription calls it, a school in which such men as Bernardino Luini, Andrea Solario, Marco Oggione, Cesare da Sesto, and Beltaffio were formed, it would not be difficult to discover from whence he derived the beautiful life of his art; but there are no grounds whatever for supposing that he ever studied at Milan. It is quite possible, however, that his master, Bartolotti, of whose education we know nothing, might at some time or other have come within the sphere of Leonardo's teaching, and that thus Allegri benefited by it at second hand. At any rate Leonardo's influence was paramount at the beginning of the fifteenth century all through Lombardy. There is scarcely a master of the northern schools of Italy who did not come in some degree beneath it, and it is not likely that Allegri, whose art bears a greater affinity to that of Leonardo than to that of any other master, should have been the only one to escape.

Such being the case, it does not seem probable that it was not until he went to Mantua, and came under the influence of Mantegna, that his art first received its peculiar bias. Doubtless it was the study of Mantegna at an early period of his career that led to that perfect knowledge of foreshortening and perspective that he exhibits with such daring in his wonderful ceiling decorations; but this knowledge, astonishing as it is, is not the only or even the chief characteristic of Allegri's style. Far more individual is his delicate perception of the minutest gradations of light and shade, his joy, if one may call it so, in the expression of the marvellous chiaroscuro of human life. This it is that distinguishes Allegri from every other painter, and this he cer-

tainly could not have gained from Mantegna, whose antique sculpturesque forms do not admit of any great play of light and colour. On the other hand, Leonardo, though not pre-eminent as a colourist, was constantly occupied with the subtleties of light and shade. He wrote, as we know, a complete treatise on light,[1] in which he laid down the laws regulating the phenomena of light and vision with a knowledge far in advance of his time. He is sometimes credited indeed with the discovery of the diffraction of light, but the passage on which this supposition rests is too vague to deprive Grimaldi of the honour of the discovery made by him in 1665. His use of chiaroscuro, however, was greatly superior to all the painters who had preceded him. He was the first who painted in that modern manner that Vasari so much extols, and his strong modelling of light and shade, ranging from whitest light to blackest shade, with every variety of grey half tone between, points him out more decisively than any other painter as the predecessor, and in some degree the teacher of Allegri, with whom the love of chiaroscuro was a passion. "Correggio was the first," says Kugler, "who may be said to have warred systematically against all flatness of surface; the play of his light and shade and the position of his figures equally assist the appearance of depth in space;" and again, "Instead of form, another element of beauty predominates in Correggio— that of chiaroscuro, that peculiar play of light and shade which sheds an harmonious repose over his works. His command over this element is founded on that delicacy of perception, that quickness of feeling, which is alive to every play of light, and is thus enabled to reproduce it in the form of exquisite *modelling*. He knew how to anatomize light and shade in endless gradation;

[1] Published in part by Manzi, in the Roman edition of the "Treatise on Painting."

to give the greatest brilliancy without dazzling, the deepest shade without offending the eye." The same might be said of Leonardo, but certainly not of Mantegna, whose study of antique sculpture led him to define his outlines with almost harsh precision, and especially to avoid that soft modelling of the human form that is one of the chief characteristics of Allegri's art. Both painters, it is true, delighted in form, but the one drew it in its sculpturesque grandeur, the other in its sensuous beauty. Vasari, indeed, implies, rather than actually asserts, that Allegri's drawing was defective, and other critics, taking up his opinion, have not hesitated to affirm that the perfection of his colouring was gained at a sacrifice of the severer principles of design; but this is chiefly because he did not care to indulge in the anatomical displays that many of his predecessors and contemporaries fancied the true aim of art. He was essentially a colourist, and therefore it is assumed rather than proved that he was not great in design, whereas his design, if one only studies it in its due relation to the other qualities of his art, will often be found to be more correct than that of other masters who make it their principal study. In Allegri's works the figures and grouping, that other painters usually make their chief or even sole object, are so employed as to seem only the setting, if one may call it so, of the exquisite poetry of his art. It is this poetry, this rhythmical movement that runs through his works, that gives them such a wonderful charm. Except, perhaps, Leonardo, in whose works we also perceive a strange fascinating rhythm, no painter ever expressed the poetry of motion with the joyous grace of Allegri. All earlier masters, when they strove to depict it, did so in a stiff and awkward manner, and their efforts too often resulted in strange grimaces and contortions of the human figure. Even Raphael, who was a perfect master of dignified action, had not this peculiar rhythmical movement. His poetry is that of calm grandeur, as in

his great frescoes, or holy meditative repose, as in his Madonna pictures. But Allegri's figures seem literally filled with life. It is not merely that they live and move, but they move as it were to quick, passionate music. One can almost count their heart-beats.

This sense of movement in Allegri's works has been remarked by almost all who have studied him attentively. Burckhardt says of it: " This motion is nothing merely external; it interpenetrates the figures from within outwards. Correggio divines, knows and paints the finest movements of the nervous life; " and Kugler writes : " In his compositions all is life and motion, and even in his devotional subjects painted for altar-pieces, which prescribe a certain earnestness and sobriety, he introduces an element which is always joyous, sometimes even humorous. All his figures express the overflowing consciousness of life, the impulses of love and pleasure."

Another chief characteristic of Allegri's art is its supreme beauty of colour. " Correggio," says Ruskin, " uniting the sensual element of the Greek schools with their gloom, and their light with their beauty, became the captain of the painter's art as such. Other men have nobler or more numerous gifts, but as a painter, master of the art of laying colour so as to be lovely, Correggio is alone." It is extremely difficult to decide from whence he derived this wonderful knowledge of colour—certainly not from Mantegna, whose colouring is of the coldest. The great colour school of Venice, under the patriarch Giovanni Bellini, had developed to a remarkable extent even in Allegri's youth. He was the contemporary of Giorgione, Titian, Cima da Conegliano, Palma Vecchio, Catena, Previtali, Pordenone, and several others of the masters formed in the Bellini school, and, if it could be proved that he also had come within its influence, his predilection for colour would be more easy to

explain. But there is no proof that Allegri ever visited Venice, any more than Rome, and unless he did we can only suppose that at some time or other during his early development he learnt something of the mysteries of Venetian colour at second hand, so to speak, through some of the pupils of the Bellini settled in other towns of Italy. Palma Vecchio is perhaps the master to whom he is most nearly allied in his treatment of colour; indeed, so much does he resemble him in the soft lus-cious tones in which he expresses female loveliness, that it is im-possible not to imagine that either both painters were under the same influence, or else that the one learnt from the other.

Mr. J. A. Crowe is of opinion that Lorenzo Costa, the able pupil of Francia, was an artist with whom Allegri must at some time in his early career have been intimately associated. It is probable also, he thinks, that our master knew the Veronese painter Francesco Bonsignore, and gained from him certain secrets of colour; " but," he writes,[1] " we cannot *prove* any rela-tions between him and other painters. We can only infer that the lessons which were decisive in forming his style were not obtained at Correggio, but whether these lessons were taken at Parma or Modena is uncertain. I myself incline to Parma, where Cima da Conegliano at one time cultivated an art that was subsequently confounded with that of Leonardo, and where many pupils of the Paduan school practised on the Mantuan lines which recur in the earlier efforts of Correggio. The Venetian influence comes after the Mantuan. During a stay at Mantua which I fully believe in, I think Costa was the man with whom he associated most.[1] Compare Correggio's early

[1] In a private letter to the editor.

[2] Costa was invited to Mantua by the Marchese Francesco Gonzaga, and might well have been there during Allegri's stay in that city.

' Madonna and S. Francis' at Dresden, with Lorenzo Lem-
bruno's ' Apollo and Marsyas' at the Berlin Museum, and you
will see that both men must have studied under the same master.
Now Lembruno, we are sure, was a pupil of Costa's."

But, wherever derived, the radiant loveliness of Allegri's
colour is wholly his own. Perugino, Francia, and Bellini delight
in pure and solemn colour for the expression of their spiritual
ideals; Titian revels in the deep glory of gold and purple; Tin-
toretto, the dyer's son, produces astounding effects with his rapid
dashes of crimson and yellow; Veronese expresses by means of
gorgeous colour his love of earthly pomp and pageantry, and
Rubens, with profuse magnificence, throws all the colours of his.
palette on to canvas at once, making out of them, as Coleridge
remarks, " one vast and magnificent whole, consisting of heaven
and earth and all things therein;" but none of these masters have
quite the same voluptuous poetry in their colouring as Allegri.
His melting tones and peculiar fusion of tints produce a satisfied
sense of delight in " simple beauty and nought else," that few
other painters ever awaken. His paintings make no demand on
our intellects. Even their colour and perfect chiaroscuro are so
thoroughly spontaneous that our attention is not drawn to them.
We never think of analysing Allegri's mode of execution, but
are content with simply drinking in the delicious harmonies that
he produces, and listening as it were to his soft, luscious strains.

And this brings us to the consideration of yet another
quality of Allegri's art which is very difficult to estimate. This
is its so-called sensuality. It must be admitted that in the pas-
sionate expression and voluptuous beauty of many of his mytho-
logical, and several even of his sacred pictures, Allegri comes
dangerously near to the licence of the later Greeks, but even in
these works there is a certain childlike naïveté that is wholly
incompatible with impurity and coarseness.

His own mind, indeed, seems to have been entirely uncon-scious of evil. Living at that time of Renaissance when the old ascetic ideas of religion had lost their hold on the minds of educated men, and when the revival of the knowledge of Greek art and literature had brought about a wonderful cultivation of the taste, he no longer, it is true, considered like the old monkish painters that the chief aim of art was to remind people to pray and fast, and to present them with a palpable image to be wor-shipped. He regarded art, like the other great masters of the time, purely from an æsthetic point of view, and from this point rightly considered the human body in its developed beauty the highest subject of art. Striving after the utmost perfection of sensuous life apart from intellectual and moral life, he falls at times, it must be owned, into a sort of refined ideal sensuality; but he is unconscious of this tendency himself, and of the insidious danger lurking therein, that became so painfully apparent in the works of later painters, who dragged art down from the serene heights of ideal beauty to minister to the pas-sions of mankind. He has been accused by some writers of having precipitated this degradation of art, but he did so no more than Giorgione and Titian, with whom also sensuality is idealized and glorified. There is no moral elevation in any of these painters' works, but neither is there any baseness. To talk, therefore, of Allegri's " inherent sensuality," as Ruskin does, while exalting " the Venetian mind, and Titian's especially as the central type of it, as wholly realist, universal and manly," seems unfair. He, as well as the Venetians, merely recognized the fact that " the human creature, though the highest of the animals, was nevertheless a perfect animal, and his happiness, health, and nobleness depended on the due power of every animal passion, as well as the cultivation of every spiritual tendency."

d

Amongst the Greeks beauty of every kind received a sort of worship, and the Renaissance was chiefly a Renaissance of this love of beauty, which had been crushed out of men's minds by images of pain and terror during the long ages of superstitious belief. The naked human body in particular, which had been regarded by the early Christians with united dread and aversion as a source of fearful temptation and evil, was once more exalted as the noblest theme for art. Michel Angelo gave it its most scientific, and Titian and Allegri its most sensuous expression. In Allegri, especially, the old Greek feeling for beauty is wholly revived. His art one can imagine to resemble more nearly that of Apelles than the art of any other master. In both painters we find sensuous beauty developed to its highest degree of perfection, just before a period of degradation. They neither of them are responsible for the fall. They simply represent the flower of art at its full bloom, after which, as before said, decay seems inevitable.

Turning from Allegri's art to the artist himself is a most disappointing process. "Even in the highest works of art," writes Carlyle, "our interest, as the critics complain, is too apt to be strongly or even mainly of a biographic sort. In the art we can nowise forget the artist." But our artist's life yields no food for interest of this sort. Robbed of its traditionary setting, it has no biographic piquancy whatever to gratify the taste of the reader, nothing but a few dry facts and dates, and even these occurring only at distant intervals. It is strange, certainly, considering, as Dr. Meyer has shown, the esteem in which Allegri's art was held shortly after his death, that more was not then discovered concerning his life and character; but, in spite of the unbounded admiration of connoisseurs and artists, no interest seems to have been felt in his history, and no pains taken to discover the truth about it until it was too late for much to be discovered. Even

in his native town, in less than a century after his death, the facts
of his life, except as preserved in a few registers recently made
known, appear to have been utterly forgotten. Nor did the
Carracci, over whom the influence of Allegri was so potent, make
any attempt while instituting researches as to his works and their
whereabouts to discover anything regarding his history, but
blindly accepted Vasari's statements as facts, and uttered loud
lamentations over our master's dreadful poverty and hard fate.

It was not until the eighteenth century that Vasari's relations
came to be discredited, and attempts made to discover the real
facts of Allegri's life. But by this time the truth was very
difficult to disentangle from the fiction, and researches often
ended in merely creating contradictions and perplexing the per-
plexed subject still more. Thus at one time it was supposed
that, so far from being of poor and obscure origin, our master
belonged to a noble family of the name of *de Allegris*, who
possessed a castle and estates at a short distance from Correggio,
but this was soon disproved by further researches, as was also
the idea, at one time prevalent, of his residence in Rome, and
study of the works of Raphael and Michel Angelo.

The really ascertained facts of his life, stripped of all con-
jecture and traditionary clothing, may be told in a very short space.
He was born in 1494, the son of a merchant in Correggio named
Pellegrini Allegri. His mother's name was Bernardina Piazzoli
of the Aromani family. He had an uncle named Lorenzo who
was a painter, but presumably a bad one ; whether his nephew
learnt first of him, or of another better painter of Correggio
named Bartolotti, is not certain.

In 1511, at a time when the plague was raging in Correggio,
he went to Mantua, where he resided for some time, probably
studying the works of Mantegna. In 1514 he must have been
back in Correggio, for in that year he produced his first thoroughly

authenticated picture, " The Madonna with S. Francis and other Saints," of the Dresden Gallery, an altar-piece painted as a commission from the Minor friars.

He was first called to Parma in 1518, at which time he painted the frescoes in the convent of San Paolo. In the following year he stood witness to two legal documents in Correggio, and about the same time his maternal uncle Francesco Ormanni bequeathed to him all his property—a house and several acres of land—in "consideration of important services." At the end of the same year he was married to Girolama Merlini, who brought him a small dowry. His eldest son, Pomponio, was born on the 3rd of September, 1521, and a daughter in 1524. He had besides two other children, one of whom died young. He appears for the first two or three years after his marriage to have lived sometimes in Parma, where he had undertaken important works, and sometimes in Correggio ; but he finally settled in the former town, where he executed his great monumental works, the frescoes in the dome of San Giovanni and the celebrated "Assumption of the Virgin" in the dome of the Cathedral. After the death of his wife, which is supposed by Dr. Meyer[1] to have taken place in Parma about the year 1528, Allegri returned once more to his native town, which, as far as we know, he did not again quit until his death, that happened on March 5, 1534, in his fortieth year.

This is all that with the utmost labour and research modern science has been able to gather concerning the outward life of this great master. Concerning his inner life, what manner of man he was, and how he moved and talked among his fellows, we have not so much as a little glimpse. Not one scrap of

[1] But only, it must be stated, on the somewhat insufficient ground, that the registry of her death does not occur in the church register of Correggio.

writing, beyond a few signatures and receipts, remains by his hand; not even one authentic speech to reveal in momentary flash the thought of the man, for the celebrated and oft-repeated exclamation assigned to him " Anch' io sono pittore ! " has been long since relegated to the realms of fable from whence so many of these artistic anecdotes arise.

All that has been done indeed in the way of elucidating his life has but tended to overthrow traditionary evidence, without establishing very much of verified fact in its place.

Vasari's wonderful narration, which formerly excited so much interest and compassion for the melancholy and oppressed painter, only serves in modern criticism to point the moral of that unfortunate chronicler's untrustworthiness. But because the garrulous old Aretine made mistakes at times, and in his love of a story delighted to retail any anecdote that he happened to pick up regarding the subjects of his biographies without examining into its truth, there is no reason for refusing to accept the sound substratum of knowledge that often lies beneath his more apparent ignorance and carelessness. The unveracity of the delightful biographer in matters of date and petty fact has been abundantly proved by the modern historians of Italian art ; but his good sense, clear insight, and hearty appreciation of the artists of whom he writes, and his graphic mode of setting forth their histories, are qualities that are scarcely sufficiently appreciated at the present day. Even his account of Allegri, regarding whom it is evident he had very little real knowledge, is truthful beyond what we might expect in its warm admiration of the Lombard master's genius. In spite of his not having had the good fortune to have been born in Tuscany, Vasari admits him to have been a most exalted artist who, in a few years, favoured by nature and advanced by diligent study, attained the greatest perfection in the new manner of art. " Had he," he

says, " been able to study the works of the great masters in Florence and Rome, he would have been a dangerous rival to many of his great contemporaries, and, proceeding from good to better, he would have attained to the highest summit of excellence."

Nor is Vasari so wrong in what he implies as to the insufficient payment that Allegri received for his works. He was not miserably poor, it is true, and the story of his dying beneath a weight of copper coin is, doubtless, a mere fable ; but even Dr. Meyer admits that he did not disdain at times to be paid in kind as well as in coin, and was accustomed to receive from some of the less wealthy of his patrons articles of provision (*nahrungsmitteln*) in part payment for his pictures. This mode of remuneration is scarcely more dignified than the reception of copper money, particularly if we imagine him driving home himself the fat pig that he received from the lady patron for whom he painted the " S. Jerome" (see page 193).

It is tolerably certain, indeed, from all the facts that have been gained concerning his life, that Allegri lived in a totally different sphere to that in which his great contemporaries moved. With the exception of the Marquis of Mantua, Federigo Gonzaga, his only patrons were ecclesiastical bodies and private individuals, who probably could not afford to pay as munificently as the popes, emperors, and kings who employed Raphael, Michel Angelo, and Titian, and whose commissions did not bring so much fame in their wake. In comparison with these favoured artists, Allegri may well have been considered by Vasari, who measured everything by their standard, poor, ill-paid, and, consequently, unhappy, though, perhaps, in reality, his quiet domestic life, devoted simply to the pursuit of his art, was far happier than that of the magnificent Titian, who kept up almost regal state in Venice, or of the solitary giant Michel

Angelo, who was not, however, too great to allow himself to be disturbed by the miserable jealousies and hatreds that prevailed in the brilliant circles of Rome and Florence.

All Allegri's biographers seem to agree that he must have been of a singularly contented and unambitious character—a lovable man, free from all feelings of envy or self-conceit. Vasari says of him, and having no evidence against his statement we ought surely to accept it, " that he was a person who held himself in but very slight esteem, nor could he even persuade himself that he knew anything satisfactorily respecting his art; perceiving its difficulties, he could not give himself credit for approaching the perfection to which he would so fain have seen it carried; he was a man who contented himself with very little, and always lived in the manner of a good Christian." Contented with little, and living in the manner of a good Christian! What higher praise can be bestowed upon any man?

M. M. H.

ANTONIO ALLEGRI DA CORREGGIO.

CHAPTER I.

TRADITIONS OF HIS LIFE.

His historical importance.—The first accounts respecting him.—Vasari's narrations and other tales.—Supposed likenesses.—Traits of character.—Vasari's unfounded reports concerning the master's misfortunes.

AMONG the great masters who characterise the highest period of Italian painting, Correggio stands alone, not only by the circumstances of his life, but also by the nature of his art. Even Vasari denominates him "pittore singolarissimo," remarking at the same time, that the mighty mother Nature, lest she should be considered too partial, produced artists in Lombardy as distinguished of their kind as those who had for so many years adorned Tuscany. This confession, made by one who was so thoroughly Florentine in his style of art, must have been yielded somewhat reluctantly, and probably only because of his admiration for Correggio, whom he does not hesitate to place in the first rank of

B

Lombard painters. " Among these," he continues, " Antonio, endowed with the most brilliant gifts, has thoroughly mastered the modern manner of art; and, within a short space of time, has risen to a foremost position among the painters of his age."

Vasari, when he speaks of modern manner (we ought rather to say style or art), refers more particularly to that freedom in pictorial representation which distinguishes the masters of the height of the cinquecento period, following in the footsteps of Leonardo da Vinci; and, despite his slight acquaintanceship with Correggio, he displays no small degree of astonishment at the rapid way in which he mastered the technicalities of modern art. He has, indeed, given in one direction the very highest possible development to the art of the painter. He fully realized in his conceptions the charming play of light that reveals all the hidden graces of form and colour, and yet is dissolved again in its own radiance; and thereby was able to express the quick pulse of life in its wildest movements. This sense of movement, which Allegri emancipated from austere rules and laws, and made dependent upon the judicious arrangement of light, entitles him to be considered modern in a broader acceptation of the term than Vasari understood. We cannot fail to perceive how the modern relations of the mind to secular knowledge as well as to Christianity are shadowed forth in his works.

If we adopt Vasari's view, we must conclude that Correggio at one stroke freed himself from the conventionalities of the past, and carried the new form of artistic expression as far as his

genius would permit. He, together with Michael Angelo, exercised the greatest influence over painting in the seventeenth century; but the ensuing one was still more deeply impressed with the character of his genius. The Caracci especially appear to have profited by his studies. He belonged to that type of past art which they and their cotemporaries strove to revive. The art of rococo, also, received from him its strongest impulse; and the artistic adornments which lend such undeniable beauty to ecclesiastical and palatial architecture were modelled after his style. It is singular that the same master who fought against mannerism in the academical revival of art, should have contributed to resuscitate a style of painting which, though charming, is certainly not free from this fault.

This, however, only testifies to the universality of the master's genius, as well as to the peculiar position he occupied in the transitional epoch of two centuries. That which particularly appears to have won the admiration of the Caracci was not only "the pure and exalted style of the painter" (these are the words in the sonnet of Agostino Caracci), but the artistic conception displayed in his productions, which unite a lifelike movement to the charm of a sensuous but unconventional style of beauty. It was this, apart from his higher gifts, that stimulated the art of rococo throughout the century, and established its position among the fine arts. The Caracci themselves paved the way to the adoption of this style of painting by their diffusion of the art-principles of Allegri. But as every new era in art seizes upon a type, the age we are now writing of modelled itself after

Correggio; and the advent of Raphael Mengs proves that his influence extended to a still later period. Mengs, although in a weaker degree than the Caracci, is likewise a talented disciple of our master. He is also one of the first who made close researches into his life and works.[1] At last he collected the little information he could glean about his life, and imparted it to the world, together with the result of a diligent examination of his works.

The strong individuality of Allegri greatly contributed to extend his influence, and rank him among the greatest artists of the Italian school of painting. But that which, next to his art, helped to give him so high a place, can only be seen in the course of our biography.

The great cinquecento masters had naturally each their own peculiar style, which made its impress on the age in which they lived. But they were neither equal in historical importance, nor in the influence which each individually exercised. If we admit Correggio's natural gifts, and view him as an artist who in his delineation of nature drew but little from traditional art, his genius carving out new tracks for itself, we must confess that it is only Leonardo da Vinci and Michel Angelo who can equal

[1] Raphael Mengs, " Memoirs concerning the Life and Works of Correggio." Translated into English in 1796. 3 vols. Mengs was so deeply imbued with his study of Correggio that besides expounding his method of painting he actually painted a picture on the same principle as the " Notte," making the whole of the light emanate from the body of the child. This picture was so highly valued by Mengs's patron, Charles III. of Spain, for whom it was painted, that he had it covered with a single plate of glass, which, as the picture measured 9 ft. 10 in. by 7 ft., must have cost a large sum at that time.—ED.

him. And when we furthermore take into consideration that the influence of his style made itself felt for centuries, we must admit that it is only the latter artist who can be compared with him. Raphael indubitably exercised a powerful influence over the art of his own day, as well as over that of succeeding times. He marks the stationary point between the rise and decline of art in Italy. His influence is equalizing and connecting. He not only gives further development to the art-principles of the early masters, but embellishes his style by infusing into it the new perceptions of the coming age, thus forming a distinguished link in the artistic chain.

Thus his position in the history of art corresponds with his harmonious, cultivated character, which combined the various ways of interpreting nature into one symmetrical whole. But Correggio has left the impression of his peculiar style on whole centuries. He viewed nature in a new and completely different light from his predecessors and contemporaries, and founded a school of art of quite an individual character by investing his representations with an appearance of natural, everyday life. Everywhere, even in the most unlooked-for places the un-mistakeable traces of his influence make themselves apparent. Whether we glance into the village church, or gaze upon the pious devotional pictures of a later date in private houses, in Italy, Germany, and the Tyrol, we often recognize in the Holy Virgin of the village painter, a Madonna of the Correggio type. And again, whoever may chance to observe, with a practised eye, the cheerful pictorial representations in French and German palaces of the preceding century, will see Correggio's angels

smiling in the corners of the painted skies. The power of the master's genius was such that he influenced the art of entire epochs, particularly that of the eighteenth century.

Yet Correggio represented art entirely from his own point of view, and depicted the life comprised within the circle of his conceptions according to his individual ideas. He saw beauty only in charming, animated grace; the sublime only in friendly conciliatory earnestness. Even greatness, severity, and dignity are made to partake in his pictures more or less of this character, and if he attempts to depart from it, he invariably fails. His greatness did not consist in knowledge and sentiment any more than in his perception of that ideal which surpasses nature. He is in this point the very antithesis of Michel Angelo, with whom he possesses in other respects many traits in common. He is deficient in sublimity, but his manner of representing life is so finished, so full of charm, so truly human and natural, that his influence must be felt through every age.[1]

The great interest we feel in our age in Correggio's life and works, proves how high a place he has attained in art, and that his influence has extended to periods unswayed by his peculiar way of depicting nature. His greatest influence terminated in the age

[1] Correggio's manner of representing life differs from that of most other painters. He does not trouble himself about the deep mysteries of existence: he shuts his ears to the still sad music of humanity, and listens only to Nature's most joyous tones. He works from no divine pattern like Raphael, no lofty ideal like M. Angelo, but has a pleasant vision of a serene golden age, in which his creations live, untroubled by thought and unstained by sin and sorrow.—ED.

of Louis XVI., but masters of modern times owe much to
him. Unfortunately the accounts transmitted of his life, even
the results of new researches, are wholly unsatisfactory.

There is no painter of the cinquecento we are so little
acquainted with as Correggio. His influence not only does not
appear to have made itself felt during his life, but we do not
hear of him at all until several years after his death. The
Florentine school developed extensively in Rome, and the
Venetian ruled the style of art of the second half of the sixteenth
century and the beginning of the seventeenth, but Correggio
left no school of his own. It is possible that the privacy and
retirement of his life, in addition to his never having frequented
the great centres of art in Italy, may account for this. Well-
known cotemporary authors do not even mention him. Even
Ariosto, who was born in the same part of Italy, omits to insert
his name among the many great painters of his age he so flatter-
ingly enumerates in his "Orlando Furioso." Among a few
younger authors who must have lived at the same time as he did,
we find only Ludovico Dolce and Ortensio Landi making any
mention of him. The latter (who was born at the beginning of
the 16th century) gives a brief account of Correggio and his
works in his seven books "de' Cataloghi a varie cose appar-
tenenti" (Venezia, 1552, page 498); but even this was written a
long time after Correggio's death, when Landi, after a restless,
wandering life, at last settled down quietly in Venice. The
book, which is a curious compilation, consists partly of satirical
anecdotes of persons of distinction, and events of all sorts,

which took place in the Old and New Worlds. It also gives a desultory list of new artists who had become celebrated in painting, some of whose names have long since been lost to posterity, while others only appear in the second-class lists. Michel Angelo and Leonardo da Vinci are not mentioned at all. Correggio, who has the honour to appear in this mixed company, is favoured with the fullest details. He says: "Antonio Allegri da Correggio, a very distinguished painter, takes nature more as his model than any other artist. Among his many excellent works we may mention the 'Birth of our Lord,' in a chapel of the Church of St. Prospero, at Reggio. In Parma there is a cupola painted by him. No one depicts children better than he does, and none possess the power of representing hair and drapery in a more life-like manner. He died young, without ever having seen Rome." Whether Landi annexed these observations to others made by Vasari, the first edition of whose work appeared A.D. 1550, or whether he personally found an opportunity of inspecting the paintings referred to, during his travels, is uncertain. It is, however, remarkable that he should have noticed Correggio's talent for depicting hair, an observation we also find in Vasari.[1] It seems scarcely likely that he was acquainted

[1] That the Italians highly estimated an artist's facility in painting hair appears from a little anecdote related by Camerarius concerning Albrecht Dürer. While the great German artist was staying in Venice, the patriarch of Venetian painting, Giovanni Bellini, came to see him and his works. He was particularly struck with Dürer's fine and beautiful painting of hair, and asked him, as a mark of friendship, to give him the brush wherewith he executed such marvellously fine strokes. Dürer, not understanding, immediately offered him a number of brushes

with the painter; for in early youth he was mixed up in all
sorts of disputes, in consequence of which he was compelled to
leave Italy, A.D. 1534. He could consequently only have seen
the works of Correggio about 1544-45, as it was that time he
commenced his various peregrinations in different parts of his
fatherland, and there is evidence of his having visited the town
of Correggio during his travels in one of his letters which he
published under the name of Lucrezia Gonzaga. He appears
moreover to have been acquainted with the poet Rinaldo Corso,
who resided there, and the son of our master, Pomponio Allegri,
was in the habit of visiting at Rinaldo's house :[1] it is therefore

of all sorts, telling him to take which he preferred. Bellini of course explained that
he only wanted the particular brush with which Dürer painted hair, whereupon
Dürer took up one of the ordinary brushes such as he had offered Bellini, and
proceeded to paint a long and fine tress of woman's hair, thereby convincing the
Italian master that it was the painter and not the brush that did the work.—ED.

[1] This is Pungileoni's account; and that a certain intimacy subsisted between
the two is proved by the circumstance that Rinaldo Corso was security for one of
Pomponio's farmed estates near Reggio. (Pungileoni, "Memorie Istoriche
di Antonio Allegri da Correggio." Parma, 1817-21, i. 265, ii. 261.) Rinaldo
Corso, of whom we shall speak again, married one Lucrezia Lombardi, possibly
a relation of the learned Giovanni Lombardi, who was an old and much
esteemed friend of our master, and the acquaintanceship between the respective
families may have sprung up this way. Rinaldo moreover stood in friendly
relations with the princely house of the territory, the lady-mistress of which,
Veronica, was, as we shall see, the patroness of our master. Rinaldo
acted in the capacity of secretary to her son, Girolamo da Correggio, who
became cardinal in 1539, partly owing to the faithlessness of his wife, and
partly in order to seek rest from political intrigue. He died as Bishop of
Stromboli. Correggio could only have remembered him as a child, as he was
born in 1525. Ortensio Landi, in speaking of Rinaldo in his letters, says he was
astonished to meet with a Corsican in Correggio who, instead of murdering his

highly probable that Landi met him there, and was thus enabled to add to the information he had already acquired concerning his father. He must in any case have felt great interest in the artist ; but even if he were personally acquainted with the son, his information respecting the person and life of Correggio seems only to have been from hearsay.

The voluminous writer Ludovico Dolce (born in Venice, 1508) also only knew Correggio at second-hand. In his " Dialogues on Painting " (Venezia, 1557), Pietro Aretino instructs a certain Gio. Francesco Fabrini on the progress of art, and in contradiction to an observation of the latter, places Raphael before Michael Angelo, and Titian in the highest rank of all. He then goes on to mention a crowd of masters who had distinguished themselves, among whom we notice the names of Leonardo da Vinci, Giorgione, Giulio Romano,[1] and next to him also Correggio. He observes, " But he (Giulio Romano) was surpassed in colouring as well as in a certain charm of manner by Antonio Allegri, that graceful master whose paintings exhibited in Parma are as beautiful as we can wish to see. He was certainly a better colourist than draughtsman." But Correggio is only mentioned here as a good master ; of his surpassing merit there is no question whatever. In colouring Titian is placed before every one else. " To him alone belongs

neighbour, defended widows and orphans, and wrote charming prose and poetry. Rinaldo began to distinguish himself in literature in his seventeenth year.

[1] And we may add Albrecht Dürer, of whom Aretino writes "that he would have been inferior to none, had he only been born and educated in Italy."—ED.

the glory of perfection in colouring," he says later on in his work. And here also the deficiency of Correggio in drawing is commented upon, a remark which has been often made respecting his productions. We shall however see that this adverse judgment is first put forth by Vasari, although he hints at the defect somewhat obscurely. The scraps of information which Dolce repeats concerning our painter are mostly to be found in Vasari, as well as a few anecdotes, also stolen. In many other writings Dolce mentions Correggio in a desultory fashion, always however as one of the most distinguished men of the century. Nowhere do we find any evidence to show that he stood in personal relations with him. Dolce's books were, moreover, written long after the death of Allegri, and Landi and Dolce were both foreigners, who were neither acquainted with the birthplace of Correggio nor had any communication with Parma. Parma itself possessed no writer of merit, a misfortune which was in itself sufficient to throw a veil of oblivion over the memory of the master.

Neither can we regard Vasari's account as the report of a cotemporary, for he was only twenty-two when Correggio died. Not only did he not live in his times, but he knew nothing of his connections, and his account is a mere loose web of report and fiction. None therefore of his own cotemporaries mention our master's name. Scannelli (of whom more hereafter) complains that the talent of Correggio was obscured by the poverty of his condition, and accounts in this way for his being unknown to the most celebrated authors.

Correggio, on his side, has left nothing behind him save a few deeds and receipts, no writings or letters. The greatest events of the epoch did not stir him. He had nothing in common with the men of progress who decided the fate of Italy, nor with those who possessed a still wider influence. It seems highly probable that he worked for Federigo Gonzaga of Mantua, without however enjoying that intimacy which so often existed at that time between princes and artists or savants. He does not even appear to have stood in any close relations with the nobility of his own town. We hear of a commission given to him, and an honourable testimonial awarded towards the decline of his life, and there is certainly a letter of the gifted Veronica Gambara, the wife of Giberto da Correggio, to Beatrice d'Este, Marchese of Mantua, dated Sept. 3rd, 1528, in which she expresses the warmest admiration for our artist, but for the most part, from what cause we know not, his lords appear to have made but little use of his talents. There is no evidence, either, of his having associated with the great masters of his day, although he was their cotemporary and equal in birth. He seems, however, to have been acquainted with Giulio Romano, who was much employed by Federigo Gonzaga at Mantua, and had to thank this master, who was decidedly his inferior, for the commission before mentioned. It is remarkable that the only acknowledgment which was awarded to him consists in a diploma bestowed upon him by the Benedictine monks at Parma, and which they preserve among their documents. A similar honour was conferred upon Torquato Tasso, and the distinction

was never given to any but those who had rendered signal services to the fraternity. But the lay inhabitants of Parma appear to have shamefully ignored the worth of the painter whose masterpieces adorn their walls. We shall see later the manner in which one of them behaved to him during his life-time. That they appreciated him still less after his death, and scarcely cared to become acquainted with his works, is plainly shown in a letter of Annibale Caracci to his uncle Ludovico, dated Parma, April 28th, 1580. " I am ready to go distracted and weep when I picture to myself the misfortunes of poor Antonio. The idea is overwhelming of a distinguished man like him being crushed and misunderstood in a country where he ought to have been raised to the stars, instead of being allowed to die miserably." The inhabitants of Parma of the sixteenth century seem indeed to have justified the censure previously passed upon them, " that they cared only for eating, drinking, and love-making." Whether Allegri was really unhappy remains to be seen, but that his life, fate, and works were little known in Parma is proved by Caracci supposing that he died there, an error which ought most unquestionably to have been rectified in the town itself.

It is easy to understand that Correggio's retired life, moving within such a narrow circle, and scarcely noticed by his cotemporaries, should be soon forgotten, and should fail to furnish us with information relating even to its chief events. Everything tended to wrap this secluded existence in deeper obscurity. The

career of the artist was distinguished by no incident which influenced his fate or turned the current of his being. On the other hand, it is clear that the nature of his life had little influence over his art. We are consequently as much in the dark respecting the circumstances which led to the production of his masterpieces as we are with regard to the life of the artist himself. In addition to this, Correggio hardly ever crossed the boundary of his own home, so remote from the centres of Italian civilization and culture. There is no reason to suppose that he ever visited Rome or Bologna, on the contrary everything tends to prove that he did not. Consequently his cotemporaries, even if he had at that time attained to any celebrity as an artist, must have been alike ignorant of his personal appearance and the occurrences of his life. It follows, therefore, that when enquiries came to be instituted respecting the one and the other at a later period, both were found equally veiled in obscurity.

In the absence of real facts, a thirst for tradition was excited. Vasari having nothing authentic to communicate, made up for the deficiency by flights of fancy, which for the last two hundred years have placed the master and his career in a totally erroneous light. According to his description Correggio appears to have been a man of retiring disposition, who although endowed with a certain kindliness of heart yielded to the sway of his passions more than was desirable. Being poor, and therefore compelled to make every effort and exertion to support his family, he is said to have contracted a habit of saving which degenerated

into avarice. To support this statement Vasari gives us the following anecdote relating to his death.

According to the story, a payment had been made to Correggio in Parma of sixty scudi in copper coin. Loaded with this ponderous sum, he walked in to Correggio, and being overcome with heat and fatigue took a glass of water to refresh himself, which brought on a violent fever, from the effects of which he never recovered. The absurdity of this story has been long recognized. Such a sum in copper would have been a weight of from three to four hundred weight, and would have required the strength of a Goliath to carry it.

Vasari's anecdotes, however, established the poverty of the master as an undisputed fact. Scannelli, a writer of the seventeenth century, who exerted himself to prove that Correggio was equal in birth to the great masters of his day, takes every opportunity of speaking of his misery and unhappy life, in order, we presume, that the light of his genius may shine all the clearer in the gloom of misfortune. It is quite possible he was sincere, no contradictory statements were made, and Annibale Caracci appeared also to entertain a similar opinion. The fable of Correggio's poverty is still more enlarged upon in another quarter. Giuseppe Bigellini assures us in a letter dated Correggio, March 10th, 1688,[1] that the dwelling-place of the artist was more like a beggar's hut than anything else, and Linguet relates in his "Annals" that the master died of misery

[1] In the Bottari collection, vol. iii. 499.

in a village, leaving his children a prey to want and starvation. A certain Pater Sebastiano Resta of Milan, also, who lived towards the end of the seventeenth century and interested himself greatly in the fate of our master, keeps the fable of his poverty alive with divers new stories; and more recently this moving recital of the conflict of a great artistic soul with the stings of poverty took possession of the mind of Oehlenschläger, who in his tragedy of "Correggio" (1816), mingling up the anecdotes referred to with additions of his own of the grossest improbability, makes a heart-rending picture of the master's life and struggles with misfortune for which there is not the shadow of a foundation.

At the beginning of the eighteenth century a natural reaction set in against the belief in these fables. Gherardo Brunerio, who in his time instituted investigations into the life of the master, endeavours to prove his descent from an opulent and distinguished family, while an historian of Reggio [1] has got his family tree quite complete. According to these accounts Allegri sprang from an ancient family of that name living in Campagnola, and holding a castle in the district of Correggio in feudal tenure. Our Allegri's family certainly belonged to the same place, but the literary historian Tiraboschi proves the two families to be distinct, and in his notes upon the artists of the duchy of Modena establishes the correct descent of Correggio beyond refutation.

[1] Taccoli, " Memorie Storiche di Reggio."

In reality, however, Allegri lived, if not in affluent at least in comfortable circumstances, and his works were not perhaps on the whole worse remunerated than those of many of his distinguished cotemporaries. In a letter to the above-mentioned Brunorio, dated March 27th, 1716, Gio. Ant. Grassetti, the then librarian of Modena, remarks that no artist of his day was better remunerated by private individuals, but this is decidedly a wrong statement. The slender resources of the population, and the modest style of living of the people amongst whom Correggio pursued his calling, would alone be sufficient to contradict it. The master in many cases sold his small but highly finished pictures at very low prices, and even occasionally was content to receive a few provisions in part payment of the sum owed. Writers have concluded from this that Correggio must have been an excellent house-father (Hausvater); but it is far more likely that this species of payment suited his customers better than any other.

But, however obscure his life may have been, the genius of the master was too conspicuous to have allowed him to fall into entire oblivion, and it is undeniable that his talents received ample recognition at the hands of such cotemporary artists as had become acquainted with his works. The testimony to this effect brought forward by the above-mentioned Seb. Resta in one of his letters is, however, more than suspicious. In this letter he speaks of the admiration of Giulio Romano and Titian for Correggio. The latter in the year 1530 certainly passed through Parma on his way to Bologna to visit Charles V. and

had consequently an opportunity of seeing the paintings of Correggio in the church of St. John, but Resta was probably influenced by the statements of an older champion,[1] whose historical accuracy is extremely questionable. His reports are at all events unworthy of belief, for he appears almost to have made it the mission of his life to elevate Correggio to his true rank as an artist, and was not particular in the choice of the means he made use of in so doing. The evidence even of Vasari carries more weight.

The latter was far better acquainted with the works of Correggio than he was with the events of his life, although he, in common with others, is guilty of the great error of mistaking the locality where the painter's masterpieces were placed. He had repeatedly seen Allegri's works in Parma and Modena. The first time being, as he announces in his own life, during his first artistic journey from Florence to Venice in the year 1542, when he saw and inspected the works of art of Modena, Parma, Verona, and Mantua " in a few days ;" the other time during a journey to Modena, when he viewed a great many of Correggio's paintings, as well as in Reggio and Parma, where he also stayed a few days. Now his own individual style of art was essentially Florentine-Roman, and the peculiarities of the Parmese master must have appeared strange, and antagonistic to his preconceived ideas. It must consequently have been some time before he could have understood him sufficiently well to have appreciated

Scannelli, " Microcosmo."

him. The inadequacy of these flying visits to make Vasari thoroughly conversant with Correggio's manner is proved by his attributing to him a few drawings in his collection, which were clearly the productions of another master. We must however render justice to the artistic insight which enabled him to discover the true and great in a totally foreign style of art. His doubts were soon overcome by the warmest admiration, and although he criticizes perhaps here and there in trifling matters, he does ample justice to the greatness of our master in the aggregate.

And in this he evidently shares the opinions of his cotemporaries. He remarks forcibly : " There remains a great deal still to be said respecting the works of Antonio, but as they have all been noticed by the most distinguished disciples of our art, and lauded as something divine, I will not pursue the subject any farther." Whether the cotemporary masters who stood at the summit of their profession in Rome and Florence, whether Raphael and Michael Angelo were acquainted with his works, is very doubtful, for none of his productions had reached those cities during his lifetime, and did not do so even for some time after his death. His fame could only have been diffused in those artistic circles by persons who had seen his works during their travels, and as we see from Giulio Romano's account, this seems only to have taken place after his death. Vasari give an instance of this in recounting the following anecdote of Girolamo da Carpi. While residing in Bologna, in the house of the Count Ercolani, Carpi saw a picture of Correggio's (Christ appearing to

St. Mary Magdalene), and it made so deep an impression upon him that, not content with having obtained a copy, he went to Modena, in order to make himself acquainted with the master's other works. Here, overcome with admiration and astonishment, he copied certain pictures, and thence proceeded to Parma, where he heard there were other paintings to be seen by Correggio. These communications were made to Vasari by Carpi himself, who was staying in Rome at the time, having been appointed inspector of the building in the Belvedere by Pope Julius III., in the year 1550. Carpi's residence in Bologna, which decided his style of art, and his travels afterwards, must have been undertaken in early life, for he was born at the beginning of the century, and went to Bologna with the intention of raising himself from the humble position of heraldic painter— his father's profession—to that of artist. He became acquainted with Correggio's masterpieces very soon after that master's death; but there is no evidence to show that he knew him personally. Girolamo doubtless contributed much to spread the fame of Correggio in Rome; but it must not be overlooked that even at this time, one of his pictures had reached Bologna, and that by this means his influence was extended beyond the narrow domain of his labours.

In addition to this Vasari observes that Giulio Romano stated, after seeing Correggio's "Danaë and Leda," that he had never beheld any painting equal to it. As before said, these artists may have been acquainted with each other, although their relations could scarcely have ripened into intimacy. Romano,

in obedience to a citation from Federigo Gonzaga, went to Mantua in 1524, and resided there for some years. In March, 1540, he was in communication with the architectural inspectors of the Steccata at Parma, concerning the cartoons that he executed for paintings in the church, and it is possible that he may have gone from Mantua to Parma, and have met Correggio in the latter town. At any rate he appears to have seen his pictures there, and it is easy to see how greatly they influenced the style of his productions in the Palazzo del Te.

Vasari reminds us in more than one place of the high estimation in which Correggio was held by artists. He closes his biography with a Latin epigram, composed by a Florentine nobleman at the request of the whole artistic fraternity. Even in these distiches Correggio is characterized as a painter of the Graces, a distinction which the painters of the eighteenth and nineteenth centuries have repeatedly conferred upon him. His early death is, moreover, made to support the fanciful idea that the nymphs having, during the painter's lifetime, implored Jupiter that he alone might be allowed to depict them, he so far acceded to their request as to " raise the youth to the stars," in order that he might have a better opportunity of viewing the nude goddesses, and thereby be enabled to represent them still more advantageously.[1] A second epigram was added to this in the first edition of Vasari's work, and ended thus :—

[1]
Hujus cum regeret mortales spiritus artus
Pictoris, Charites supplicuere Jovi:
Non alia pingi dextra, Pater alme, rogamus,

"Their homage pay his home the mountain and the wave,
And crowds of weeping painters gather round his grave."

The above testimony in itself enables us to draw the conclusion, that although few writers upon him knew Correggio personally, and the accounts respecting his life are contradictory, yet connoisseurs spread his fame even in distant art-circles, and that in such circles he was ranked, soon after his death, with the first masters. The verdict passed upon his great talent was all the more flattering and disinterested, as it emanated from those who had been totally unacquainted with him.

It is, indeed, passing strange that so gifted a man as Correggio should have been destitute of princely patronage, and that he should have been employed only by monks in monumental works; that he should have led a sequestered life in a small district in Italy, and not even have been known by sight to other artists. So strange, that man's innate love of the mysterious made him endeavour to render it still less comprehensible. It is easy to see that the theory of his poverty was set up in order to account for his leading such a mean, obscure life; and as the master was alike destitute of the favour of the great and the patronage of the public, and as he died without recognition of his genius, and without leaving any school, his death

Hunc præter, nulli pingere nos liceat.
Annuit his votis summi regnator Olympi,
Et juvenum subito sidera ad alta tulit,
Ut posset melius Charitum simulacra referre
Præsens, et nudas cerneret inde Deas.

was also supposed to have been unhappy. Poverty, however, in itself is not sufficient to elucidate so exceptional a career. He was not unknown, for he was much occupied, and found a sale for his pictures. Probably he was himself undesirous of widening his narrow circle and extending his influence. The reproach of being of a miserly disposition, which Vasari casts upon him, probably from mere hearsay, has about as flimsy a source as the other false lights he throws upon his life and character. Even Mengs remarks that the very works of the master refute such an accusation, as the materials he employed in painting are of the most costly description. He used that expensive pigment, ultramarine, to extravagance, the finest varnish, and only the best boards and canvas. The employment of such excellent vehicles doubtless contributed to preserve his paintings in their present state of almost normal freshness. He appears at times even to have put an underwash of gold in order to enhance the brilliancy of the lights. However that may be, he does not seem to have been easily satisfied with his work, for he finished his paintings with excessive care, although, for some reason or other, he disposed of them at a low price. An avaricious disposition would not go to work in this manner, and it is easy to see that the charge is a mere flight of the imagination to help to account for the supposed manner of his death.

Misconception and error have unhappily tended to set more than one portion of Correggio's life in a false light. First of all, we are informed of the number of masters he had to direct his

artistic studies. Then he is stated to have contracted a second marriage. Sometimes the person whom he is said to have espoused after the pretended demise of his first wife, in 1526, is represented as being one Giacopina, of great beauty, but who, according to a later biographer (Ratti), furnished food for the fable of an unhappy marriage; sometimes as one Mazzola, belonging to a family of artists in Parma, with whom our Allegri was certainly in some way connected. The mistake arose in a false entry in the baptismal register in Parma, when, at the christening of one of the painter's children, the name of Giacopina was erroneously substituted for that of Girolama, the real name of Correggio's wife. The inaccuracy of the insertion, for which the registry clerk is doubtless to blame, is proved by the fact of Girolama being mentioned as still living in legal documents in 1528. The second error is attributable to the generally highly trustworthy Tiraboschi, who must have inadvertently taken it from the Benedictine, Maurizio Zappata, who, in a Latin pamphlet on the churches of Parma, mentions Girolama as being the daughter of one Pietro Ilario Mazzola. Zappata, however, tells us nothing more, except that Correggio settled in Parma, married, and had such and such children by his wife, Hieronyma.

The remembrance of Correggio's personal appearance, and the circumstances of his life, were so soon lost after his death that Vasari, who visited Parma and Modena only eight years subsequently, could elicit but little information respecting him. He informs us that he sought in vain for a likeness of the

master; he was so humble and modest, he says, that not only had he omitted to depict himself, but must have refused even to allow any other artist to do so. Several pretended likenesses of him have, nevertheless, been produced; there is not one, however, of which the authenticity is affirmed or even appears probable. The portrait in the Sienese edition of Vasari's works—which appears to have some claims to genuineness—was taken from a picture in a villa of the King of Sardinia, near Turin, the so-called Vigna della Regina. It had been removed there from the gallery of the Margrave of Monferrat, and was probably copied from an original painting in Parma. It represents the front face of a middle-aged man with a long and thick beard. Lanzi found the following inscription upon it :—" Antonius Corregius f" (fecit). Michele Antonioli, an industrious inquirer into the history of the master, and who occupied himself much at the end of the preceding century with eliciting information respecting him, received a copy of the same from Tiraboschi. But he considered it on examination to be the portrait of a priest, named Antonio Correggio, the rector of St. Martino. This supposed likeness has stood as the original of several engravings. Another portrait, after an engraving by Bugatti, is found in two other editions of Vasari, as well as in the German translation. It represents a somewhat wrinkled, bald head, in a bending posture. We are ignorant what original sketch Bugatti had before him; he may have copied it from a drawing by Lanzi, in the so-called "Galleria portabile" of Seb. Resta, a collection which has been added to the Ambrosian Library in Milan. Pungileoni

E

affirms that the head in this drawing corresponds with Bugatti's engraving.

The picture called " Correggio and his Family " portrays a bald-headed man with a wife and four children, three boys and a girl, who are barefooted and meanly attired. But it was part of the plan of Pater Resta to take every opportunity of making the master interesting. Now Correggio had indisputably three daughters and a son, only he died in his fortieth year, so it is scarcely likely he could have laid pretensions to a bald head and wrinkled face. The woodcut in the Bologna edition of Vasari's works (1648-1653) much resembles this picture in general style. It is probably taken from an early paper drawing in the Pitti gallery, and Zenobio Weber struck a copper medal from it in the painter's honour in 1779. The one which adorns Ratti's and Mengs' writings on Allegri is probably copied from a painting by Dosso Dossi, first met with in Genoa, and thence transported to England. It is quite possible that Dossi may have met Correggio in Mantua, but there are no grounds for the supposition. According to the report of Ratti, who made a copy of it, the following inscription was found upon the back :— " Ritratto di Maestro Antonio da Correggio, fatto per mano di Dosso Dossi ; " [1] but it is in the first place very doubtful whether this inscription is old and trustworthy, and in the second place whether it is indeed intended to represent our master, or, as

[1] A copy of this portrait was found in the Galleria Bodoniana at Parma. The medallion likeness of Correggio in the frontispiece of Pungileoni's work has been engraved from it.

is far more likely, the miniature painter, Antonio Bernieri da Correggio, who is so often confused with him. It is also possible that the picture is the same as that which belonged to Count Girolamo Bernieri, and was bequeathed to the Dominican order in Correggio in 1638.

There is, moreover, a profile of an old man in white drapery to be seen among the frescoes of Lattanzio Gambara, under the portico in the chief nave of the cathedral in Parma, which is supposed to be our master. Gambara worked there from the year 1568-1573. But he was only born a year before the death of Correggio, so it is impossible to say from what original he painted his picture. Equally questionable is a pen-and-ink drawing of a head bearing his name at the beginning of a volume of copper-plate engravings of his works. There is also a description of a "Portrait of Correggio," in the old original catalogue of the Farnese gallery in Parma. It runs thus :—" A man with a black beard and dressed in black, with a pointed collar." The picture has disappeared. Tiraboschi lastly informs us of a portrait in the possession of Signor Giuliani, in Modena, which has been engraved, but he doubts its authenticity.

Vasari then was certainly correct in stating that Correggio had not only omitted to take his own portrait, but had not sat to any other artist. It was not till some time after his death, when the master's genius had evoked an interest in his memory, that the desire to perpetuate his lineaments was awakened, and then

r See note at end of chapter.

every endeavour was made to either find or make his portrait. During his lifetime he was, as we have seen, so little known that it seems scarcely possible that any celebrated brother artist should have been enabled to hand down his portrait to posterity, and Vasari thinks he was too modest, and too little impressed with his own worth, to have painted it himself.

We have certainly no historical authority for ascribing this quality to the master. As Vasari knew so little of his outward life, it is likely that he was still less acquainted with his inner personality. The other writers of the sixteenth and seventeenth centuries formed their opinions upon the subject upon very uncertain grounds, partly from Vasari and partly from the still less reliable authority of oral communications. How could correct information with regard to a master of whose life we know next to nothing, and who has left no personal evidence, no letter, not even a portrait behind him, be obtained in such a manner?

We must consequently receive with caution every statement that is advanced with regard to his character and disposition. Ideas respecting the latter appear chiefly deduced from the retired style of his life. Vasari may, it is true, have elicited some few particulars from Giulio Romano, supposing that he had indeed been personally acquainted with the master. We must endeavour, however, to examine the truthfulness of the reports concerning his qualities of mind, destitute as we are of every species of cotemporary information which might help us to see clearly into the inner man. We only possess documents relating to his labours and outer existence. The only thing we can do

in such circumstances is to judge of his character by the few facts and sketches which have been transmitted to us respecting his life, and examine the testimony of the oldest Italian writers.

Scannelli remarks, relative to his modesty and contented disposition, that he was " without ambition, possessing well-disciplined passions, quiet and grave in disposition; and that he thought life worth having, without seeking his fortune in large foreign towns, or the favour of princes." This is only an enlargement of the statement which Vasari makes respecting the man's retiring disposition, " who thought but little of himself, and was contented with a little." Correggio appears to have been ignorant of the art of flattering the great, and profiting by their favour; it may be, he was also deficient in that finish of manner and address with which the most distinguished masters cannot dispense in their intercourse with princes. His relations with Federigo Gonzaga appear to have terminated as soon as the pictures he executed for this prince were completed. Gonzaga, nevertheless, took the greatest possible interest in art and artists, stood on the most friendly confidential terms with Titian, opened to Giulio Romano an extensive field for the exercise and development of his architectural and artistic gifts, and, according to Vasari, loved this master more than can be well expressed. The commissions which Correggio executed for him appear, however, to have been unproductive of any further result. It has been said that, in order to give him some outward recognition of merit, he created him cavaliere. The latter statement is made by the French engraver, Ravanet, who went to Parma in order to

obtain every information respecting the master, with the intention of writing a biography. He learnt the fact from Count Gastone della Torre di Rezzonico, who, on his side, was making every inquiry into the life of the painter, and tried to find out a correct account of the occurrence in reliable documents. But the story has nothing to support it, and seems very improbable. Gonzaga does not appear to have troubled himself about the master after the completion of the pictures, although they were intended as a present for Charles V., which circumstance proves sufficiently how highly our artist was esteemed.

Vasari is therefore no doubt correct in stating that the master was shy in his intercourse with the world, and little desirous of passing the narrow limits of his home, or extending his sphere of action. He possessed nothing of the spirit of wandering which distinguished the great artists of those times. His travels were limited to a radius of a few miles round Correggio, Mantua, Parma, Modena, and Reggio. All his powers, all his wishes, appear to have been centred in an undisturbed, solitary exercise of his calling. It is characteristic, and therefore partly credible, what Vasari informs us respecting his habits and mode of working. He was "*malinconico*" in his profession, which, rightly translated, means thoughtful or meditative, not hypochondriacal, devoted to his art, and firmly resolved to discover and overcome every difficulty pertaining thereto, as far as lay in his power. Further on he remarks, that he did not believe Correggio ever attained to that degree of perfection in his art that he longed after.

We .must not, however, allow ourselves to be led away by Vasari's observation, into the belief that Correggio only experienced the toils and drudgery of art, and was ever a prey to the doubts of a self-tormenting nature. Quite the reverse is the effect produced by pictures, in which cheerfulness universally prevails. Compared with the facility with which Vasari and his cotemporaries worked, the great care which our master displayed even in his boldest efforts, seems somewhat wearisome. Work was certainly no light task to him, and with the ideal ever present before his eyes, he devoted the whole of his mental powers, united to the most persevering industry, to its realization. It is precisely this, as we shall show by-and-bye, which gave such a peculiar bias to his artistic character—the union of a genial conception with a thoroughly scientific calculation and application of every means in his power to give it perfect visible expression.

The earnestness with which Correggio prosecuted his art is demonstrated in another account, transmitted to us by Lomazzo, an author and painter of the sixteenth century. Lomazzo writes [1] thus: "Above all we must not forget Correggio, who, like Apelles in his day, besought his brother artists to examine his pictures, and find fault with them (that is to say, criticise), although they were marvellous, and worthy of the highest praise, while he regarded the encomiums and commendation of the public almost with derision." This is rather strong language for an

[1] " Idea del Tempio della Pittura."

author of those times, but it is characteristic of the man, who always strove after perfection in art, and spared no trouble to attain to it. In addition to this he gives us a trait of his over-weening modesty, which is worthy of all the greater credence as he has taken it from some other source than Vasari. Some few acknowledgments of his genius the master doubtless received; but he evidently was not accustomed to be appreciated, honoured, and admired, and perhaps the panegyrics of the world would not have raised him in his own opinion.

The question here suggests itself whether this disproportion between the high artistic gifts with which he must have been aware he was endowed, and the narrow, limited sphere of his action, united to the small amount of approbation that was meted out to him, weighed oppressively upon his spirits. Might not the circumstance of fame not doing justice to the great powers he felt within him have had the effect of rendering him still more reserved and retiring ? He must have known how Raphael and Michael Angelo, the glory of whose names filled the whole of Italy, were fêted at Rome, received commissions from popes and princes, while he worked for monks and nuns. This ready comparison between his fate and theirs might well have led to gloomy thoughts. And although we may not allow ourselves to be influenced by Vasari's assertion, in believing that the master was in reality unhappy, yet it is quite possible that such was the case. Vasari also states that the artist's productions were inadequately remunerated. He observes : " Antonio was cer-tainly worthy of all the honour and recognition during his life-

time which was conferred upon him, verbally and otherwise, after his decease." It is possible, therefore, that there may be some foundation for the supposition that Correggio was saddened by his want of good fortune.

Vasari also gives us another trait which, if it really existed in the disposition of the master, must have occasioned him many a sad hour. "Although possessed of natural kindliness of heart," writes Vasari, "he afflicted himself more than was reasonable by resisting the pressure of those passions which ordinarily oppress mankind." [1]

We must, however, be very careful not to take Vasari's words in too literal a sense : he is neither happy in his expressions, nor distinguished by logical combinations of thought. In the above observations on the character and life of the man, he probably only wished to imply that poor Correggio found his weary, indigent life a greater burden than he could bear. He enumerates his misfortunes one by one. The artist was compelled to work for his family in the sweat of his brow ; human passions held him in subjection (which was all the more deplorable as he was burdened by want, the happier biographer, who took life so easily, may have thought), and his very profession was rendered as laborious as possible. It seems hard to understand how the Aretin master ventured to hazard such opinions, seeing that he could only judge of the character of the man from

[1] It runs thus: "Ancora che e' fusse tirato da una bontà naturale, si affligeva nientedimanco più del dovere nel portare i pesi di quelle passioni che ordinariamente opprimono gli uomini."

F

hearsay: he merely drew his conclusions from the very distant view he had been enabled to gain of his outward life. But the favoured *protégé* of the Medici and a long line of popes must have regarded this retired, tranquil existence as an affliction.

We have indeed no right to infer that Correggio was held in greater bondage by human passions than is natural, nor yet that his style of life was distasteful to him. If he were naturally as modest and frugal as he is represented to have been with some plausibility, he would no doubt have been satisfied with the destiny that was allotted to him, and which he assisted in working out. Frugal natures are neither unhappy nor given to repining, and if, as Scannelli states, he was without ambition, he could have felt no envy at the success of Raphael and Michael Angelo.

Let us strive to look at the master through his works, and, after having duly selected one of these, examine it carefully and meditate on the mind that created it. In doing this we shall find ourselves induced to take a completely opposite view respecting his disposition to the one which has been commonly accepted, owing to Vasari's gloomy description. Endowed with the rare talent of producing new creations out of new inspirations, possessing the gift of genius, provided with every means of carrying out the highest degree of artistic cultivation it was possible to attain, led astray by no foreign influences, never losing sight of his own individuality, or turning aside from the ideal he endeavoured to realize (which cannot, for instance, be said of Raphael), striving without ceasing to give the fullest

expression to his artistic conceptions, and this always with the happiest result, he has the rare faculty of embodying the aërial creations of his mind with equal certainty and power of concentration. The absence of external effort also testifies to his internal harmony and unity of thought. How the master under such circumstances could have been unhappy is not very easy to understand! And what was there wanting in his exterior life and position? The few great works which the limited resources of Parma permitted fell to his share to execute. His increasing fortune must have met the rising exigencies of his family, and he might have looked forward to a happy old age when the capacity for work should have forsaken him. The sphere of action in which his great works were produced was, no doubt, limited. But it was well filled, and perhaps he who resided within its narrow bounds did not care to widen it, and was no doubt happy and contented in his modest way.

If we judge of the master's disposition by the sentiment expressed in his paintings, we must infer that such was in reality the case. And no painter has a greater right to be so judged than Correggio; for the same harmony of feeling seems to pervade all his works, and, even on occasions when he appears to wish to strike out a new line, his habitual serenity of mind is still discernible, because, doubtless, it was the natural tone of his disposition. And this expression is never forced, never the result of weary effort or striving against antagonistic influences, suggesting the notion that it was but the relief to the darker side of his character, as is sometimes the case with humourists.

His works always give evidence of the same sportive, happy
flow of a genial and candid nature. We shall see how Correggio
struck the gamut of all pleasurable sensations in his produc-
tions, from the tranquil joy of a well-disciplined happiness to the
exquisite charm of sensuous beauty, and the fervid ecstasy of
religious enthusiasm. It is remarkable that he of all masters
should first have understood how to depict the smile of a
calm, internal joy, and in such a manner that the spectator
insensibly yields to its fascination. Leonardo has attempted it,
but not succeeded in delineating it satisfactorily. The smile of
his women, who are doubtless of a higher nature than those of
our master, has always something constrained and unnatural.
May not such a happy smile have existed in the soul of the
painter, and interwoven a golden thread of joy into life's dark
woof, like the sunshine that penetrates through the darkest
shades of his productions?

Note to p. 28.—Among the engraved portraits may be mentioned one by John
Jackson, the author of the "History of Wood Engraving," that forms the frontis-
piece to Coxe's "Life of Correggio," a small work published in 1828. This
portrait is taken from the one in Lattanzio Gambara's fresco, and represents,
not an old man, as Dr. Meyer states, but a middle-aged, handsome man, with
a fine long beard, melancholy eyes, and a very thoughtful expression of face.
Lattanzio Gambara is supposed to have copied this portrait from some more
ancient representation of the master then existing in the cathedral in which he
achieved his greatest works. One would like to believe this charming portrait
genuine, but unfortunately there is no satisfactory proof of it being so.—ED.

CHAPTER II.

THE VERDICT OF THE PAST EPOCH UPON CORREGGIO'S ART AND ITS INFLUENCE.

Vasari's criticism and its effects.—The Carracci's estimation of the master.—The seventeenth and eighteenth centuries.—New researches.

FOR some time after his death Correggio occupied a high position among his contemporaries; but by degrees the gentle censure that Vasari contrived to insinuate with his praise, managed to qualify the admiration of succeeding critics. As a colourist, it is true, his merits were pretty generally admitted. Borghini, indeed, went so far as to assert that he surpassed every other master in this branch of his art; but his talents in other respects passed unnoticed, and Vasari's implied opinion respecting his deficiency in drawing was accepted without investigation. " Had he left Lombardy and gone to Rome," says Vasari, " he would, doubtless, have achieved great results, and been a source of anxiety to many who were considered great painters. As his pictures were so praiseworthy without his having ever seen either antique or

modern works, it stands to reason that, if he had possessed these advantages, he would have improved his style of art to such an extent, that he might easily have attained to the highest rank in the profession ; " and in the same strain he continues—" Had he not finished his paintings so elaborately, his drawings could never have won for him the fame which his pictures have obtained among artists." And further on : "this art" (that is to say painting) " is so difficult, and has so many requisites, that it scarcely lies within the power of any individual to accomplish everything. There are many who are excellent draughtsmen, but are deficient in colouring, and others have painted charmingly, but not distinguished themselves in drawing. It all depends upon the natural capacity of the man, and the practice he has been able to bestow upon any particular branch in his youth. But we learn everything in order to strive to bring our productions to that state of perfection which unites drawing and colouring, and Correggio deserves great praise, as he has reached the height of perfection in those works which he has painted in oil and fresco." The unexpected turn which the concluding sentence takes is most amusing, and characteristic, not only of Vasari's style of writing, but of his treatment of our master. One expects him to say Correggio was an excellent colourist, but inferior draughtsman. He cannot, however, bring himself to speak candidly, but bends about, and makes his escape by coming to a dead silence with respect to the drawing. After much wavering, however, he at last comes to the point, and terminates his criticisms by stating that Correggio was, and remained a

colourist, which, according to the view of art of those days, expressed deficiency in other respects. We find the same opinion given much more candidly by Sandrart, who, although in reality copying from Vasari, adds the following conclusion of his own, which the latter did not care to draw. He observes :—" It is certain that no master understood the secrets of the palette better than he, or painted with such cheerful grace, yet so smooth, soft, and flesh-like. None have equalled him in the art of producing the effect of roundness without shadow, and we may well say of this Antonio that, in the matter of painting, that is good painting, he was better instructed than any other artist; and if we say his drawing was not equal to his colouring, we do not wish to detract from the great praise that is due to him," &c.[1]

Vasari is very possibly to blame that the master's worth and

[1] This opinion respecting Allegri's defective drawing appears to be very general among artists and critics even at the present day, though few adduce any satisfactory proofs of it. F. von Schlegel writes : " I should attach more importance to the opinion of those critics who censure this master because his compositions do not harmonize with their ideas of correctness of design and ideal form, had I not observed that the critics themselves rarely penetrate the whole deep meaning of the painter; nay, are frequently quite ignorant of it, having never given themselves time to examine his works in connection. I must first insist on his being studied and *understood;* the rest will soon follow."

The fact is, that Allegri, like Leonardo and his school and the great Venetian colourists, made line and light less his study than mass, light, and colour. His outlines are never drawn with harsh precision, but are expressed by means of soft lights and shadows melting imperceptibly into one another. He uses colour, in fact, to denote solid forms in light and shade, where painters of the linear schools would use line. This is no fault in him any more than in Giorgione and Titian, and it is absurd to judge him by a standard that he never tries to attain.—ED.

rare originality have not been more appreciated. As a practical
man, and perhaps wishing to atone for the injustice he does to
the capabilities and disposition of Correggio, he dwells long and
admiringly upon minutiæ, such as the folds of his drapery; the
winning smile of his little angels; his exquisite landscape back-
grounds; his foreshortening, and, above all, the natural, almost
delusive, manner in which he painted hair. He alludes to these
beauties more than once, especially to the painting of hair, and
in one place it seems as if he wished to imply that Correggio had
in this particular rendered a service to art in itself sufficient to
mark the epoch, and that all artists ought consequently to feel
grateful to him. The passage runs thus :—" It was through him
that the eyes of Lombard painters were opened (that is to say,
he was the first to introduce the new method to the Lombard
painters), and many painters of note belonging to that country
have lately sprung up, who, following in his footsteps, have pro-
duced memorable and distinguished works. Among other
things he has shown us how to depict hair, hitherto considered
so difficult, with such facility that all artists ought to feel eternally
grateful to him." [1] There is something almost comical in the
turn Vasari gives to these laudatory remarks with respect to the
hair-painting. It leads one to imagine that it was this peculiar
talent which opened the eyes of Lombardy. His artistic in-
fluence is much more likely to have made itself felt through
what he mentions in a preceding paragraph—namely, his pic-

[1] See ante, page 8.

turesque grace and finish. Vasari fits in his phrases as best he can, and seems to have cared but little for their logical sequence. It is, however, clear that he attaches much importance to this hair-painting, as he lays such stress upon it in the introduction to the third part of his biographies; and he is not, perhaps, so far wrong in making this simple trait a mark of distinction between the earlier and later epochs, for certainly neither before nor after his time has any master—not even Raphael—carried the delineation of hair to such a degree of perfection, or has succeeded in producing such golden tones. He also alludes to Correggio's masterly arrangement of drapery. But this warm eulogy seems a little out of place in a paragraph in which Parmigiano is given the precedency in " grace and charm of manner." Scannelli is much irritated at this " hair-praise," and seizes every opportunity for breaking a lance with Vasari for dwelling on things of such secondary importance, and passing over in silence the really marvellous qualities of the master.

It was not long, however, before Correggio's talent was rendered full justice. The Carracci, especially, who endeavoured to remodel art from their great prototypes, felt his worth in its fullest significance. The eldest of the three—the judicious Lodovico, under whose teaching the whole school was placed— early directed the attention of his cousins to the study of our master, and when Annibale went to Parma, being then only twenty years of age, he was quite enraptured at the sight of Antonio's works. His residence there evidently made an epoch in his

life, and his brother Agostino, at his earnest request, also came
to Parma, but whether at this time or later, their biographer,
Malvasia, does not state. This visit decided the influence which
Correggio had over their whole style of art. The quick insight
which ever accompanies the inspiration of a man of an impres-
sionable disposition, enabled Annibale at once to perceive the
worth of our master. The accuracy of his design, combined with
the grace and vivacity of his colouring and the life-like appear-
ance of his representations, appear to have especially elicited the
admiration of the seventeenth century master. Annibale, in his
letter to his uncle, particularly draws attention to this latter
quality, as being so opposed to the artificial, studied style of art
of his cotemporaries. He terms it the " ingenuousness and
purity" of the master, and says "that in the productions of other
artists objects are represented as they might be, but in this
man's works as they are in reality." Annibale, whose *forte*
certainly did not consist in conversing and writing, makes use of
awkward phrases; indeed, he admits himself that he cannot
express himself clearly, but he knows well what he means, and,
on the whole, the sense of his letters is obvious. Greatly
charmed as he appears to have been by Correggio's graceful and
faithful portraiture of real life, he never for a moment thinks of
giving him the precedency over Raphael. He could only have
attained to so exalted a position by the union and mastery of
every available resource. That Correggio, however, possessed
many other qualities besides that of colouring is freely admitted
by Annibale. D'Agincourt, also, in an extensive work which

appeared at a much later date, remarks emphatically upon the master's " harmony of form and colour."

The Carracci did not stand alone among the celebrated artists of the second half of the sixteenth and the beginning of the seventeenth century in their appreciation of our master's powers, but they studied him with a conscientious zeal and thoroughness that helped to make them the founders of a distinguished school of art. The master's style exercised a modifying influence, in a more or less degree, upon the method of all the Roman and Florentine painters. In Rome it was more particularly Baroccio whose exceptional talent speedily took a new direction under his influence; and in Florence, Cardi da Cigoli, Pagani, and Cristofano Allori substituted Correggio's life-like warmth and graceful manner, in place of the cold and affected style that they had been led to adopt in imitation of Michael Angelo. That they, in common with Baroccio, in their endeavours to escape from the tyranny of formalism, fell into an opposite extreme, is attributable to their respective idiosyncrasies, which did not admit of a radical and academical reform like that of the Carracci.

Correggio's originality of conception and uniform excellence of form and colour led the Carracci to place him almost in the highest rank of painters. These attributes appear to have been noticed also by Ortensio Landi, who styles him the "noblest master," more gifted by nature than any other master. Annibale discourses upon Correggio's originality more fully in a second letter to his uncle, dated April 28th, 1580: "Correggio's thoughts," he says, " are his own thoughts, emanating from his own imagi-

nation.　One sees that they are the offspring of his brain, and
that he took nature alone into his counsels.　Others have ever
leant upon some foreign support, some on models, others on
statues and engravings."

It was the verdict passed upon Correggio by the Carracci
that chiefly gave the tone to the opinion of the seventeenth cen-
tury, though the appreciation of his works was partly spontaneous,
and the few artists and amateurs who mention him evince the
great fascination his works seem to have held over unprejudiced
minds.　Tassoni expresses his admiration for him about the
beginning of the seventeenth century in the following manner :
" Pliny praises the paintings of Apelles, with which those of our
master may in some respects be compared, chiefly for their grace,
beauty of finish, and charm of colour; but no one can quite equal
Antonio, who has attained the highest point of perfection in
artistic colouring, expression of beauty, and grace."　We have
already alluded to the eulogium passed upon him by Scannelli.
Correggio, Raphael, and Titian are, according to his ideas, the
three greatest painters ; and in his classification of the artists in
his " Microcosmos of Painting," a work he produced after the
" Microcosmos of Men," he assigns the first rank to our master.
In the midst of a great deal of bombastic and allegorical imagery,
we find the character of Antonio faithfully portrayed.　In alluding
to him among the other distinguished men of progress of the
modern mode of art, he observes, " he has in reality reached the
zenith of faithful portraiture of nature."　Scaramuccia bestows the
following ecstatic panegyric upon him: "This is the very quintes-

sence of good style. You need not seek further, for here are hidden the costly jewels and all the imaginable essentials of our highly difficult art. You do not need to seek further. Oh, thou spirit of my Antonio of Correggio, what master didst thou have from whom thou couldst have acquired such divine powers ? "

In the eighteenth century both artists and amateurs stood under the immediate influence of Correggio. It now became the fashion for cultivated foreigners to travel to Italy, and their opinions were soon disseminated in letters and reports. The fame of Antonio became consequently diffused in foreign countries as well as in his own native land. The descriptions contained in the art-journeys of Blainville, Richard, Richardson, De la-Lande, Cochin, De Brosses, are full of admiration of our master, and many rank him even higher than Raphael. Some few, as, for instance, Cochin, comment upon the incorrectness of his drawing; but he criticizes from the point of view of the classical schools of art, which admit of no licence. There also arose about this time an interest in the person, life, and fate of the master, and we shall soon have to speak of the result of the investigations which were set on foot.

In the present century, Correggio's fame has somewhat diminished, although his artistic importance is not denied. Modern critics acknowledge him to be one of the greatest masters of the height of the cinque cento period, but they reproach him with having contributed to the decadence of art. Burckhardt, one of the most discerning connoisseurs of the Renaissance, has especially judged him severely, although he

acknowledges his great gifts. According to him Correggio has demoralized art, and made all his conceptions an excuse for representing life only under the aspect of sensuous beauty. Modern criticism, which demands from art certain moral qualities, is the result of a peculiar mode of thought, which does not affect the character of our master. Such a sentiment never found place in the more naïve criticisms of earlier epochs. It never once occurred to his admirers of former times that the charming influence of his painting had a dark side, or that he sinned against the purity and dignity of art by making it a vehicle for sensuous expression. If sometimes a little censure was blended with the admiration elicited by his works by early writers, it was directed against some linear deficiency or error in subordination ; the moral character of his art was never impeached.

As we have already stated, it was in the eighteenth century that attempts were first made to clear up the facts relating to Correggio's life, and disperse the cloud of tradition which so long hung over his modest career. We cannot, however, say that the efforts of the Pater Sebastiano Resta, who worked towards the end of the seventeenth century, contributed much that way, although he made every endeavour to elicit information, and to resuscitate an interest in the master's life. His zeal in investigation arose partly from personal motives. He had a numerous collection of drawings in his possession, most of which he attributed to Correggio, while they were chiefly the work of a totally distinct hand, being only copies of the master's

productions. According to the opinion of Count Rezzonico, they were done by an artist named Franco.[1] It is possible Resta believed in them himself, but at any rate it was his interest to make the collection which had cost him very dear pass for the work of Antonio. With this view it was also desirable to increase the growing interest in the master, so he spread abroad a number of fables relating to his life which awakened a deep and lasting sympathy for his fate. He may have disseminated them in good faith, for he acted from a strange admixture of personal motive and a sincere desire to do honour to the great master, whose fame he desired to restore; but it is curious to see how he obtained these accounts, and the means he used to establish their veracity. We shall recur to this later, when we come to the examination of the truth of Correggio's pretended residence in Rome. Resta's tales and the anecdotes he put into circulation are entirely unworthy of belief, but his efforts had at least the good result of drawing attention to Correggio's life. Some few of his letters have been printed by Bottari, but by far the greater number addressed to the painter, Giuseppe Magnavacca, are in England.[2]

The Swiss painter, Ludovico Antonio David (born 1648), who spent nearly his whole life in Italy, undertook to compile a biography of Correggio about the beginning of the eighteenth century. This has never been printed, as it formed part of a

[1] G. Campori, "Lettere artistiche inedite." Modena, 1866.
[2] Tiraboschi vol. vi. 247.

larger work which he left in manuscript, but he, David, made the first rent in the old web of tradition by trying to prove that Allegri descended from an old landed family. This new fable, exactly the reverse of the old, was taken up by Gherardo Brunorio, who published it in a letter in 1716.[1]

The well-known collector and connoisseur, Pierre Crozat, also collected some material with regard to the life of our master at the beginning of the century. But the work he contemplated was never completed.

Shortly after the latter writers appeared Raphael Mengs, who added to his researches a critical examination of the master's works. As we have before stated, it is remarkable that a man like Mengs should have undertaken the work ; a painter less distinguished by his original genius than by his imitation of the great masters, whom he took as types in the classical revival he effected.

Mengs in truth occupies the standing point between two artistic epochs. He repeats many of the old errors, among others that of Allegri's second marriage. But he approaches the traditions on the whole with caution, evinces an unbounded admiration for Correggio's method, and informs us of the fate and place of destination of several of his works. His treatise, " On the Life and Works of Antonio Allegri," appeared in the year 1780.

In the year 1781 a larger biography appeared at Genoa,

[1] "Risposta dell' Ill. Sig. Abate N. N. di Correggio, ad un Cavaliere Accademico," &c. Bologna, 1716.

compiled by the Genoese painter Carlo Giuseppe Ratti, a writer on art who had been persuaded to undertake the work in question by Mengs, and merely repeated his opinions. About the same time Michele Antonioli instituted diligent investigations into the circumstances of the master's life, and not only collected stray accounts, here and there, but also discovered documents which throw a new light on several points. The work, however, was never completed, and Pungileoni made use of most of his materials.

Somewhat later, in the year 1786, the profound and conscientious librarian of Modena, Tiraboschi, published a more compendious treatise on Correggio, which had more influence in dissipating the cloud of fables and traditions which hung over his life, than any work which had yet appeared. It is a highly meritorious work, and one that was undertaken in a true spirit of historical inquiry; although he may not always have succeeded in obtaining accurate information, his researches with respect to the origin, genuineness, and whereabouts of Correggio's paintings are very valuable.

Towards the end of the century, Pater Ireneo Affò interested himself much in our master, particularly with regard to a monumental work which had long been missing, and respecting which he was enabled to give a detailed account.[1] A little later Pater Luigi Pungileoni[2] collected in a work of three volumes all

[1] Ir. Affo, " Ragionamento sopra una stanza dipinta del A. Allegri de Correggio nel Monasterio di San Paolo." Parma, 1794.

[2] Luigi Pungileoni, " Memorie Istoriche di Antonio Allegri detto il Correggio." 3 vols. Parma, 1817-21.

H

the earlier reports and documents relating to Correggio, endea-
voured to sift the truth therefrom, and to produce a faithful
account of the master's life and career; but his book is discon-
nected, put together without order, and written in prolix,
pedantic language. It is nothing more than a diligent compila-
tion of materials which he had obtained for the most part from
his predecessor, Antonioli, and made use of without acknow-
ledgment.[1] After this appeared Michele Leoni's pamphlet, and
Pietro Martini has lately presented us with a revised and clearer
edition of Pungileoni's materials, but with no new additions of
any importance.[2] The only foreign author worth mentioning
who has written any detailed account of Correggio is Sir C. L.
Eastlake, who has made pertinent observations upon his style of
painting which are deserving of attention.[3]

Before we proceed to give an account of Correggio's life and
works, a few observations are necessary with regard to his name.
Vasari generally calls him plainly Correggio. He also bore the
nickname of Lieto or Lieti, and signed his name in this way,
not out of frolic or pride, as has been supposed, but in receipts
in connection with the Convent of St. Giovanni, and the Chapter
of the Cathedral of Parma, while the said Chapter, after the
fashion of the day, generally styles him Antonio da Corezo.

[1] Dr. Meyer scarcely makes it apparent that up to the date of his own work
Pungileoni was the standard authority on the life and works of Correggio, and
that his work, although perhaps prolix, is distinguished by great industry and
careful analysis.—ED.

[2] Studj intorno il Corregio. Parma, 1865.

[3] In his materials for the " History of Oil Painting."

In the public documents preserved in Correggio he is called "Antonio de Allegris." Tiraboschi informs us that, in the entry of his burial in the Church register of San Francisco at Correggio, he is termed the Master "Antonio di Alegri" or "de' Alegro depintare." On the other hand, his son signs a testimonial in reference to a painting of Giambattista Titi in Parma, thus :— "Io Pomponio Lieti, pittore, di mano propria." In a few Latin despatches, dated 1521, his name Allegri (joyful) is translated according to the custom of the humanists in those days into Latin (Lætus); but, towards the end of the sixteenth century, the master is commonly called after his birth-place, Correggio, and we find this appellation adhered to in the letters of Annibale Carracci.

His contemporary, the miniature-painter, Antonio Bernieri, is also called Antonio da Correggio, as well as a later artist, who lived towards the end of the sixteenth century, but whose works have passed into oblivion. The former was a pupil of our masters up to his eighteenth year. It is not impossible that the smaller and more insignificant works which have been supposed to be youthful attempts of our master, may have emanated from one of these artists, also that the pretended likeness of Correggio, painted by Dosso Dossi, may, as before said, represent the miniature-painter, Bernieri.

CHAPTER III.

Youth and Education.

His family and condition in life.—Primary education.—His uncle Lorenzo.—Residence in Modena and Mantua.—Mantegna and his influence.—Pretended residence in Rome.—Alleged universality of Correggio's education.—Youthful works.

ANTONIO ALLEGRI was probably born in the year 1494, in Correggio, a little town between Modena and Reggio, but nearest to the latter. It was in those days the residence of a petty prince who held his court there. This date for his birth is given in an inscription on a monument raised by Girolamo Conti in memory of the master in 1690, which states that Correggio died in 1534 in his fortieth year. The baptismal records of the place only date back as far as 1496, but Pungileoni assures us that, according to two documents which he found there, but respecting which he gives no details, the birth of our master took place some time between the 1st of February and the 14th of October.

Pellegrino Allegri, or Pellegrinus de Allegris (also called Domani), was a merchant or shopkeeper of Correggio. He married Bernardina Piazzola of the Ormani or Aromani family,

who brought him a dowry of 100 lire, a by no means insignificant sum in those days, and appears to have lived in comfortable circumstances. In 1516 he purchased a clothier's business, and also for nine years farmed two estates with a certain Vincenzo Mariani, of San Martino in Rio, engaging to pay 150 golden ducats a-year, a third of which was to be paid down immediately. These are infallible signs of his being in comfortable circumstances. In the year 1519 Pellegrino married his daughter Catarina to this same Vincenzo, presenting her afterwards, according to the custom of those days, with a marriage portion of 100 golden scudi, in June, 1521. That his property steadily increased is clearly proved by his will which he made in the year 1538, four years after the death of his son ; he therein bequeathed to his grandchild Francesca, the daughter of our master, 250 scudi in gold. In 1519 young Antonio's circumstances were also improved by a present from his maternal uncle, and on his marriage, which took place towards the end of the same year, his young wife brought him a very fair dowry for those times. We may therefore safely draw the conclusion from the preceding statements that Correggio was brought up and lived in comfortable bourgeois circumstances.

It is said that Pellegrino had destined his son for the learned professions (delle lettere), by which at that time the humanities were understood, but the information is not authenticated ; he appears at any rate to have devoted himself to painting at an

[1] Pungileoni, on the other hand, considers that the youthful Antonio was

early age. Correggio, like many other small places in Italy in those times, possessed its home-bred artists. The little court contributed somewhat towards the support of the art industries of the place, particularly to that of the tapestry manufacture, and in the days of Veronica Gambara, the second wife of Giberto, it extended its patronage to scientific pursuits as well. There was evidently at one period plenty of well-remunerated employment for artists, for in 1507 Francesca of Brandenburg (princess of the Electoral house of Brandenburg), the wife of Borso of Correggio, built a palace in the town in the style of the Renaissance, the walls of which were adorned with frescoes. The young Antonio could consequently have easily obtained instruction in the rudiments of art, as well as have found opportunities for forming his taste, in his own neighbourhood. But there is no authentic information as to his first masters. He very probably took his first lessons from his uncle Lorenzo, but there is no proof of the statement.

This uncle, who died towards the end of the year 1527 and left no known works behind him, plays an equivocal and rather a curious part in art history. Except for his relationship to his nephew he would be hardly worth notice. According to many accounts it is doubtful whether he rose to the rank of artist at all. In a pamphlet by Rinaldo Corso, dated 1542, we find the

instructed by Giovanni Berni in all the usual elements of knowledge, and that he learnt rhetoric and poetry under Battista Marastoni, a native of Modena, who settled in Correggio about 1500, and became professor of rhetoric and belles lettres.—ED.

following paragraph: "like one of our painters at Correggio, named Master Lorenzo, who, intending to paint a lion, represented a goat instead, and wrote underneath 'a lion.'" It is one of the well-known artistic anecdotes that appear in different forms, and perhaps only shows how busy tradition was on all sides to connect the life of the famous master and every one pertaining to him with something out of the common. But, if the fable does indeed relate in any way to Correggio's uncle, it proves that he must have been an artist of a very mean order. The documents found by Pungileoni in Correggio prove that Lorenzo was chiefly employed in the trading department of the profession. We find, however, that in the year 1503 he painted a picture for the Convent of San Francesco, which he probably disposed of at a low price.

The frieze of a saloon in the ancient palace at Correggio, which the lord of the territory, Count Giberto, caused to be painted in fresco in 1498, represents scenes from Ovid's Metamorphoses, and bears the signature of Laurentius P. But this work, which bears some resemblance to our master's earlier attempts, seems too good to ascribe to his uncle Lorenzo.[1] The

[1] Possibly this frieze was the work of an artist of Correggio named Baldassare Lusenti, who is mentioned as having, "with other painters of Correggio," executed many works for the Counts of Novellara. According to the testimony of a certain Becchignoli, in 1512, his pictures were distinguished for their good colour and beauty ("ben colorite e piene di vaghezza"). He is known to have painted a chapel dedicated to St. Ursula for the celebrated Isotta de' Correggi, but this chapel no longer exists, so that we have no certain work by his hand.

But in the archives of Novellara it is stated that the Donna Caterina Torelli,

latter was married twice, first to Catarina Calcagni, and the second time to Maria Prato, of San Martino. Three daughters and a son named Quirino were the issue of these marriages. The son studied painting, but without result. Lorenzo's second wife died before he did, and probably his children also, for on March 11th, 1527, he made over his property to his brother Pellegrino, only retaining the usufruct. He must have been rather well off, as he had the means of purchasing a little estate from Antonio Zaragni in 1482. This information is not without importance, as it throws light upon the financial resources of the family.

But, even if the young Antonio studied the rudiments of painting with his uncle, it is clear that he could not have pro-

widow of Gian Pietro Gonzaga, wishing to have some rooms in her castle decorated in an elegant style, commissioned "the painters of Correggio—that is, Mastro Antonio and Mastro Ladino and two youths, all of Correzo," to paint them. In the books of the administration also is found a list of payments, dating from 1514 to 1518, made by one of the Gonzaga family, for the lodging of the same "painters of Correggio and their assistants". (Stessi depintori de Correza e loro brigate). Bigi is of opinion that the two youths named as working under Mastro Antonio (probably Antonio Bartolotti)—and Mastro Ladino, an artist of the Landino or Landini family, were none other than our master Antonio Allegri and this Baldassare Lusenti. Allegri was then about twenty years of age, and might well have been working under Bartolotti, not exactly as a pupil, but as one of the chief painters of his "brigade." Bigi, in fact, affirms that he was, resting his opinion on the fact that the paintings in one of the cabinets of the castle clearly reveal the mind and hand of the painter of the Monastery of S. Paolo. One of these paintings, a fine fresco, representing Jove with Ganymede and two genii, was, in 1845, transferred to canvas, and placed in the Gallery of Modena, where it still remains, and is assigned to Allegri. Even Dr. Meyer admits that it is perhaps genuine. —Bigi, "Notizie di Antonio Allegri," 1873.—ED.

ceeded very far with such a master. It is possible also that he worked under an equally mediocre artist of his birth-place, named Antonio Bartolotti[1] (nicknamed Tognino) as, according to Pungileoni, a fresco of this master's bears some resemblance to Correggio's youthful productions. He could have gained nothing from him, however, beyond a certain technical practice in tempera painting. As to his further development we know nothing. According to Tiraboschi there is an old MS. in Parma which designates Michele and Pier Ilario Mazzola, the uncles of

[1] Dr. Meyer differs greatly from other authorities in bestowing so little notice upon this master, who is generally considered to have been the young Allegri's first and principal instructor in painting. Antonio Bartolotti, or Bartolozzo, called also Tognino degli Ancini, or Anceschi, was born at Correggio about the year 1450, and became in 1500 head of the school of painting— Caposcuola—in that town. In the "Memorie Patrie" of Bulbarini he is spoken of as a "painter esteemed for the perfection of his design, his delicate *impasto*, and the harmony of his tints;" and, moreover, as having "often assisted the youthful Allegri, *his pupil.*" Unfortunately there is very little remaining of this master's work, but the registers of the Frati Conventuali mention "a gracious Madonna" that he painted for their church, and other paintings in their convent no longer existing. In the Palazzo of the lords of Correggio, however, two rooms may still be seen that were probably painted by Bartolotti's scholars, under his direction. They are somewhat in the style of Mantegna, but are greatly inferior to that master's works.

The only paintings by Bartolotti himself that are known to be preserved are two figures of S. Peter and S. Teresa, in the Church of S. Maria, at Correggio, and a fine altar-piece representing the Virgin and Child, with S. Francesco d'Assisi and S. Quirino. In a corner of this painting are the letters A. B. D. N. D. F. MCCCCCXI. These are supposed to mean "Antonius Bartolotti De Nostra Devotione Facta, 1511," which is the year in which the plague desolated Correggio. That this picture bore allusion to this dreadful calamity is furthermore rendered probable by S. Quirino, the patron saint of the city, being represented as in the act of offering the city to the protection of the Virgin, in which offering St. Francis appears to concur. The picture was originally painted for the Church of S. Quirino, but was afterwards placed in the Church of S. Maria, from whence, in the year

Parmigiano, our master's famous successor in art, as his early instructors. But this authority only repeats with uncertainty the assertions of others without confirming them. The statement which it likewise makes with respect to Correggio's tender age when he came to Parma is utterly without foundation.

Mengs, on the contrary, holds the opinion that Correggio studied under two painters in Modena, who formerly were held in a certain degree of estimation—namely, Francesco Bianchi, who died in 1510, and was also called Ferrari or Frari, and Pellegrino Munari. The statement with regard to the former is, at any rate, partly confirmed by an old biographical account of the painters of Modena, by Vedriani,[1] who obtained his inform-ation from the chronicle of one Tomaso Lancilotti, who was cotemporary with Correggio. But the passage referred to in this work is an addition of Spaccini, the publisher of the chronicle, and nothing relating to it is found in the MS. of the chronicler. There is no particular reason, however, for rejecting it. Gianantonio Spaccini, who was himself from Modena, and, moreover, a very fair portrait-painter, scarcely lived a hundred

1787, it was transported to Modena, and afterwards located in the Gallery degli Estensi, where it is still preserved. It is described by Dall' Olio in his pamphlet entitled " Pregii del R. Palazzo di Modena." This is probably the work to which Pungileoni refers as bearing some resemblance to Allegri's early performances.

Thus it will be seen that, although there is no absolute proof that Allegri was Bartolotti's pupil, yet there is fair ground for the supposition, and also that, if Bulbarini's statements are correct, he might have learnt more from him than a mere technical practice in tempera painting. Allegri was seventeen years old in 1511, when Bartolotti was engaged upon the painting in the Modena Gallery.—ED.

[1] Vedriani, Pittori, &c. Modenesi, 1662.

years later than Ferrari, and might, therefore, have obtained trustworthy information respecting the master; and it is quite natural that he should have enlarged upon Lancilotti's notices of the artist, which were very short. The question of Correggio's artistic education, and the different masters he had, is, however, so important in endeavouring to account for his quick and peculiar development, that really reliable information respecting it would amply reward any amount of trouble in investigation. In the want of credible witnesses, and the doubts cast upon Spaccini's addition, we can only come to a decision by comparing the works of the respective masters, and there are several noticeable traits in the paintings of Frari which remind us of Correggio. His youthful production, " The Madonna and St. Francis " (Dresden), to which we shall recur later, displays, in many points, an affinity with a painting by Frari in the Louvre, representing an enthroned Madonna sitting between two saints. The similarity is most striking in the arrangement, the character of the faces, and the bas-reliefs which adorn the throne. Francesco Bianchi appears to have been influenced in his style by Francia. We find in his productions the expression of soft and sweet pathos which Francia had in common with the Umbrian School, but reduced to natural limits. We shall see later on how this mode of expression was afterwards adopted by Correggio. Nor is there any historical evidence to contradict the presumption that the young Antonio studied under Bianchi, and a comparison between the two styles authorizes us to believe that such was, indeed, the case. Frari had the reputation in Modena of

being a highly talented master, and the grace of arrangement and harmony of colour in his painting in the Louvre amply testify to his great ability. He died, however, in 1510, when Correggio could only have been sixteen years of age ; according to Vedriani he was seventy-three at the time of his decease, but later authors state his age to have been only sixty-three. In either case Correggio may very possibly have profited by his instructions, as it was not uncommon in those times for a young artist of fifteen to be sufficiently advanced to receive and profit by a high and comprehensive system of education. It is, moreover, probable that his father, Pellegrino, finding that he could learn nothing further in Correggio, resolved to place him under a competent master in Modena, a town near at hand ; and the young Antonio may have studied sufficiently long under Frari to have caught something of his method, and then returned to Correggio after his death. His presence at the christening of a son of the Vigarini family on January 12th, 1511, proves that he resided there at that time.

Correggio's term of study (Lehrzeit) did not, however, expire then. His earliest works betray the influence of other methods of painting besides that of Frari, and indirectly of Francia.[1]

The Lombard School of painting, particularly in Mantua

[1] These suppositions respecting Frari of course fall to the ground if we accept Bartolotti as his teacher. With such an established and excellent master near at hand in Correggio, it seems unlikely that Pellegrino Allegri would have sent his son to Modena. See also the opinion of Mr. J. A. Crowe as to his teachers, as stated in the introduction.—ED.

and Padua and other environs, was, at the close of the fif-
teenth and the beginning of the sixteenth century, under the
immediate influence of Mantegna. That Mantegna was one
of the masters who helped to mould the style of Correggio
was first affirmed in the seventeenth century. Scannelli, who
quotes it as the opinion of a distinguished connoisseur in
painting, is, as far as my knowledge goes, the first to assert it.
It is not likely, however, that Antonio came under Mantegna's
immediate guidance, as he was only twelve years of age
when that master died (in 1506, not, as was formerly believed,
in 1517). But that he perfected himself as a painter under the
influence of his school, and modelled his style of art chiefly
therefrom, there can be little doubt. There is so far truth in
Scannelli's widely circulated report; but it matters little now
whether, as some think, he worked under Francesco, Andrea's
son, who was then living, or merely studied Mantegna's paintings.
We can scarcely entertain the former supposition, for Francesco
was not held in any especial favour by the nobility in Mantua,
and was often banished to Buscoldo. Besides, Correggio was
forward enough at this time to form his style after a model
without assistance. There is nothing, therefore, in his life to
contradict the probability of his having resided in Mantua at
that impressionable age when external influences are most easily
felt, and are often most enduring. The plague, which visited the
town of Correggio in 1511, induced many of the inhabitants, as
well as Manfredo, the prince of the territory, the father and prede-
cessor of Giberto, to retire to Mantua for safety. Pungelioni

goes so far as to say that the young painter went there in Manfredo's suite, but there is nothing to support this supposition. The little court at Correggio appears to have interested itself but little about him. Pungileoni, however, takes every possible pains to prove that Correggio resided in Mantua from the year 1511 to 1513, and endeavoured to find documents corroborative of his statement, but all his endeavours were fruitless.

If, however, there is a want of historical proof, the internal evidence is sufficient to show that the young Antonio completed his art-study under the powerful influence of Mantegna in Mantua. His long-budding genius blossomed here, and it was here that he became a master! Great as his natural capabilities may have been, the well-directed study of the principles of art, and the all-absorbing influence of Mantegna, must have contributed not a little to the development of those qualities which constitute the charm of his conceptions.

In Mantegna we find united, in a surprising manner, a thorough acquaintance with the antique mode of delineating form, acquired from his master Squarcione, and the naturalistic tendencies of his age. In order to combine the beauties of both methods, he strove to represent the human form in full action on the painted background, drawn with perfect accuracy of outline, yet with such realistic effect that his figures appear as if they indeed moved in space. He was untiring in his efforts to discover the correct point of sight, so as to carry out in his composition the severest rules of perspective, and give to each form the requisite foreshortening. Not satisfied even with this,

he arranged the vanishing point in the picture so as to cover the eye of the spectator. He carried the principles of fresco-painting to a greater degree of perfection than they had hitherto attained, investing his subjects with a look of perfect reality, and lastly, coeval with Leonardo da Vinci, although not following the same style of painting, he endeavoured, through the varied play of light and shadow and evanescence of colouring, to convey an idea of rotundity. We shall see later how the same qualities in painting are discernible in our master's productions. One of his most striking traits is the foreshortening of the figures from the point of sight of the spectator, which is particularly noticeable in the paintings on the ceilings, where the forms are viewed from beneath to above. This trait, as well as an evident predilection for this style of representation, combined with the great skill displayed by Correggio in carrying out the above ideas, can only be accounted for by the supposition that he had thoroughly studied Mantegna's method. In the Florentine-Roman School there is no attempt made to give an appearance of reality to figures flying in space. Nor was there any bias this way observable in the schools of Upper Italy at this period. The style is peculiar to Mantegna and his scholars. This mode of foreshortening requires so profound an acquaintance with the human form in all its movements and positions, that it would necessitate the labour of a lifetime to attain to it; and the evidence of an early mastery over those highly difficult art principles could only be accounted for by the supposition of the artist having studied them from a model near at hand. Such

was clearly the case with Correggio, and he the more quickly acquired the secret of giving a life-like appearance and action to his figures, as the bent of his genius lay in that direction.

But it is not merely in his peculiar style of foreshortening that we may take Mantegna as one of the models of our master, but also in that joyous, playful style of art which naïvely introduces smiling girls' faces and mischievous children into scenes of the most serious character. This charm in Mantegna is a little toned down by a certain austerity. His treatment of form in general is more or less classical and severe; he never attempts to invest his figures with that free, bold action which we so admire in Correggio. But his good-natured-looking genii, who hold the tablets with inscriptions, are evidently the models of Correggio's " Putti."

Besides the great works in the Castello del Corte, there was no scarcity of other work by Mantegna in Mantua; and the young Antonio had ample opportunities of forming his style therefrom. The paintings in the Church of St. Andrea, a charming architectural structure by Leon Battista Alberti, adorned in the most costly manner; a round picture in the new castle, on the ceiling of the Scalcheria, which still exists; the frescoes in the master's own house; the Madonna della Vittoria, now in the Gallery of the Louvre, all offered many subjects for study, particularly the last, which evidently inspired Correggio with the conception of his own Madonna of St. Francis. And the impulse communicated by Mantegna to art did not terminate with his lifetime. In the year 1507, the Marchese Francesco, who first

distinguished himself by his prowess in war, and then bequeathed a name to posterity, glorified by his intense love of art, invited to his court the Ferrarese master, Lorenzo Costa, who enjoyed a high reputation at Bologna in those days. In addition to Mantegna's sons (one of whom, Lodovico, died in 1509), the Monsignori worked for him, and, a little later, one Lorenzo Leonbruno, a born Mantuese, but whose influence was confined to his native town. He was an excellent master, and the few works he has left behind him have lately been brought into fresh notice. By means of Costa, Correggio was brought anew under the influence of Francesco Francia, an influence which developed his innate talent for grace of conception and expressional beauty, and so put the finishing touch to the advantages he had derived from his study of Mantegna. But the Court was not desirous of employing nameless artists, though it was nothing loth to obtain the productions of distinguished foreign masters. Isabella Gonzaga especially was unremitting in her efforts to gain them. She placed herself in connection with Pietro Perugino, who sent her a picture in 1505, and entered into a lively correspondence with Pietro Bembo (secretary of Leo X. and friend of Raphael), in order to induce him to use his influence in procuring two paintings by Giovanni Bellini for her. And we find these masters, and others who occupied a high rank in their profession, well represented in the richly stocked catalogue of the Marchesa's art-treasures.

We consequently see Correggio at that impressionable age when moulding influences contribute so greatly to the develop-

K

ment of talent, under the direct influence of different masters, whose distinguished works bear testimony to their arduous aspirations after the realization of perfection in art, according to their respective modes of interpreting it. The study of such no doubt assisted greatly in maturing his natural genius.

There is one master, however, whose influence is clearly discernible in Antonio's works, who never resided in Mantua— LEONARDO DA VINCI! The inventory of the art-treasures of the Dukes of Mantua in 1627 mentions a sketch by Leonardo ; but up to that date his name is not found in any Mantuese catalogue. No work of his had been seen in Modena at that time. We have information of two paintings in the possession of the Dukes of Modena in the seventeenth century—one being a half-length portrait of St. Catherine, and prized as one of the master's rarest productions. But, even admitting their genuineness, they did not arrive there until a much later period than the one about which we are now writing. There are no grounds for supposing that Correggio was ever in Milan, and had studied Leonardo's works there, nor, indeed, that he had extended his travels beyond Mantua and Modena. Leonardo, on his side, lived chiefly in Florence from the year 1500 to 1514, and during that time only paid flying visits to Milan. It is possible that he may have visited Mantua and Modena during some of his peregrinations,[1]

[1] The Gonzaga archives at Mantua contain a series of despatches from Venice entitled, " Carteggio degli Inviati di Venezia," in one of which it is stated that Leonardo da Vinci had delivered to the agent of the Gonzagas in Venice a likeness of Isabel d'Este, Marchioness of Gonzaga. This was in 1500. Nothing is

and Correggio may have become acquainted with the master and his style of art that way. But we are here involved in a labyrinth of conjecture, to which the story of his life offers us no solution. As it would have been impossible for him to have attained to such early mastership in the government and foreshortening of his figures without the advantage of Mantegna's example, so it is equally improbable that he should have so soon acquired such power and certainty in the production of artistic effects by means of gradation and evanescence of colouring, without having had Leonardo as a pattern. The celebrated chiarooscuro of Correggio finds its nearest prototype in Da Vinci. We shall refer later to a still further resemblance between these two masters.

We perceive, then, that great as was our master's individuality, it was impossible for him to have perfected himself in his art unassisted by foreign agency. We cannot otherwise account for such precocious development. He gives evidence, however, of the originality of his own character by conforming to the principles of the old masters, while blending their mode of treatment with his own method of modelling after nature, thus investing his conceptions with all the charm of originality. But it would have been as little possible for Correggio to have

known for certain concerning this portrait, but it is surmised that it is none other than the celebrated Belle Ferronière of the Louvre. If painted from life it would point to the probability of Leonardo having been, at some time or other, at Mantua. See "Academy," vol. i. p. 123, "Two Lost Years in the Life of Leonardo da Vinci."—ED.

attained to such early proficiency without the help of models, as for the body to nourish itself with its own flesh and blood.

As the residence of the young master in Mantua has since the seventeenth century been received as an established fact, the idea occurred to many, after the events of his life had been inquired into, that he might have left some fruits of his labour behind him. Every effort was consequently made to discover some monument of his genius, and the "Church History of Mantua," dating from the commencement of the seventeenth century, was diligently studied. In this work several paintings in the vestibule of S. Andrea are ascribed to Correggio, which are said to. demonstrate the influence of three different types, one being that of Mantegna—an assertion which has been endorsed by later critics. But these paintings, according to the opinion of connoisseurs (who have written much about them), did not emanate from Correggio at all, but were the work of Francesco Mantegna, the son of the great Andrea. Still less do they consider that the paintings in the Chapel of Mantegna in the same church, or those in an apartment of the Castello di Corte, can be attributed to our master. It is curious that he should at any time have been considered the originator of works which undoubtedly belonged to the Mantegna School. We scarcely need further proof that he had thoroughly studied its principles.

There is likewise another painting in Mantua which is attributed to our master by his old champion, the author of the "Church History of Mantua," who even goes so far as to assert that he had been commissioned to paint it by the Marchese

Francesco. It represents the figure of Gonzaga in complete armour, kneeling before the Virgin Mary, with his horse, which saved him in battle when fighting against the French, standing by. The picture is painted on the wall over an arch of the colonnade of the Piazza del Erbe, and was still visible in the eighteenth century, but now only a few vestiges of colour remain. No proofs, however, can be adduced to confirm the statement that it was painted by Correggio, and it is improbable that Gonzaga gave such a commission to a boy-painter, when he was surrounded by distinguished artists. Besides which, his cotemporary, Mario Equicola, would have mentioned such a work in his " Chronicles of Mantua," which extend to the year 1521.

We must, therefore, reject all historical accounts of Correggio's residence in Mantua ; but that his art received a bias there which determined his future career there can be little doubt. That such was the case is indeed distinctly proved by the character of his works, as well as by those qualities which suggest the inspiration of Mantegna. But he resided there merely as a student, being probably about eighteen years of age at the time, and appears neither to have sought commissions nor to have received them. It is possible that he only studied the most striking works of art, without seeking the aid of any of the distinguished masters there, not even that of Lorenzo Costa. Mantegna, the only artist whose personal direction he is likely to have sought, was dead.

Early writers, who entertain the opinion that Correggio

could only have acquired his peculiar method of foreshortening
from a model, give the preference to Melozzo da Forli, a pupil
of Piero della Francesca, who distinguished himself in Rome
under Sixtus IV.[1] Melozzo was certainly the only master in
those times in Rome who with equal or even greater boldness
than Mantegna represented figures floating in space fore-
shortened from beneath to above. But it is unlikely that he
was the master to inspire Correggio with such an idea, when he
must already have found opportunities of studying under such a
distinguished model as Mantegna. It was clearly after the
advent of the latter and the establishment of the Paduan style
of painting, that Melozzo adopted that mode of treatment, and
it is not impossible that he may have acquired it from Ansovino

[1] Burckhardt has also entertained this view (" Cicerone," 2nd ed., p. 965), and
in confirmation thereof points out the master's chef-d'œuvre, the fresco painting
in the dome of the Apostles' Church in Rome. This work, dating from the
year 1472, represents the Ascension of Christ, amidst a crowd of cherubim. The
Apostles are represented looking up, and there are several attendant angels.
Most of the figures are foreshortened from the lower point of sight. In the last
century, in removing the choir, the chief portion was detached, representing the
Ascension of Christ, and removed to the stairs of the Quirinal, and fourteen other
fragments were taken to the Sacristy of St. Peter's. Crowe and Cavalcaselle
(" History of Painting," ii. 558) see considerable traces of the influence of Piero
della Francesca and Giovanni Santi, also a few traits of Mantegna ; but I discern
the influence of the latter in the painting in a very high degree. It is chiefly
manifested in the perspective of the figures, which is the principal mark of distinc-
tion in Melozzo's art, and was doubtless imitated from the Paduese school, and
still further developed. The great influence of Andrea Mantegna exhibited in
Correggio's style does not appear to strike Burckhardt, although he thinks he
studied under his son, Francesco Mantegna. He does not appear to be well
acquainted with the paintings in the Castello di Corte.

da Forli, who had studied under Mantegna in Padua, and was his near countryman. His works give irrefragable proof of Mantegna's direct or indirect influence, although he may in part have profited by Piero della Francesca's instructions. He may, perhaps, be considered as a fellow student of Correggio, but certainly not his model.

These relations, moreover, presuppose a circumstance in the life of Correggio, namely, his residence in Rome, which all evidence tends to refute. Vasari, who is most likely to have heard of it, regards it as an established fact that he was never there ; and Ortensio Landi also assures us that Correggio died without ever having seen Rome. His evidence on this point carries weight, for if the contrary had been the case he must have heard of it from Pomponio, Antonio's son (p. 10). It was in the eighteenth century that the notion of Correggio's having been to Rome was first promulgated by the before-mentioned Pater Resta, who makes out that our master resided there from the year 1517 to 1520 ; at the very time, consequently, when he attained to full mastership over his art. He is said also to have visited that city in 1530. Resta, in his manuscript notes on Correggio's life and works, deposes to having twelve good proofs to adduce that such was the case. He brings forward in support of his assertion—1st, several drawings after Raphael in the lodges of the Vatican, which, he pretends, emanated from Correggio ; 2nd, a picture in the hospital of St. Brigida, which he likewise ascribes to him ; and, 3rd, the similarity between his paintings and those of Melozzo in the Apostles' Church

in Rome. According to Resta, Correggio not only went to Rome to study, but wandered throughout Italy, poor and unknown, from capital to capital, in order to make himself acquainted with the works of the great masters—a heart-rending spectacle, which invests the spurious drawings in Resta's possession with the warmest interest! It is amusing to read in Tiraboschi of the means which the good Pater used to obtain credence for his fables. Wishing to gain the support of the parishioners of Correggio to his hypothesis, he wrote in 1698 to Bigellini, a priest of that town, inclosing a document which he requested the citizens of Correggio to sign. In this document we are informed that the wife of one Antonio, who was ninety years of age, had heard the story of Correggio's journey to Rome from another old lady of equally advanced age, and so on. It was in this way, through the oral testimony of several old crones, that the news at last reached the ears of the good Pater Resta in 1690. But the fathers of the town of Correggio appear to have had some hesitation in appending their names to such a memorial; they evidently knew nothing about such a journey.

Shortly after, however, Mengs adopted the same view with regard to Correggio's Roman journey. He stated that he considered it impossible that Correggio should have attained to such proficiency in art without the study of the antique, and Raphael and Michael Angelo's works. He recognized a type of the latter in the Apostles in the Dome of San Giovanni, but thought that Correggio only went to Rome for the sake of study, and lived quite unknown.

But the idea that Correggio sought to improve his style by modelling his productions after Raphael and Michael Angelo appears to me thoroughly erroneous; his mode of art is totally distinct from the Florentine-Roman School, as well as his peculiar way of interpreting the antique. He was perhaps the only master of his day who was uninfluenced by the art of his cotemporaries, and formed his own style quite independently of those who simultaneously with him stood at the height of Italian painting.

Correggio has left no tangible proof whatever of his having ever been in Rome, nor is there a sign of any of the masters of the day being aware of his presence there, or having any connection with him. It is impossible that our master should have been so completely ignored, if he had really visited Rome and left any distinguished work behind him. His pretended journey is generally stated to have taken place some time between the autumn of 1516 and that of 1519. During the latter year, however, he was working hard in Parma, and left many monuments of his industry. Baptismal registers and legal documents prove the presence of the young master in Correggio on October 4th, 1516, July 14th, 1517, in January and the 17th of March, 1518. There is, moreover, proof of his having been greatly occupied at this time, and that he went to Parma about the middle of the year 1518. There is consequently no time left in which his visit to Rome could have taken place, for it is not a brief residence there of a few weeks or even months that is spoken of. His marriage also took place towards the close of the year 1519,

an event which must undoubtedly have retained him in his own home for some time.

The fable of our master's residence in Bologna was also brought on the tapis by Pater Resta. It is a creation that lives in the air, and those who repeat it give themselves no trouble to ascertain at what period of Correggio's life it is supposed to have taken place. Pater Resta certainly informs us that he followed in the suite of Veronica Gambara, when she went to Bologna to do homage to Leo X. and Francis I. of France. But it is a mere empty supposition, and all the more idle, as Raphael's picture, which gave rise to the anecdote, was not there at all at that time.

It is, moreover, certain that the young Antonio, making allowances for the deduction of his year of art-study in Modena, and his residence in Mantua, spent his youth in his own home. It was there he studied the humanities, which in those days formed part of the education of every artist. But Correggio, owing to the narrow circle in which he moved and the little intercourse he had with the world, was certainly inferior in general knowledge to most of his cotemporaries. Pungileoni mentions Giovanni Berni of Piacenza as being his first master, without, however, stating the sources from which he derived his information, and he is said to have received his instructions in poetry and eloquence from Battista Marastoni of Modena; both professors certainly resided in Correggio, and it is this circumstance, probably, that makes Pungileoni assume that they were his instructors. But he appears to have been mostly assisted in his studies by

the doctor Giambattista Lombardi, a native of Correggio, and president of a little academy which Veronica Gambara had instituted there. It was from him our master acquired that profound knowledge of anatomy which is displayed in his productions. Pungileoni also states that Lombardi presented his young friend in 1513 with a geographical codex by Berlinghieri in manuscript. The following words were found written on one of the pages : Joan Baptista Lombardi de Corrigia. Art. Schol. Ferrariæ die 1. Feb., and beneath : Antonius Allegri die 2 de Jugno 1513. Pungileoni omits to say how he became acquainted with this circumstance. Should, however, the fact be authentic, it proves the close connection that subsisted between the master and his pupil.

Correggio thoroughly studied everything in connection with his art. In addition to all the technical science appertaining thereto, and anatomy, he must have mastered the laws of lineal and aërial perspective ; for he knew how to calculate the exact amount of shade to throw from any object, and graduated the proportions of his figures according to distance with a nicety that made them appear as if they were living beings. Owing to the great artistic knowledge he displayed in his paintings in this respect, many writers have endowed him with a large amount of learning. In addition to the above sciences he is supposed to have studied philosophy and mathematics, and enjoyed every sort of mental cultivation, as well as to have been on terms of intimacy with the most celebrated professors of his day. The circumstances of his life conduce to another opinion, and Cor-

reggio himself affords no proof of such a wide field of know-
ledge. The circle of his pictorial conceptions is undoubtedly
limited, and he appears to have been little anxious to enlarge it,
or enrich his paintings with figures and details displaying a large
amount of historical and theological information. He under-
stood his art thoroughly, but it was evidently not his object to
make it a vehicle for processes of profound thought, nor does he
appear to have cared to represent the different sides of life by a
varied selection of subjects.

We have very little authentic information respecting Cor-
reggio's early works. Pungileoni thinks that when he was a boy
(either as pupil or assistant) he helped to paint the frescoes in the
palace at Correggio, built by Francesca di Brandenburgo in 1507.
They must have been done a year or two after the completion of
the building. It is quite possible that Antonio, who was at the
time about fifteen, might have been employed in such decora-
tions; but the supposition is not worth much, as the style of
ornamentation does not appear to have been of a very high
order. It is, however, interesting to learn that it is said to have
exhibited the same traits as those observable in his later works.
On the dome of one of the apartments, different groups of chil-
dren were represented at play. Over the frieze there were
lunettes with allegorical figures; in the middle of the dome there
was a kind of balcony with figures, foreshortened from beneath
after Mantegna's method. It was, indeed, probably imitated
from Mantegna's frescoes in the dome in Mantua. It is easy
to understand that this idea, so new and striking, should have

made a deep impression on the young master, and that the original model should have incited him to similar attempts. But there is no vestige now left of the painting which Punge-lioni saw. Tiraboschi mentions another palace of the lords of Correggio, erected by Count Niccolò, who died in the middle of the fifteenth century, and which Veronica Gambara adorned with paintings at a later date. "According," he says, "to what is be-lieved in his home, the young Antonio made the first essay of his skill therein." If so, this must have been previous to his going to Mantua and Modena. Veronica was married to Giberto in 1509, so Correggio must have completed this work in the same year, before he studied under Frari. This is scarcely possible. He could hardly have been acquainted with the rudiments of his art, and there were numerous artists of ability then residing in the town who would more likely have been chosen, unless he had given striking tokens of his talent in the frescoes of Francesca's palace, and thus shown himself worthy of such a commission. The utmost we can say is that one supposition supports the other. But the palace was de-stroyed in Tiraboschi's time, so nothing can be decided respect-ing it one way or the other.

That our master, however, was employed at one time in adorning one of the palaces of the lords of Correggio is proved by a passage in the manuscript chronicle of Lucio Zuccardi of Correggio, which was written at the beginning of the seventeenth century. It runs thus : " In those days there lived one Antonio Allegri, an excellent artist, who painted the palace outside the

town which was once the residence of Charles V. He was an artist whose fame was greater than that of any other master." This testimony to our master's high reputation is of no importance, proceeding, as it did, from one of his countrymen; but the information he gives us with so much certainty respecting his painting is worth notice, although it may not be of ancient date. " The palace outside the town" is clearly the one which Count Niccolò built, and which Tiraboschi describes as being in one of the suburbs. Pungileoni, on the contrary, maintains that the adornment of this palace took place shortly before the visit of Charles V., and was done in honour of the distinguished guest.

"The nobility of Correggio," he says, " made every preparation for a suitable reception of the emperor, and, as they had such an excellent artist in their town" (that is to say, Correggio), " they engaged him to adorn one or more apartments with painting beautiful fables in the domes and lunettes." This would have been about the year 1530, when Charles V. was returning from his coronation in Bologna, and passed through Correggio. The work must, therefore, have been performed about the close of the artist's career, and he undoubtedly spent his last years in his own home. Pungileoni obtained his information from an old chronicle, doubtless that of Zuccardi; but the time when Correggio did the paintings is not specified. As, however, the imperial visit was connected with the palace, Pungileoni follows up the idea that the paintings must have been done about that time. There is no authority for the supposition whatever; indeed, historical

facts tend to refute it. It was only towards the latter end of the year 1530 that Correggio returned from Parma, probably not long before the emperor made a short stay in the town after returning from Bologna.

If Correggio ever really executed any commissions for the lords of his town, it must have been between the years 1516 and 1518, after he had returned from Mantua, and before he went to Parma. It is quite possible that his princess, Veronica Gambara, discerned the talent of the young master, which was already coming into notice, and availed herself of his abilities. Veronica held a distinguished position among the celebrated women of her country.[1] As poetess she was ranked with Vittoria Colonna by the learned Lilio Giraldi, whose opinion was held in high estimation. He says :—" The two princesses and poetesses are almost equal to men, and we read their productions with all the more interest, as they emanate from distinguished and noble ladies." The lady of Correggio had also received an unusually good education. According to what is stated, she even knew

[1] "Dialogi duo de poetis nostrorum temporum." Florentiæ, 1551. The poems of Veronica, which were first scattered among different collections (in " Rime di diverse eccellenti autori Bresciani, &c. mandate in luce da G. Ruscelli." Venetia, 1554), were afterwards collected and published with a few of her letters ("Rime e lettere di Veronica Gambara, raccolte da Felice Rizzardi." Brescia, 1759.) Rinaldo Corso, whose ancestors were of Corsican extraction, but settled in Correggio, has given a short description of her life : " Vita di Giberto terzo di Correggio, colla Vita di Veronica Gambara." Ancona, 1566. I have, unfortunately, not been able to meet with this rare manuscript. A longer biography prefaces the edition of her poems by G. B. Zamboni, in 1759.

Greek, which in those days was a rare acquirement; at all
events, a Greek book was found in the library of a scholar in
the eighteenth century, bearing the following inscription on the
title-page in the writing of the sixteenth century : "Ad usum
Veronicæ Gambaræ." It had formerly belonged to the cele-
brated Venetian Collection of Aldus. The noble lady not only
attracted around her all the celebrated men of her times,
but kept up an active correspondence with Pietro Bembo,
whose counsel she frequently sought respecting her poems. It
is therefore highly probable that a lady who took such interest
in the humanities, should have patronized the artists of her own
town. One of her letters proves how highly she esteemed our
master, and the interest she took in him and his works. But,
although the palaces at Correggio show that the nobility in the
town were not behind-hand in availing themselves of native
talent in adorning their apartments, we can nowhere find evidence
that our master received any commission of importance in his
own town. Veronica may not have had the power of doing
much for him after the death of her husband, which took place
in 1518, and the little court was certainly not sufficiently influ-
ential to assist in spreading his fame.

There is very little trustworthy evidence to adduce respecting
Correggio's earlier works. According to Pater Resta, he used
to paint charming little landscapes to make presents of to his
friends and relations. One of them is said to have been found
in the gallery of Count Gonzaga di Novellara; another in the
possession of the Marchese del Carpio. By the last is, doubtless,

meant a landscape representing "The Flight into Egypt."[1] The story, which Pungileoni affirms to have found in an old manuscript of the seventeenth century, about Allegri having painted little landscapes, and sold them at a low price in the square or market-place in Parma, is utterly without foundation, as he was not there in his early youth.

Several Madonnas and representations of the Holy Family on a small scale, were supposed to have been early productions of our master at the beginning of the present century, but their authenticity is more or less doubtful. One of them, representing the "Virgin Mary with the Infant Jesus, a little S. John the Baptist, and a few angels' heads," formerly in the possession of Count Facchini at Mantua, and now belonging to the heir of Aless. Rievo, is attributed to Correggio by some of his champions. The severity of the outlines remind us a little of the Mantegna School, but it is only by this indirect way that we can consider it to be our master's work, there being no real grounds for the presumption. A second one, in which St. Anna and a monk are depicted, was found in private possession in Mantua. It

[1] Bigi mentions a picture representing a Repose in Egypt, which he supposes Allegri executed when he was about twenty years of age, for an altar-piece in the Church of the Conventual Friars in Correggio. The Duke of Modena, he says, admired this work so much, that he employed the painter Bulangeri to copy it, and in the end contrived to gain possession of the original and substitute the copy in its stead. The town's folk, however, did not submit to this without a protest, and the Duke was obliged to settle matters by ceding some land and a sum of money to the Franciscan Friars. "Memorie Patrie Manoscritte," quoted by Bigi.—ED.

M

was engraved with the master's name, and is enumerated by Lanzi with his other works. It has, however, no better claim to be considered genuine. A third, also representing the Infant Jesus and a little St. John the Baptist, is a very small picture. It belonged at the beginning of the century to the painter, Biagio Martini, and was declared at that time, after due examination and grave deliberation on the part of all the professors of the Academy in Parma, to be a genuine Correggio. But we have lately been too little impressed with the importance to be attached to academical decrees to put great faith in their decision, and the acquaintance with the master's style of art was, moreover, very much circumscribed in those days.

The late Otto Mündler considers the earliest work of Correggio (communicated in correspondence) to be that of the "Madonna and Child, St. Mary Magdalene, and St. Lucia," bearing the signature—Antonius Lætus. Faciebat. Mündler wrote to me, "Great doubt is raised with regard to the originality of the painting, some supposing it to be only a copy. My opinion on the subject, however, is that it is genuine, and one of the master's earliest works extant, in spite of the dulness of the colouring, proceeding chiefly from the darkness of the background, and the palpable weakness and inefficiency of the drawing. It bears all the signs of an attempt of a lad of sixteen to give expression to his rising thoughts and inspirations, although his performance, doubtless, fell short of the instructions of his masters or those conveyed by his models. Notwithstanding the timid way of putting his thoughts on canvas, and the

unskilfulness of his hand, one can discern clearly the powerful aspirations of youthful genius as well as the struggle with his diffidence. But the idea of motion expressed in the figures, the depth of the pathos, grand subordination of the masses, and the artistic arrangement of light and shadow which we so admire in the 'St. Francis' at Dresden, are budding here." The painting is now in the Brera at Milan. In spite of Mündler's opinion, however, there seems scarcely a doubt that this supposed youthful work is merely a copy of a long-lost picture by Correggio.

There is a similar picture in the Parish Church of the little town of Albinea (near Reggio), where it is considered to be a copy of a panel which our master is said to have painted for the High Altar of this Church. This is, however, erroneous, as it was a totally different subject that he painted for the Church of Albinea. We have also information respecting a third copy, and the circumstance of there being so many representations of the same subject proves that an original painting must have existed at some time or other. But we are ignorant as to what led to its production, when it was executed, and its place of destination. The style and position of the figures, however, even in the copy, remind us of the " Madonna of St. Francis," the first really authentic work of our master, only the style of the latter is more mature and developed ; the former picture was, no doubt, inferior in every way.

On the other hand, G. Frizzoni (communicated in correspondence) assigns as one of the master's earliest attempts a painting on wood which formerly belonged to the Bolognini

family, and has lately been placed in the Ambrosian Gallery in Milan. It is marked " Scuola Parmigiana," and represents the Holy Virgin with the Infant Jesus on her knee, and a little St. John the Baptist standing near. It is not known to me.

There is, however, another, which may be regarded with greater certitude as one of our master's earlier works, its claim to authenticity being supported by several connoisseurs of note. This picture represents the youth on the Mount of Olives who took flight when our Saviour was made prisoner, and left the linen cloth in the hands of the young men. In the background are depicted the guards, Judas kissing Christ, and Peter cutting off Malchus' ear. The original appears to have been found in the seventeenth century in the Casa Barberini in Rome, was transported thence to England, and has now disappeared. Mengs saw a duplicate in the possession of an Englishman in Rome. He considered the sketch to be authentic, and particularly remarked that the face of the youth resembled that of the eldest son in the group of the Laocoon in Rome, which confirmed him in the opinion that the master had been there. The likeness was most likely purely accidental. Lanzi saw another facsimile in Rome; he held it likewise to be authentic, although he regarded its date (1505) as apocryphal. The latter as well as other existing facsimiles are certainly only copies. The circumstance, however, of there being so many copies proves that the master had painted a work of this kind. The Correggioesque character of the composition, making allowances for the youthful age at which he produced it, is unmistakable.

The circumstances in connection with another painting of Correggio's, which is also said to be a youthful attempt, are rather peculiar. According to report, it was first painted for a sign-board for an inn in the Via Flaminia in Rome, and it is possible that it was intended for that purpose, as it represents two laden mules and a driver travelling through a country of the most picturesque beauty.[1] There is nothing very strange in the fact of Correggio having painted sign-boards. Art and trade often stood in close connection in those days. But tradition, of course, steps in, and informs us that the master could not pay his bill, and compensated the landlord by presenting him with a sign-board. The fact, however, of its being found in the neighbourhood of Rome is suspicious. How did it come there? The board has made divers journeys in company with a few really authentic pictures by the master, so people have come to the conclusion that it was also painted by him; but it is in reality very dubious.

Most persons hold the opinion that the first work by our master of undoubted authenticity is the so-called "Portrait of a Doctor" in the "Dresden Gallery." The circumstance of its having been transferred, together with five other paintings of historical authenticity, from the possession of the Dukes of

[1] This curious picture, or a repetition of it, is now in the possession of the Duke of Sutherland, and was exhibited in 1871 at the Royal Academy (Old Masters). It is so totally unlike what we know of Correggio's work, that it is not possible to assign it to him on internal evidence, but it is a clever, spirited work, whoever painted it.—ED.

Modena to the Saxon Court, would seem a sufficient guarantee.
The painting, however, possesses so few of the master's traits,
that it cannot be unhesitatingly ascribed to him. It unques-
tionably belongs to the best period of Italian art; but it is
deficient in character, and there is an uncertainty in the drawing,
and a massiveness about the colouring, which is not likely to
have existed even in Correggio's early works. It has suffered
much in the cleaning; but, even taking this into account, it
possesses very few of our master's characteristics. It is more in
the style of Giorgione, only it is too weak for him. It is, never-
theless, considered one of Correggio's early attempts, and is
supposed to have been painted shortly before the " Madonna of
St. Francis." Numerous rumours also have been set afloat as to
whose likeness it represented. That it was evidently that of
some scholar is proved by the book which the beardless, serious-
looking man holds supported against the table. In old catalogues
it is always called " The Portrait of a Doctor," and it also bore the
same appellation when it was in the possession of the Dukes of
Modena. As Vasari mentions the Doctor Francesco Grillenzoni
at Modena as being our master's friend, it was supposed to have
been his portrait, sometimes also that of his brother Giovanni.
It is, however, impossible that such could be the case, if, as is
stated, it was one of our master's youthful productions; for both
these gentlemen were in the full bloom of manhood when Cor-
reggio was a youth, and this portrait represents quite an aged
man. Pungileoni holds the opinion that it was the portrait of
Giambattista Lombardi, who was a fatherly friend of the young

Antonio. It is supposed that he expressed his gratitude for the picture by presenting the young painter with the codex already referred to; but this is all mere conjecture, and cannot be decided one way or other, even if the painting is in reality the production of our master.

All other portraits exhibited in different galleries are more or less doubtful, if not manifestly spurious. One in the Gallery at Parma, representing, as is alleged, Count Sanvitale, is said to possess a few of Correggio's traits. But such is only the opinion of the engraver, Toschi, who defines the subject " as being attributed to Correggio." We have no information whatever as to whether he ever painted portraits. He might have done a few for opulent private individuals in Parma. Portraits of persons, whose names are not mentioned in history, and who are quite forgotten, are not likely to have been preserved anywhere, much less in Italy. It is characteristic of Correggio and the retirement of his life that he had no opportunity of painting portraits of persons whose memory posterity might have thought it worth her while to preserve. He was evidently never brought in connection with statesmen, nor any distinguished men of science or letters. Perhaps, also, he was deficient in the requisite keen perception of individual expression.

CHAPTER IV.

CORREGGIO'S FIRST MASTER-WORKS AND THE CALL TO PARMA.

Correggio as master in his native town.—His first great work, "The Madonna of St. Francis."—Works from 1515 to 1518.—Altar-piece of St. Martha.—Triptych.—"Marriage of St. Catherine."—Altar-piece in Albinea.—Call to Parma (1518).—The paintings in the Convent of San Paolo.

ACCORDING to trustworthy information, Correggio was about twenty-three when his talents came into notice. His first authentic work was produced in the year 1514, and this picture has fortunately been pre-served to us. A document, dated July 4th, 1514, which was found among the archives of Correggio, states that one Quirino Zuccardi bequeathed a house to the Convent of the Minor Brethren of St. Francis, on condition that they should have an altar-piece painted for the adjoining church. The monks, however, made over the house to Quirino's heir, on receiving from him a sum of money to pay for the picture. The artist selected to execute this work was the young Allegri, and they entered into an agreement with him on the 30th of August, 1514, with the consent of his

father as he was still minor, to pay him 100 ducats, half to be paid
down immediately, and the remainder after the completion of the
painting. In another document, bearing the date October 4th,
1514, one Pietro Landini engages to have a panel prepared for the
painting within the space of one month ; and, again, in one of the
convent ledgers there is an entry dated April 4th, 1515, notify-
ing that the second half of the 100 ducats had been paid to
Correggio. Consequently, if he only received the panel in No-
vember, he must have finished the altar-piece in six months.

Not only the order for the painting, but the care with which
the whole transaction was carried out, evinces the great import-
ance which the Franciscans attached to the commission. We
require no further proof to convince us that Correggio was at this
time considered the most distinguished artist in the town, other-
wise the work would certainly not have been confided to him.
Pungileoni also informs us of the sums which our master paid
for gold-leaf and ultramarine; the former cost forty lire, the
latter three. It would appear by this that he gilded and painted
his own frames, a custom by no means uncommon in those days.

The altar-piece in question, entitled the "Madonna of St.
Francis," is now in the Dresden Gallery. It reveals to us the
dawning creative fancy of the young master, blended with a
certain leaning to the type of his predecessors. There is dis-
cernible in the composition the architectural severity, as well as
the constrained manner of the Quattro Cento. The Virgin
Mary, holding the child on her lap, is depicted sitting upon an
elevated throne-chair, under a vaulted roof, supported by Ionic

pillars. Beneath the roof, and forming part of the architecture
of the columns, are two naked angels, bearing medallions repre-
senting Moses holding the tablets of the law. Above the glory
round the Virgin's head is a ring of angels' heads, and on either
side two little naked angels floating in space. At the side of the
throne two saints are represented—St. Francis, kneeling with his
face turned towards the child ; and St. John the Baptist, pointing
to the Infant Jesus—both being in a line with the spectator.
Farther back, on one side of St. John the Baptist, stands St. Cathe-
rine, with her foot on the wheel and the palm of martyrdom in
her hand; on the other, close to St. Francis, St. Anthony of
Padua, holding a lily and a book.

The arrangement of the whole work (even the bas-reliefs in
the socle of the throne) reminds one of Bianchi Ferrari's picture
in the Louvre. The Mantegna type is also noticeable, not only
in the accuracy of the drawing, but in the peculiar, and in this
case timid, foreshortening of the head of St. Francis, as well as
the sharp, angular folds in the drapery. The figure and position
of the Virgin Mary is strongly suggestive of the Madonna della
Vittoria of the Paduese master, now in the Louvre. Other types
are also discernible. The exalted religious sentiment expressed
in the faces and attitudes of the saints, especially in that of
St. Francis, in whom it approaches to enthusiasm, points to the
Umbrian School and Francesco Francia, under whose influence
our master had been brought through his instructor in Modena,
Bianchi Ferrari. The engaging expression of happiness in
adoration which distinguishes the best works of this master, is

THE MADONNA ENTHRONED.

S. FRANCIS AND S. ANTHONY OF PADUA: S. JOHN

THE BAPTIST AND S. CATHERINE.

PAINTED FOR THE FRANCISCAN CONVENT AT CARPI.

Now in the Dresden Gallery.

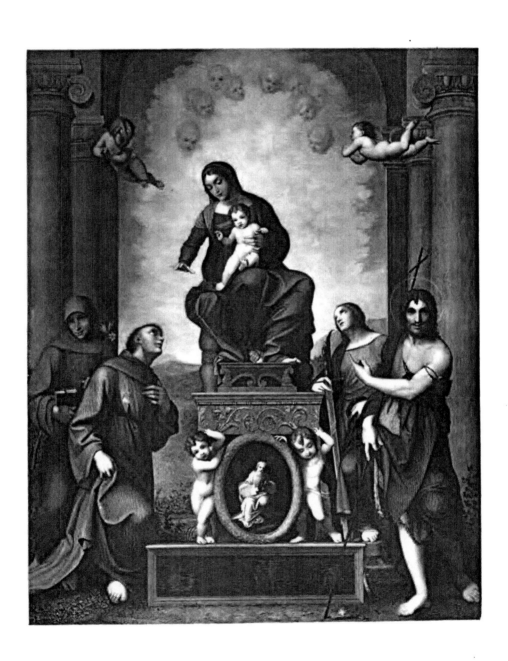

here depicted with so much charm and skill, that the young Antonio shows himself to be already quite equal to his models. This trait is all the more interesting, as Correggio has not struck this particular key-note of feeling in any other composition. But, as Mengs remarks, the heads of the Madonna and Child, and still more that of St. John the Baptist, are suggestive of another influence—that of Leonardo da Vinci. This picture carries with it irrefragable proof that Correggio studied this master quite as much as Mantegna. His "Madonna," rather too thin in the cheeks, and not, strictly speaking, beautiful, even wears the smile peculiar to the female faces of Leonardo. But his management of the chiaroscuro especially indicates the influence of the Lombard master. In many places it displays the sombre tone which characterizes Leonardo, and the shadows are deeper and browner than those in Correggio's later works.

It is indeed curious to observe in this painting how Correggio combines the two distinct methods of Mantegna and Leonardo. Their respective traits—namely, accuracy of drawing governing form in all its attitudes, the life-like appearance communicated by expression, and the skilful management of the chiaroscuro— are here blended together in one subject, and present all the beauty of artistic conception which lends an individual charm to our master's subsequent works. The cheerfulness of sensuous life, united to the devotional seriousness of the subject, distinguishes this picture from all his later productions, in which the expression of religious pathos is greatly moderated. St. Catherine, indeed, exhibits an ecstasy of feeling which appears to master

her whole being, and almost transports her beyond the bounds of nature.

In spite, however, of the solemnity of the subject, Correggio succeeded in introducing light and freedom into it. The figures do not press closely one against the other, as in Mantegna's compositions. There is space and air between them, and they appear to move with freedom in their respective places. These are not closed in walls : the hall opens freely to the air, and there is a cheerful landscape and a bright sky, forming a charming setting to the enthroned Virgin. It is scarcely possible that the master could have so quickly acquired the art of introducing freedom into the midst of close grouping without the help of a model, and we are again reminded of the influence of Leonardo, as neutralizing the austerity of Mantegna.

But, although the " Madonna of St. Francis " clearly shows us that Correggio formed his styles after certain models, it, nevertheless, is remarkable for the individual talent it displays.

Let us compare this production of Correggio at twenty years of age with that of Raphael, who at the same period of life painted the "Sposalizio" (in the Brera at Milan), and we shall see how greatly the original power of the former surpasses that of the latter master. The "Sposalizio" is scarcely more than a refined " Perugino ;" while the " Madonna of St. Francis " embodies the method of two masters, and suggests the influence of a third. Mantegna and Leonardo decided the character of the painting of Upper Italy, and the Florentine and Umbrian

Schools that of Middle Italy. As Raphael in his mode of treat-
ment combined the methods of these two schools, Correggio fused
the types of the two masters into one, and, although deficient in
some of the great qualities of his models, succeeded in carrying
Italian painting to the highest degree of perfection. The selec-
tion and combination of two opposite interpretations of art, with
the view of representing nature more fully and faithfully, betokens
an epoch-making master.

Soon after the " Madonna of St. Francis," Correggio executed
a picture (small in size) for the Church of the Franciscans at
Correggio. This was probably ordered by the Cavalier Fran-
cesco Munari for the chapel of the Conception, in which it was
placed ; for during the whole time it was there it was cleaned and
preserved by the Munari family. It represents " The Repose
in Egypt," and also has a St. Francis kneeling before the Infant
Jesus. There is a similar composition in the Tribune of the
Uffizi in Florence, which is considered there to be an original
painting ; but we have no evidence as to how it came to be placed
in that gallery. Mary, dressed in white, is sitting under a palm-
tree, holding the child, standing upright, upon her knee, and
stretching out its hand to receive some dates which St. Joseph,
who is standing a little way off, is presenting to it ; on the other
side kneels the worshipping St. Francis.

Mengs considers this picture to be genuine, because he cannot
specify any other master who is likely to have painted it except
Correggio. Its authenticity is, however, frequently disputed ;
and we consider it very doubtful, in consequence of the glaring

colours and slight heaviness in delineation of the figures. It is
sometimes attributed to Baroccio, and sometimes to Tiarini.
The composition of the painting is, however, either Correggio's
own, or has been borrowed from him. It reveals the master to
us in all his individuality. It makes the simple Gospel-story the
groundwork, and constructs thereon a happy family picture, set
in a bright, cheerful landscape. Even the kneeling figure of
St. Francis scarcely expresses the religious meaning of the paint-
ing. There is nothing solemn in the deportment of the figures ;
no depth of earnestness in the expression of the faces suggestive
of the superhuman. The " bambino " only looks like an amiable
child reaching out its hand for dates. But the general arrange-
ment is wanting in that grace which distinguishes the master's
later works; and there is something constrained in the attitude
of the Madonna.[1]

It is generally stated—without, however, there being any
proofs to support the assertion—that Correggio painted a triptych
in the year 1516, for the Brothers of the Hospital of Santa Maria
della Misericordia, in his native town. That such a work did
once exist is proved by a deed of sale found in the ledgers of the
brotherhood, which is still extant. The last Lord of Correggio,
Don Siro of Austria, obtained possession of it on paying the sum
of 300 golden ducats (eight lire), at which price it had been

[1] Lanzi thinks that this Florentine picture was the altar-piece painted in 1514
for the Franciscans at Correggio, and which Tiraboschi thought had disappeared.
He confirms the assertion of the latter that it had two side pictures or wings re-
presenting a St. Bartholomew and a St. John.

valued by the painter Giacomo, on the 18th of December, 1612. A picture, now in the Vatican, which is attributed to Correggio, is said to have constituted the centre portion of this altar-piece; but it is certainly not by our master, and is scarcely good enough to be a copy by Lodovico Carracci, which it is also sometimes stated to be. All that we can say is, that it belongs to the Carracci School. The side picture of "St. John" was said to be, in 1841, in the possession of a Doctor G. G. Bianconi, in Bologna. Tiraboschi's hypothesis, that the paintings were destroyed in 1630, after the plundering of Mantua, is erroneous, as they were under the curatorship of the Count Novellara in 1644, and returned to Don Siro in the course of the same year; but, with regard to their subsequent fate and place of destination, we have no authentic information.

It is stated that there was also in the Oratory of the Misericordia a picture by the master representing "Herodias carrying the head of John the Baptist in a charger." This has also disappeared.

In the year 1517 our master painted another picture, representing "St. Martha, in company with the Apostle St. Peter, St. Mary Magdalen, and St. Leonard." It is called, for brevity's sake, the "St. Martha;" but we have no historical account as to what has become of the original work, unless, indeed, it prove to be the one which is now in England, in Lord Ashburton's possession. But this appears scarcely likely, as, according to Waagen's report, this painting was obtained from the Ercolani Collection, in Bologna. Its characteristics certainly coincide with

those Lanzi mentions as existing in the old picture, and the composition also tallies with the work alluded to by Pungileoni. The only thing is, in the English picture the saints are supposed to represent SS. Peter, Margaret, Magdalen, and Antony of Padua. It is furthermore interesting, in that the style reminds us of the "St. Francis." Waagen remarks in reference to this,—"The painting is much severer in outline, and the folds of the drapery and local tints in the garments are considerably darker than is apparent in Correggio's later productions. It exhibits in this particular a striking resemblance with the altar-piece of the 'St. Francis.' Both works are executed in the customary style of church paintings, and suggest the influence of Francesco Francia, who gave the impulse to this chaste mode of painting in Lombardy. 'St. Margaret' reminds one strongly of the 'St. Catherine' of the Dresden Gallery. The style of the drawing and position of the hands are identical. The colouring is massive, and there is even gold on the garments of St. Peter." Whether the depth of colouring referred to and the dark shading is, as Eastlake inclines to think, attributable to the cleaning, or rather to a fault in the copy, which it probably is, it is hard to say. But there was, no doubt, a certain austerity in the style of the original, for it belonged to the period when the master still partly depended upon his models. The Mantegna influence which Lanzi so emphatically mentions is very apparent.

The difference in style between our master's productions of 1518 and 1519 and the "Madonna of St. Francis" is so great, that connoisseurs have been led to believe that there must have

been intermediate pictures; but the accounts which have been transmitted to us of Correggio's great industry in the intervening period are, to my mind, a sufficient solution of the question. He worked hard, according to the principles inculcated by his models, until he felt that he had thoroughly mastered his art. This is proved by the " Madonna of St. Francis," in which picture it is not too much to say that, in technical skill and ability, Correggio places himself on a level with Mantegna, Francia, and Leonardo.

The freedom which he attained at this period is further demonstrated in a work entitled the " Marriage of St. Catherine," which appeared in 1517 or the following year.

There are three replicas of this painting: one in the Louvre, the authenticity of which is unquestionable ; the second in Naples, which may also, with justice, be attributed to the master ; and the third in the Hermitage in St. Petersburg, which many consider also an original, but Waagen, with some justice, holds to be only a copy by one of the master's best pupils. It has certainly an inscription at the back of it, stating that Antonio Lieto de Correggio painted it for one Donna Matilda d'Este, in the year 1517. But there was at that time no princess Matilda of the house of Este at the court of Ferrara ; and, although the lady might possibly have descended from the family of the Marchesi of San Martino, the inscription is suspicious, and Mengs does not guarantee the genuineness of the work. The painting is smaller in size than the one in the Louvre. The Naples picture was brought from the Gallery Farnese, under the name of " Piccolo Sposalizio," and has always been considered genuine.

It is not surprising that Correggio should have painted the work three times, so graceful a subject being eminently suited to his style of art. The picture in the Louvre is not identical with the one in Naples, and the work in St. Petersburg resembles the latter more than the former.

We can only form conjectures respecting the origin of the paintings in the Louvre and Naples. The former is said to have been painted for a lady of the name of Catherine, who had nursed our artist during a very severe illness. But this savours too much of the artistic anecdote to be credible, and may be regarded as one of the numerous fables in circulation respecting our master. Pungelioni thinks that Correggio painted it as a wedding present for his sister Catherine, on the occasion of her marriage with Vincenzo Mariani. The date of the marriage is usually fixed in the year 1519, but there is no reliable authority for it. It is, consequently, supposed that Correggio painted the work during the same year, and the one in Naples in 1517 ; but there is no foundation for this assertion, any more than there is for stating that the Parisian picture was executed in the year 1519. As to its having been intended as a wedding present for his sister, it is a pretty idea, and nothing more.[1] If we, however, fix the probable date for these pictures as being the years 1517 or 1518, we are influenced by totally different reasons. We draw our inferences from the tokens that present themselves to

[1] Sandrart mentions having seen the Louvre St. Catherine in 1634. It was then in the possession of Cardinal Borghese.

our notice in the technical style of the pictures, to which we shall refer later.

In this work the master's individuality is thoroughly asserted. The religious thought which is the subject of the painting is thrown quite into the background, and the Christian idea of uniting the chaste St. Catherine to the Infant Jesus, and making her the bride of Heaven by means of a ring, is utterly lost sight of in this joyous representation of sensuous life. This glorification of sensuous life is noticed by Vasari in his " Life of Girolamo de Carpi." He tells us how greatly charmed he was by this divine picture in Modena, the faces of the figures being as beautiful as if they had been painted in paradise ! It was, doubtless, the Parisian picture which he saw. We have another proof of the esteem in which this work was held, from the fact that one of the old masters in chiaroscuro carving, probably Ugo de Carpi or Antonio de Trento, carved it in wood. The natural grace displayed in the attitudes of the figures is very striking. Even St. Sebastian, who takes a prominent part in the ceremony in spite of his wounds and arrows, is the very embodiment of tranquil joy, and glows with the rich, warm tints of animated life. All appear united together by ties of the warmest affection ; so much so, indeed, that those prejudiced persons who choose to criticize it according to the standard of the severer and more antiquated style of art, might easily reproach it with voluptuousness of expression.

The rich golden tone of the flesh, the colour of which seems to blush from beneath, is particularly striking in this picture. It

is peculiar to Correggio, and noticeable in most of his works, as well as the power he possesses of producing the most subtle gradations of light and varieties of tint.

We must not omit to mention another work by our master, which, with some show of accuracy, is supposed to have been painted at the beginning of the year 1518, but has not been heard of since the middle of the seventeenth century. It consisted of an altar-piece for the little parish church of Albinea, in the district of Reggio, and was presented to the arch-priest of the community by Giudotto di Roncopò. According to some accounts, it represented the Madonna and Child sitting between SS. Mary Magdalen and Lucia, but it really was the Birth of the Virgin, quite a different subject.[1] Not a trace, however, of the picture remains ; nor have we even a copy handed down to us. It is stated that Correggio went himself to Albinea and painted the picture there, being paid from twenty to thirty soldi per day, besides being furnished with board and lodging, but the account only dates from the eighteenth century, and is, therefore, traditional.

It would appear that the young master, with the exception of the time he spent in Albinea, was occupied in his native town, in various ways, from the years 1513 to 1518. The consideration in which his first works were held is proved by the many commissions he received, as well as the price given for the " Madonna of St. Francis." The sum of 100 ducats, or 400 lire, was very

[1] See Appendix.

THE MARRIAGE OF S. CATHERINE.

IN THE PRESENCE OF THE VIRGIN AND S. SEBASTIAN.

In the Gallery of the Louvre.

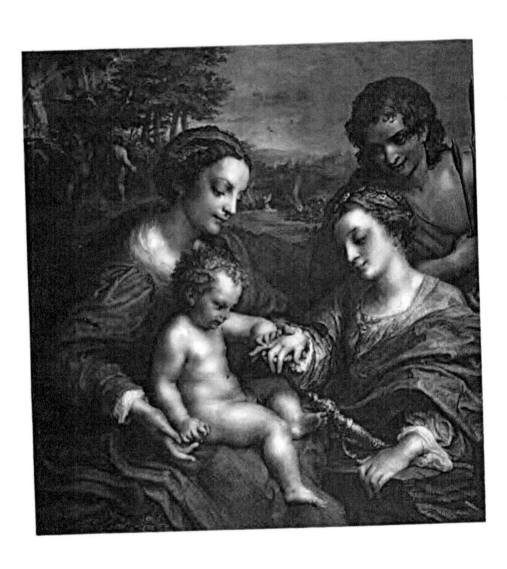

those days ; and the circumstance of the payment being

han he received for some of his other works can only

nted for by its having been a legacy. But beyond the

transmitted to us respecting his pictures, and his con-

:hereby with churches and private individuals, we have

nation as to his manner of life in his own home up to his

ourth year. There are only a few baptismal records and

cuments remaining, in which he is mentioned as witness.[1]

xtend from January 12, 1511, to March 11, 1518, and

ιt any rate, that up to that period he was a householder in

town. As we have before stated, his father's pecuniary

circumstances took a favourable turn about the year 1516.

Correggio, having perfected his art in the retirement of his

own home, had now a new and wider field of action suddenly

opened to him. He, most probably, took up his abode in Parma

in the beginning of the year 1518, not in 1520, as has been

erroneously stated. Tiraboschi is inclined to the belief that he

painted his first works there for the Benedictine Monks of San

Giovanni, which might lead us to suppose that he had been sum-

moned thither by that fraternity. There is, however, greater

likelihood that previous to this he was engaged on paintings in

[1] On the 12th January, 1511, he stood as godfather to one Antonio of the house of Vigarini ; and the 4th of October, 1516, he acted in the same capacity to Anastasia Elisabetta, daughter of one Giannantonia Toraglielo. On the 14th of July, 1517, together with Melchiore Fassi, who had ordered the picture of St. Martha, he acted as witness at the reading of the will of one Giovanna da Monte-corvino. His name is mentioned in a legal document of the notary Bottoni, dated January, 1518; and on March 17, 1518, he stood godfather to one Rosa, daughter of Francesco Bertoni.—*Baptismal Records of S. Quirino.*

the Convent of S. Paolo, and that it was in accordance with the request of the lady-abbess that he went to Parma, as she had friends who were connected with the Lords of Correggio. Consequently, as Antonio was occupied in working for the Benedictines in 1519, we may with safety conclude that the paintings in the Nunnery of S. Paolo were completed in the middle of the same year. The style and treatment of them is, moreover, confirmatory of the idea that they were finished before the grander works in S. Giovanni were attempted.

It is scarcely likely that Correggio was led by the spirit of adventure to try his fortune in Parma, and find a more extensive sphere for his talents. It is not likely, in that case, that he would have so quickly met with such important commissions. On the other hand, it may well be supposed that the altar-pieces which he had painted in his native town and Albinea had spread his fame in the neighbourhood. There were, moreover, no masters of distinction at that time in Parma, at least not such as could have satisfied the new and rising requirements of the age. Cristofano Caselli, an able pupil of the Venetian master, Giovanni Bellini, and Lodovico de Parma, who has left several paintings of Madonnas behind him in the style of Francesco Francia, were at their zenith in 1500. Alessandro Araldi (probably born as early as the year 1465), who, Lanzi affirms, was also a pupil of Bellini, although it is hard to believe it, distinguished himself more in decorative works than in figure-painting, in which branch the effect produced by the hardness of his outlines and dryness of colouring is the reverse of pleasing; while his arabesques, on

the contrary, display a rich and sportive imagination. The em-
bellishments he executed in the year 1514, in a domed room in
the Convent of S. Paolo, adjoining the apartment which was soon
after painted by our master, are still preserved. The circum-
stance of the young master being preferred to the old (for
Araldi lived as late as the year 1528) may be accepted as sufficient
proof of the fame of Antonio's exceptional talent having spread
to Parma. The Mazzola family, consisting of three brothers,
Michele, Pierilario, and Filippo, the father of Parmigiano, also
flourished in Parma at that time. The elder members belonged
to the Paduan School, and were somewhat skilful in their deline-
ation of form ; but their style of art savoured of the old method,
and was totally devoid of charm. The younger ones soon became
disciples of Correggio.

Correggio's paintings in the Convent of S. Paolo derive addi-
tional interest from the singular caprice of fate which consigned
them to almost total oblivion for two centuries. In the year
1524 the convent was cloistered up, and scarcely any one was
suffered to cross its threshold. Great as was Annibale Carracci's
energy in hunting up Correggio's works, he elicited no informa-
tion respecting the paintings in question. Some mention is made
of them in MSS. dating from the seventeenth century.[1] Crozat,
who, as we have before stated, interested himself in divers ways
concerning our master, heard of the works, and probably
d'Argenville obtained from him the short account he gives of

[1] Particularly in that of the Pater Zappata on the Churches of Parma. Punge-
lioni, ii. 119.

them in his "Biography of Correggio" (1762). But no one, save perhaps a few favoured individuals, was allowed to see them. Ratti mentions them, but with no degree of certainty, and calls them a hidden jewel. Mengs, who by some lucky chance was enabled to catch sight of these paintings, gives an account of them in his letter to the Cavaliere d'Azara, the latest editor of his writings;[1] but there is not a word about them in the text of his "Life and Works of Correggio." The painter, Antonio Bresciani, when he was at work in the church of the convent, also found an opportunity of inspecting thoroughly the carefully guarded chamber, and gave an account of it to Tiraboschi, who was thus enabled to give the first explicit information respecting it. On the 16th of June, 1794, the Academy of Parma was authorized to examine these frescoes. The deputation, which consisted of the professors of the academy and the engraver Rosaspina, immediately recognized the hand of Correggio. The Duke Ferdinand I. then visited them, in company with a few scholars. Since that time they have been exhibited to public view. Among the above-mentioned learned men was the Pater Ireneo Affò, who distinguished himself by his researches into the history and literature of Parma, and in 1794 issued a pamphlet giving a detailed account of their history and discovery.[2]

Since the days of Frederick II., the richly endowed order of the nuns of S. Paolo had enjoyed every kind of privilege, one

[1] In the Roman edition of his writings, 1787.

[2] "Ragionamento sopra una stanza dipinta del A. Allegri da Correggio nel Monastero di S. Paolo." Parma, 1794.

being that, in pursuance of a Bull of Gregory VIII., they were independent of the bishops. The abbesses, who were chosen from ancient families only, and possessed a power of life tenure, were invested with almost princely authority, which they used here, as everywhere else, in surrounding themselves with luxury, art, and every enjoyment of life. The position was consequently much sought after by distinguished families, and gave rise to endless disputes, jealousies, and discord, that occasioned so much disquietude, that the repose of the convent was greatly disturbed thereby. In vain did the Popes Julius II. and Leo X. seek to mend matters by placing the convent under ecclesiastical restrictions ; the sisters asserted their privileges and refused obedience. In Correggio's time the abbess of S. Paolo was Donna Giovanna (elected April 15th, 1507). She was the daughter of the patrician Marco Piacenza, and on the mother's side descended from the Bergonzi family, to whom Giovanna's two luxurious predecessors had also belonged. This lady, as soon as she was created abbess, behaved in the most arbitrary manner, and sowed new discord by removing the custody of the convent estates from the Garimberti family, who had had it up to this time, and making it over to her own relations. Matters grew worse and worse, a Garimberti was murdered by the new inspector and the brother of the abbess, and the convent underwent the humiliation of a search for the criminals. This defiance of law only diminished when the French occupied Parma for a time, after having taken possession of Milan. Paul III. put an end to these grievances at last. After the death of Giovanna

(they were compelled to put it off till then), all the convents in Parma were placed under sacerdotal government.

Giovanna loved pomp, and carried on her establishment in a princely style like her predecessor Orsina. Fond of building, she ordered a number of new apartments to be erected for her own private use, equally undisturbed by external commotions and papal threats. Her architect was Giorgio da Erbe, her sculptor Francesco da Grate, her painter (before Correggio) Alessandro Araldi, already mentioned. The fact of her having selected Correggio as early as the year 1518 speaks well for the discernment of the then ailing matron. In 1519 she was bedridden. Her mental power of resistance, love of the world, life, and heathen beauty were, nevertheless, as strong as ever. It is even probable that it was through a spirit of spite against her spiritual opponents that she caused her apartments to be adorned in such a very mundane fashion, for the Latin and Greek texts inscribed upon the walls testify to her haughty consciousness of independence and manifest scorn of her enemies. Above the hunting Diana over the chimney-piece was written the following passage from Plutarch, " Ignem gladio ne fodias," "Stir not the fire with the sword;" also, " Jovis omnia plena;" " Sic erat in fatis;" " Dii bene vertant;" " Omnia virtuti pervia," &c. The subjects of the paintings were not selected from the Scriptures, but were chiefly chosen from Grecian mythology and ancient art. Similar selections in ornamentation were common enough in public buildings and private houses, but rarely in convents.

The worldly tone of mind which suggested the commission assimilated well with the natural capacities of Correggio. He was innocently and unconsciously a born heathen. Consequently, the commission he received from the abbess to decorate her apartments with scenes from the life of Diana and other mythological figures must have been most acceptable; for he could give full scope in such subjects to his taste for representing corporeal beauty and blooming life in all the charm of joyous and unconstrained action.

Correggio composed his subject with perfect originality and in strict accordance with the architectural arrangements of the apartment. And, although the paintings in the lodge of the Castello in Mantua may have suggested the idea, the composition and execution possess an entirely individual character. Over the mantel-piece of the broad projecting fire-place the life-size form of Diana is represented returning after the chase to Olympus in her richly carved chariot, which she has just mounted. She grasps the reins with her outstretched right hand, and the chariot, drawn by two white does, whose hind legs only are visible, appears to ascend swiftly upwards through the clouds. One of the goddess's feet seems to have only just been taken off the ground, for it rests lightly on the ledge outside the chariot, and the position of the other bended knee suggests her being in the act of rising. She looks, nevertheless, in full motion, with her flowing raiment, a portion of which, inflated like a sail, she holds in her left hand. Her fresh, smiling, but resolute face is turned round greetingly to the spectator. This

figure, the only adornment of the wall, decides and governs at
the first glance the whole pictorial ornamentation of the room,
which serves merely as a decorative accompaniment to the
goddess. It spreads itself out in the form of a trellis-work
extending to the domed ceiling of the apartment. This trellis
is divided into sixteen arches or niches, joined together by a key-
stone formed of a round gilded surface displaying the escutcheon
and initials of the Abbess, Jo. Pl. (Joanna Placentia), surrounded
by a wreath. These divisions support the trellis-work, around
which the vine entwines its branches. The foliage appears
above it in imitation of friezework, and extends along the walls.
Sixteen consoles, one in each corner and three on each side,
correspond with the divisions of the trellis-work. They are
formed of capitals with two rams' heads in profile thereon. In
the spaces between these consoles loose cloths are twined about,
on which are placed every description of dish and goblet, in
indication, we presume, of the apartment being intended for a
dining-room.

The entire ornamentation of the ceiling forms the framework
for the real subject. In each leafy arch there is an opening
forming a medallion, joined together with a wreath of leaves
and fruit hanging down here and there. At intervals the clear
blue sky is seen peeping through the vine-leaves. In each of
these spaces we perceive, as through a window, a group of some-
times two, sometimes three genii or charming naked boys, who
are playing with hunting utensils or dogs. They are Diana's
companions of the chase, and play the same part here as the

cupids in the retinue of Aphrodite. They are represented
floating in space in the boldest and easiest positions between
the sky and the leafwork, over which occasionally, in sportive
malice, they stretch their legs. Sometimes they snatch at the
fruit which hangs over them from the trellis, sometimes they
appear to clamber upon the hunting spears, or to use them as
leaping poles to fling themselves over the ledge; or else they are
depicted amusing themselves with masks, stags' heads, wreaths,
hunting horns, or arrows of Diana, or frolicing about with the
dogs, the heads of which also appear through the openings.
The grouping of these dogs is quite as natural as the rest.
The variety displayed in the sixteen groups is wonderful ; not
a position repeats itself, each movement is different, yet every-
where we find life represented in all its exuberance.

Under the foot of the leafy arch, directly over the frieze, there
is a semicircular lunette framed in a wreath of shells. Fourteen
of these lunettes contain single figures, the remaining two have
three, all of them about a third of life size, and painted in grey
on a grey background. There is no systematic connection dis-
cernible in these figures. Correggio could not certainly have
had any organized plan in his head, he must have selected such
mythological subjects as came in his way or appeared to him
capable of artistic development. It was an Olympus, which,
although suggestive of Grecian origin, took its shape from the
painter's imagination ; and the fact that the chaste sylvan god-
dess of hunting was the chief figure portrayed was a covert
protest on the part of the abbess against the hateful monotony

of the convent under the emblem of chastity. The remaining figures merely possess a playful connection with the ancient myth. Correggio, indeed, displays but a very superficial acquaintance with antique art and fable in these representations, and we can scarcely believe he could have had the advantage of a scholar's assistance, although Affò mentions the learned Giorgio Anselini as having afforded him the necessary help. Our master could not boast, like Raphael, of having a Bembo and Castiglione among his friends. He probably took his ideas from old coins and cameos, of which there were several collections in Parma, among others that of Bernardo Bergonzi. Some of the figures appear to be destitute of signification or any connection with the rest.[1]

That which lends so great a charm to the simple figures painted in grey on grey is the graceful freedom of action and faithful portraiture of life. In accordance with the different style of subject they are graver and more dignified looking, as well as simpler in outline, than the groups of children, but not less life-like. The most striking are Juno and Minerva, the young draped Parcæ, and the youths. The rounded contours of the three Graces are full of sensuous charm, but in their voluptuous beauty there is a certain dignity. The grouping of the three Parcæ is thoroughly Correggesque, and the broad masses in which the drapery is disposed and the beauty of action border on the sublime.

[1] Dr. Meyer has given a detailed description of all these paintings, but this has been omitted from want of space and as not being of general interest.—ED.

DIANA RETURNING FROM THE CHASE.

In the Convent of S. Paolo, Parma.

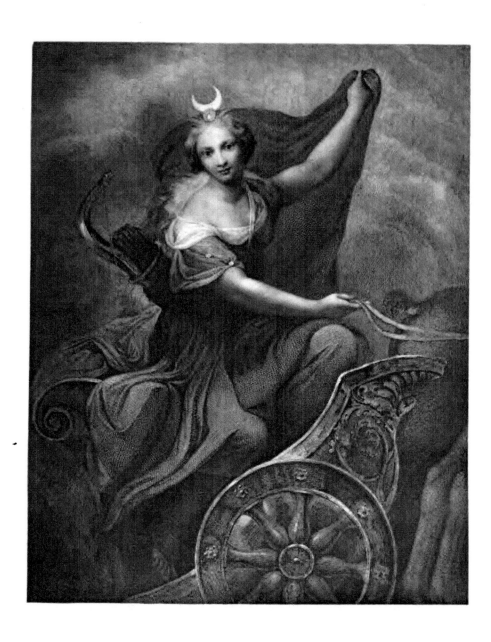

The life-like reality which Correggio has succeeded in imparting to these figures, particularly to the group of genii, is attributable to the careful finish he gives to the drawing and colouring. The delineation of form is rendered with such perfect accuracy, and the idea of roundness, conveyed by subtle gradations of shading and artistic arrangement of the broad masses of light and shadow, is so true to nature, that the figures appear to stand out in bold relief from the painted surface. Correggio herein evinces that he has attained the very zenith of his art. He shows himself to be as accomplished a master in such delineations as Michael Angelo, but he uses this proficiency in sketching each individual form in such a manner as to make it subservient to the general effect of the painting. His figures are consequently represented in the easiest postures, and suggest the boldest action by means of the ever-varying play of light. The pliant, supple form of boyhood lends itself admirably to this style of treatment. No master has depicted the natural grace of the child engaged in joyous pastime, or the wanton pliancy of the flexible form, with such finished grace and truth as Correggio. In his delineations of movement he always keeps within the bounds of nature; but there is something studied in the position in which he has represented Diana.

The consciousness of thorough mastership in the delineation of form, united to the endeavour to produce a perfect realization of nature in his conceptions, induced Correggio to adopt the mode of foreshortening from beneath to above (*di sotto in su*) which has become one of our master's most striking characteristics.

The artistic beauty of these paintings is greatly enhanced by
Correggio's skilful management of the light. The light of the
apartment was not favourable; but the master sought to remedy
this defect by giving additional breadth to that which he threw
over his figures. The warm flesh tones of his genii have that
delicacy of finish which the Italians call " morbidezza," and form
a pleasing contrast to the deep green of the foliage. The
depths of the shadows are brightened also by the lights which
shine through them, and these again softly tone down the glare
of the full lights, so that a strong contrast between light and
shadow is nowhere discernible. This is the celebrated Cor-
reggesque chiaroscuro, the master's most distinguished attribute.
It constitutes the especial charm of these paintings.

These works consequently exemplify Correggio's original mode
of treatment. They distinguish him from all his contemporaries,
and introduce a new feature in art. As we have already seen,
he most probably modelled the paintings in the Convent of S.
Paolo after Mantegna and his school; but although the works
of Mantegna may have inspired him with the idea, his indivi-
duality of style is fully manifested. His " Putti " have nothing of
the plastic sharpness and strong rigidity which distinguish those
of Mantegna; their forms are soft and pliant, and they exhibit a
freedom of action suggestive of an entire independence of austere
laws. Correggio's talent was developed within the space of a
few years; and this is all the more remarkable, as, with the
exception of the Madonna of St. Francis, no intermediate
works can be found. We have no grounds, however, for ac-

counting for the master's early maturity in the manner in which Mengs and others have sought to do. It was, no doubt, attributable to his own resolute, energetic disposition and the retired nature of his life, which kept him from foreign influences, and left him free to follow the bent of his individual genius. This first monumental work, although merely of a decorative character and of too unimportant a subject to exhibit his full powers, nevertheless evinces the perfection to which he had already carried his style of art.

The decorative arrangement of this work, with regard to the architecture, is also thoroughly original. Regardless of the limits prescribed by the style of the building, it breaks through the ceiling in order to form the arborial ornamentation through which peeps the open sky.

In his subsequent ceiling paintings Correggio takes still greater licence, and there is no doubt but that, in striving to bring about the union and co-operation of architecture and painting in order to produce one grand effect, he paved the way for the decadence of monumental art.

CHAPTER V.

MARRIAGE. CORREGGIO'S WORKS ANTECEDENT TO THE FRESCO-
PAINTINGS IN S. GIOVANNI (1519—1521).

Family circumstances.—Marriage.—The paintings of the year 1519.—"Noli
me tangere."—Worshipping Madonna.—Madonna della Cesta.—La Zingarella.—
The character of these paintings.—The silent Madonna.—Spurious Correggios.—
Ecce Homo.—Christ on the Mount of Olives.

CORREGGIO'S artistic efforts in Parma were highly
successful, and the great consideration in which his
first work was held there is proved by the numerous
commissions he immediately received. His pecu-
niary prospects also now took a favourable turn. On the 1st of
February, 1519, his maternal uncle, Francesco Ormanni, in a
formal deed of gift, drawn up in the presence of Manfredo, Lord
of Correggio, bequeathed all his property, movable or otherwise,
consisting chiefly of a house in the "old suburb" (Borgo Vecchio),
and several acres of land in the same district, " to his excellent
nephew, in consideration of some important services which he had
rendered him." But Correggio was not benefited by this in-

crease of his fortune at once. His uncle certainly died on May 4th of the same year, but the legacy was disputed by one Romanello of the Ormanni family, a relation of Francesco's on the father's side. On the 10th of December, 1521, two umpires were called in to decide the matter : one of them, Sigismundo Augustini, decided in favour of Allegri ; but the other, Ascanio Merli, declared his claims null and void, and a long and wearisome lawsuit ensued. It was brought at last to a conclusion, in the year 1528, at the command of the lord of the territory, Manfredo of Correggio. Allegri then received the estates belonging to a manor in the district of Correggio, while the house and fields in Borgo Vecchio fell to the share of Elisabetta Maniardi, the sister of the now deceased Romanello, who had inherited his rights. The reconciliation between the two families was followed by a fresh transaction : Maniardi made over the land, for the sum of fifty golden ducats, to Pellegrino Allegri, as the representative of his son Antonio. Thus, after a lapse of nearly ten years, and not without much vexation and pecuniary sacrifice, the greater part of the donation fell into the hands of Antonio. The house even seems to have come into his possession, at least his son Pomponio sold one situated in Borgo Vecchio on December 27th, 1550.

As the document relating to this donation was drawn up in the second month of the year 1519, Correggio must have been at that time in his own home. We find him, however, in the course of the year, at work in Parma ; but he visited Correggio from time to time, at intervals of a shorter or longer duration. In the

autumn of 1519, on the 4th and 15th of September, for instance he stood as witness to the drawing up of two legal acts.

Also, his sister Catherine, it would seem, was married to Vincenzio Mariani, who, as we have already seen, had financial transactions with her father, about this time, and the brother is scarcely likely to have been absent at this family event, particularly as his own wedding was approaching; for towards the end of this same year, 1519, he married Girolama Francesca, the daughter of Bartolomeo Merlini de Braghetis, the arm-bearer of the Marchese of Mantua, who fell in the battle of Taro, on the 12th of November, 1503. Girolama was only sixteen at the time of her marriage, having been baptized on the 29th of March, 1503. She brought her husband some fortune, but the settlement of the dowry only dates from the 26th of July, 1521, and that of his sister's on June 26th, 1521. These tardy confirmations of the marriage portions were then customary, and the circumstance of his sister having received hers about the same time proves that her marriage also took place in the year 1519.

But neither did Correggio enjoy this second increase of fortune immediately. Girolama had to enter into business relations with her uncle, Giovanni Merlini, who, it would appear, had been appointed trustee, before she could receive her property. She remained behind in Correggio when her husband was called to Parma to execute new commissions, and gave birth to her son Pomponio on the 3rd of September, 1521.[1] During the months

[1] Her husband's old friend, the Doctor Giambattista Lombardi, stood god-father to this child.

of May and June, 1522, she was occupied by these family matters ;
but at last, on the 26th of January, 1523, the division of the pro-
perty took place, Allegri being at this time again back in Cor-
reggio. Girolama received, as her portion, the half of a house,
worth 60 ducats, and land to the value of 263 ducats. Even
then, however, he was not without anxiety respecting the newly
gained portion, for the brothers Andrea and Quirino Mazzoli,
who were related to his wife, laid claim to some of the land, and
a lawsuit ensued in which the Mazzoli were worsted.

We see, from the above facts, that Correggio was wealthy
rather than poor ; but he had trouble enough to get possession
of his property.

We are ignorant as to how long his wife remained in Cor-
reggio, and when she went to reside with her husband in Parma.
Her second child, Francesca Litizia, born on the 6th of Decem-
ber, 1524, was probably born there, for one of the godfathers was
Giovanni Garbazzi, physician to the convent of S. Giovanni in
Parma. This daughter married a certain Pompeo Brunorio. A
third child, who it would appear died young, was also born in
Parma, on the 24th of September, 1526 ; likewise a fourth, Anna
Geria, on the 3rd of October, 1527.

We have no trustworthy accounts respecting the paintings
by Correggio, executed in 1519, partly in Parma and partly in
his native town. Tiraboschi informs us [1] that there was an entry

[1] According to the report of the Abbot Andrea Mazza, whose remarks Ratti
has also copied in his writings on Correggio.

in the books of the Convent of S. Giovanni with reference to some money that had been paid to Correggio in the year 1519. But nothing has been heard lately respecting this document, and it is uncertain whether it is lost, or, indeed, ever existed. Pungileoni also informs us of a work which Allegri executed for these Benedictines previous to the grand one in their church. It is said to have been a fresco-painting in the little cupola over the cross-passages in the dormitory,[1] and to have represented St. Benedict in a flood of glory among a number of angels. Pungileoni states that he found this account of the painting in an unpublished MS.; but, as he gives no further information respecting it, we cannot receive it as trustworthy. It is, nevertheless, probable that it is the same work which Tiraboschi refers to, and it is quite likely that the Benedictines may have chosen to make a trial of our master's capabilities before they employed him in more important works. No mention, however, is made of this painting in the books of travel of the seventeenth and eighteenth centuries, and it has, no doubt, been long since destroyed.

A painting in the same convent, some few traces of which still remain, is ascribed to our master with still less probability. It is in a niche which formerly belonged to the novice's garden, and now stands opposite to the old winter refectory, built at a later date. The figures resemble those in the Convent of S. Paolo, and certainly possess something of the master's character; but, as far as we can judge, we should consider they

[1] " Nello sfondo del cupolino su la cruciata del dormitorio." Pungileoni.

emanated from his scholars rather than from himself. The paintings in the Benedictine Abbey at Tarchiara belonging to the Convent of S. Giovanni in Parma, also appear to have been done by a scholar, most probably Francesco Rondani, for it is known that our master accompanied Rondani there, and he is said to have helped him in his work. But the source from which we have obtained this information states nothing beyond the circumstance, that, during the time that Correggio was engaged in Parma, he took his pupil to Tarchiara. There is no other reason for supposing that Allegri did any of these paintings.

Before we speak of the fresco-paintings in S. Giovanni which were really the work of our master, we must allude to a number of easel pictures, mostly of small size, executed between the years 1519 and 1521. A considerable number of them are doubtful, and many undoubtedly false: these will be mentioned in the Appendix, and we shall only specify at present those that are considered genuine. They chiefly consist of Madonnas with the Infant Jesus and a little S. John the Baptist. There is a certain similarity of style in all of them, and they were probably painted when he first went to Parma, before he undertook his greater works. These small paintings, no doubt, found rapid sale, for Vasari informs us that he executed several commissions for gentlemen in Lombardy, and Armenini states in his work, which appeared in 1587, that in his travels in Lombardy he saw in many towns several highly treasured pictures by Correggio.

But it is impossible to believe that Correggio could have

painted as many works as is stated, in the year 1519. He had certainly finished the paintings in S. Paolo in 1518, and the works he was engaged to execute during the ensuing year for the Benedictines of S. Giovanni were very inconsiderable; but he went backwards and forwards a good deal between Parma and Correggio, and could not therefore have done much in the way of painting. Besides this, he became acquainted with Girolama about this time, and the approaching wedding must have taken up a good deal of his time.

Two paintings of Madonnas of large size are, however, supposed to have been painted about this time. One of them, an altar-piece, represents a Madonna with the Infant Jesus on her arm, whom St. Christopher is in the act of taking upon his shoulder; the archangel Michael stands near him, and, at the feet of the Virgin, S. John the Baptist. The painting was in Mengs' time in the Pitti Gallery in Florence. It was long considered a genuine Correggio. But Mengs did not think the style of execution coincided with that of our master, although the composition was like. The theory that Correggio left it unfinished, and that it was completed by a painter of the Venetian School, is thoroughly erroneous.

The other work, a Madonna with the four patron saints of Parma, was purchased by the Duke Melzi of Milan, as a genuine Correggio, from the painter Baldrighi; but it is more than doubtful.

There is also a work of a quite peculiar description, supposed to have been painted by our master in the year 1519. It

is generally considered genuine; but, according to our opinion and that of Herr Otto Mündler, it most undoubtedly did not emanate from Correggio. It represents the " Vengeance of Apollo on Marsyas and the Fate of Midas," painted in small figures on a wooden panel which probably formed the cover of a musical instrument. Not long since it was in the palace of the Duke Litta at Milan. Its authenticity was long unquestioned, partly in consequence of Sanuto's engraving of it in the year 1562, and partly because Lodovico Dolce, in his dialogue on colours, in the year 1565, speaks of a seemingly similar work by our master.[1] A picture answering to the same description is also mentioned in the catalogue of the art-treasures of the Marchesa Isabella Gonzaga, of Mantua, and it seems scarcely possible that there should have been any false statement made respecting a work in the choice collection of Isabella Gonzaga, who was in constant communication with artists herself, and received works either directly from them, or through their instrumentality. But, in the inventory of Isabella's art-treasures, the painting is erroneously specified as " Apollo and Marsyas." It was most likely an allegorical picture representing Vice, a companion to another picture of the same kind, both of which are now in the " cabinet de dessein" at the Louvre, that was meant. If Correggio ever did paint a picture on this subject, it must have disappeared long ago, and is certainly not the one in the possession of the Duke Litta.

[1] " Dialogo dei Colori." Venezia, 1565.

R

A painting in the Madrid Museum, "Christ appearing as the gardener to S. Mary Magdalen" ("Noli me tangere"), the date of which is likewise fixed as 1519, is ascribed, with greater justice, to Correggio. The style of this composition is thoroughly Correggesque, although there may be some doubts respecting its authenticity. The truly mundane fashion in which the subject is conceived is very characteristic of our master. In a charming, richly wooded, mountainous landscape, Magdalen is seen kneeling, attired in rich and flowing raiment, still looking the beautiful sinner, while, not less lovely in appearance, the Redeemer is advancing towards her with a light step. If it were not for the representation of the angel in the background standing beside the newly opened grave, and other circumstances suggestive of the Resurrection, one might be tempted to believe it referred to another subject. It is highly probable that this was the original painting which Vasari states Girolamo da Carpi saw at Bologna in the palazzo of the Count Hercolani (or Ercolani), and which made such a deep impression upon him that he immediately applied himself to the study of our master's works. Vasari also alludes to it in his "Life" of Allegri, and says that it was impossible to imagine anything better and more softly painted. The story of the picture and the many hands it passed through after being removed from the palazzo of the Ercolani makes it impossible for us to identify it now as an original work. It is very difficult to decide one way or another respecting its authenticity, it having suffered, firstly, through some over-modest possessor

having in his blind zeal painted it over in part, in order to hide the nakedness of the Magdalen, and, secondly, through the removal of this over-painting. The weakness of the technical handling has led a few modern connoisseurs to regard it as a youthful work,[1] while Mengs places it on a level with the " Worshipping Madonna" in the Uffizi Gallery in Florence, which he considers one of Correggio's least happy artistic efforts. These views greatly militate against Vasari's and Girolamo's admiration, while the free, unconstrained action of the two figures and lifelike expression—traits that characterize Allegro's mature works—show that it could not possibly have been a youthful production. After weighing every consideration, therefore, we are inclined to the belief that it is most likely only an old copy.[2]

A small picture representing "A kneeling Madonna worshipping the Infant Jesus" is undoubtedly authentic. It is in the Uffizi Gallery in Florence, and was certainly painted before the great works in S. Giovanni, probably not later than 1519 or 1520. Charming as the picture is, the master's traits do not come out with freedom and boldness. Mengs found the painting of the head and hands weaker than in most of Correggio's works; the colouring is indeed almost too delicate. The Virgin is enveloped in a mantle in a peculiar way; it is

[1] Passavant, "Christian Art in Spain," Leipzig, 1853, p. 153. Waagen, in the "Jahrbücher für Kunst-wissenschaft," Leipzig, 1868, i. 114.

[2] Sir Charles Eastlake says of this picture: "The Magdalen is worthy of Correggio; the landscape is unlike him, and the Christ also harder and flatter." Memorandum, Madrid, 1859. "Kugler's Handbook," 4th ed.—ED.

bunched up from the waist, and thrown over the head like a veil, one of the falling flaps serving as a support for the child. This idea, which has been censured and considered to be an invention of Correggio's, is not new; it is found in paintings of the Florentine and German Schools, and also in a picture of the Veronese master, Girolamo dai Libri. There is something almost playful in the arrangement of the rich, voluminous garment which is made to occupy so prominent a place in this picture. The smiling Madonna bends playfully over the charming little being lying before her, with her elegant hands clasped in adoration, and, like some beautiful idyl, the whole is set in a lovely landscape, which blends effectively the beauty of the southern scenery with the stateliness of classical architecture. A full light is thrown over the Infant Jesus and the Madonna, and gradually toned off towards the background. The effect produced is almost as if the figures emitted their own radiance, which grew fainter and fainter till at last dissolved into space. It is quite in Correggio's style, but the tone is too pale, and corresponds with the somewhat studied character of the whole composition.

Correggio's individuality asserts itself far more conspicuously in the so-called Madonna della Cesta ("la Vierge au panier"), now in the National Gallery in London. It takes its name from the basket which is represented in the painting. We have only very uncertain accounts concerning the origin of this picture. It must in any case have been painted after the "Worshipping Madonna," probably in the year 1520, when Correggio first commenced the frescoes in S. Giovanni. The two works must have been

THE MADONNA ADORING THE DIVINE INFANT.

In the Uffizj Gallery, Florence.

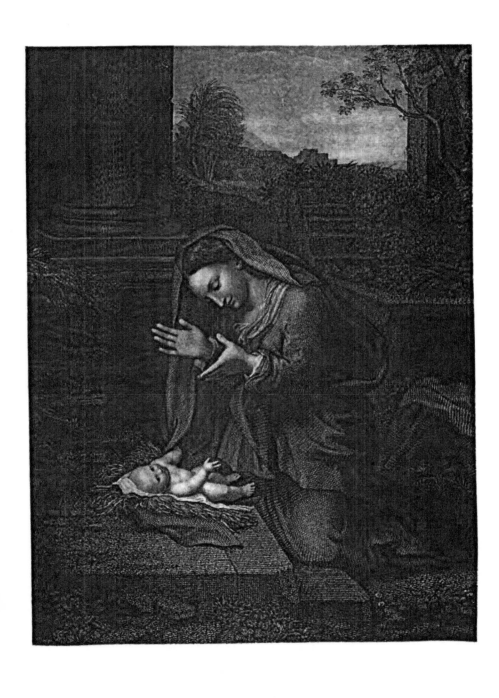

produced almost simultaneously; but, as we have previously stated, Allegri's talent developed so quickly, that we are not able to follow him step by step. The Madonna della Cesta shows both firmness and independence. The composition is quite simple, consisting merely of a peaceful representation of domestic life. The Madonna is sitting in a charming landscape background, and has a basket near her containing linen and a pair of scissors. She has just put a little shirt over the Infant Jesus, who is sitting upon her lap, and with the impulsive impatience of childhood throws himself sideways in order to reach hold of something. Joseph is at work, carpentering in the background. Mengs praises in this picture the way in which Correggio has softened off the light to the background, the gradual melting away of the objects represented, till they are absorbed in the haze of distance. Everything looks enveloped in a soft veil of light and air. The refined and delicate management of the chiaroscuro, perfectly natural as it is, constitutes the chief charm of the picture.

In the year 1520 Correggio is stated to have painted the "Madonna and Child" in the gallery in Naples, known under the name of the "Zingarella," in consequence of the strange headdress the Virgin wears, or the "Madonna del Coniglio," from the rabbit which is represented in the painting. We have no authentic information respecting this picture, and are only able to draw our inferences from the technical handling. The Madonna is supposed to be a likeness of Correggio's young wife, and although there are no grounds for the statement, and it is impos-

sible to fix a date for the production of the work, the supposition
is not improbable, for he may well have painted the picture
about the time when he commenced his works in S. Giovanni.

There are a number of fac-similes and copies of this work,
some of which lay claim to be originals. The really authentic
picture, although it has been retouched and partly painted over,
is undoubtedly the one in the gallery in Naples, whither it was
brought from the Palazzo Farnese in Parma. Mary is sitting
with her face in profile in a beautiful landscape under a palm
tree. The Infant Jesus is slumbering on her lap, clasped with
one arm, while the other supports his foot. She bends over him
affectionately, and touches his head with her forehead. Above
her, among the palm trees and clouds, hover genii without
wings, one of whom approaches nearer than the rest, and holds
a branch over her as a shade and protection. The character of
the picture is stillness and repose. The genii seem playfully to
hold a dreamy spell over the group; the rabbit in the green
grass close at hand watches them all with curiosity, but without
fear, and Mary herself lets her head fall, half slumbering. Like
a calm vision in a dream, the naked forms of the angels above
float in the soft illusive shimmer of twilight. It is interesting
to see how Correggio always strives to invest his conceptions
with the look of every-day life, and he has consequently given
Mary a sort of Eastern costume. A cloth is folded round her
head in turban fashion, and a long garment with narrow sleeves
reaches to her feet, which are encased in sandals.

Although the painting has suffered from having been daubed

over till it was almost unrecognizable in former times, it exhibits at present charming effects of colour, having been lately partially restored. The local tints, as well as the general tones, are deep and rich, and, as the flesh tones also are in part the same, it is clear that the master's intention was to invest the Madonna with an Eastern or gipsy-like appearance. In spite, however, of the depth of the tones, the painting has an almost gem-like brilliancy.

As connoisseurs have recognized in the Zingarella the portrait of Correggio's wife, it has also been thought that the various Madonna pictures of this period were representations of his own domestic life. Such might have very probably been the case, except for the circumstance that his first-born, Pomponio, came into the world in 1521, after the time in which most of these paintings are generally said to have been produced. It matters, however, little what models in real life our master chose for the subject of his compositions. His naïve and thoroughly human style of conception was not dependent upon exterior help, but found its origin in the nature of his own genius. We shall enter into closer particulars by and by, with respect to the introduction of a worldly element into sacred subjects by Correggio and the other masters of the Renaissance. In lieu of the severe and devotional style of composition one might have been led to expect from the religious character of the theme, we have a joyous, playful, naïve picture of pure domestic life. Such is particularly the case in the " Worshipping Madonna." It gives one the impression of the

mother's whole joy being centred in the child lying before her, whom she is enticing to play with her outstretched hands. The sacred thought which makes the Virgin fall adoringly before the Child in acknowledgment of its divine nature, is lost in the purely domestic character of the scene.

There are also several fac-similes of another painting, belonging to this same series of Madonna pictures, the date for which is somewhat arbitrarily fixed between the years 1519 and 1521.

This representation depicts the Virgin in the act of quieting the Infant Jesus, while John the Baptist is offering him fruit. It is universally known, from the excellent engraving of Fr. Spiere, but Italian authors do not often mention it. Correggio's "Life" gives us no information whatever respecting its origin or date of production. An obscure book on painting of the year 1652 certainly mentions a picture answering to its description, as existing in the seventeenth century, but there is no work by Allegri, respecting the origin, history, and fate of which so little is known. It is the more remarkable, as there are three fac-similes of it, all undoubtedly emanating from the hand of our master. Mündler, who has had the opportunity of seeing these three paintings in different parts of Europe, and inspecting them thoroughly, writes to us as follows :—

"The first, which appeared to me the most striking, made the strongest impression upon me. I found it in perfect preservation in the possession of the Portuguese, Count Cabral, in Rome. I saw it several times, from the years 1842 to 1844.

Often as I visited it, I always admired it as an undoubted original creation of Correggio. They then asked 5,000 lire for it. It is very probably the one now in the hands of the Prince Torlonia in Rome.

"The second example is in the Esterhazy Gallery in Pesth. In this, besides S. John the Baptist, there is a little angel with open wings, who offers the Child pears and cherries in a white cloth. The Infant Jesus, turning from his mother's breast, stretches out his little left arm eagerly for them. This picture has suffered very much; for instance, the right hand and arm of the Virgin, and the white handkerchief on her breast have been altogether newly painted. The faces and hair, as well as the body of the Infant Jesus, have, however, been sufficiently well preserved to enable us to discern the original coating of paint, and soft oily impasto. The moving air, the delicate outlines, in short the indescribable charm of the master's subtle gradations of light and colour, and the witchery of his chiaroscuro, are all to be found in this work. The delicate touches, which are the characteristic tokens of all his pictures, are also noticeable. The half-tones and shades, in spite of all the picture has suffered, are transparent, and the prevailing colour pearl-gray.

"The third repetition is in the Hermitage in St. Petersburg. Different from the two others, it is painted on wood, which is not favourable; Correggio's works are mostly on canvas. It is narrower and higher than the other two, which are almost square. Here also it is a little angel who brings the fruit to the Infant Jesus. This picture has the advantage of being in

s

perfect preservation, and having a very clear surface. The painting is beautiful and rich, but lacks the pliancy and marrowy softness which distinguishes Correggio's handling. The quivering atmosphere floating around the figures is also not so well given. It is, nevertheless, impossible to doubt its authenticity, and the lack of a certain charm and soul in it may arise from its having been a third copy."

So much for Mündler. Waagen also does not for a moment question its authenticity.[1] The circumstance of the St. Petersburg painting having been in the possession of Charles IV., as well as the Madonna della Cesta, is a further proof of its genuineness. It is, nevertheless, remarkable that Correggio should have painted the same subject three times with so little change, while he so greatly altered the composition of the "Marriage of St. Catherine," and generally displays so much variety in his Madonna pictures. It was doubtless the beauty of the idea which induced him to repeat it so often. We are well aware how indifferent he was to the meaning of a subject, and the facility with which he could alter the composition and material of a picture.

In consequence of the admiration these little Madonna pictures have always elicited, several paintings have been executed in imitation of them since the seventeenth century, and circulated as genuine Correggios, without their possessing one trait suggestive of our master. It may be asserted with justice

[1] "The Collection of Pictures in the Hermitage at St. Petersburg," 1864, p. 57.

that the greater number have no connection whatever with Correggio. They are for the most part not even executed in his style, and could only have been accepted at all, in consequence of the great desire of collectors to possess his work. The greater number of these paintings have now disappeared, or are only known by engravings. Dealers now no longer dare, as in former times, to palm off works as genuine Correggios, which possess no similarity with the master's style. The stamp of originality in Allegri's productions, to which connoisseurs have drawn so much attention, has made deception less easy. In our times spurious Raphaels find readier acceptance than imitations of our master. As far as we know, there are no Correggios existing except those in acknowledged hands. With the exception of one solitary instance, it is years since a Correggio has been exposed in the great public sales in the Hôtel Drouet in Paris, where, in consequence of the sudden vicissitudes in the financial world, so many distinguished and genuine works of the first rank have been lately brought to the hammer. This does not, however, destroy the fact of there being many so-called Correggios in different galleries, which have no connection with our master.

Among the many Madonna pictures in which the theme of maternal love plays a more or less share and charming part, we may mention one in the possession of the Marchese Cesare Campari, in Modena, considered by some few connoisseurs to be genuine. The Virgin is occupied in undressing the child, which seems to have just awoke, and looks up smilingly at her. It is

a sort of companion to the Madonna picture, in which the mother is engaged in dressing the infant (Madonna della Cesta).

Some time ago, namely, in the eighteenth century, and at the commencement of our own, there was more fraud and deceit exercised with regard to Correggio's works than with any other master. The public craved for new works by him at any price, and many were accordingly supplied. One of the most remarkable instances of this kind in the history of art is the engraving called "Charity," by Morghen, alleged to be from a genuine work.

The original of this engraving was bought by a picture-dealer in Rome named Lovera, in 1786, of the painter Christoph Unterberger, who honestly affirmed it to be a work of his brother's, who was then in Vienna. Lovera, however, insisted that it was a genuine Correggio, and numerous connoisseurs who saw it came to the same conclusion. A drawing was then made from it by an English artist named Day, for R. Morghen to engrave, and in 1795 it was bought by the Prince Nicholaus Esterhazy for 1,200 ducats; but only on the understanding that the contract should not be fulfilled unless the picture were proved to be genuine. On taking it to Vienna, Ignaz Unterberger, the brother of Christoph, brought forward incontestable evidence to show that it was his own work. The prince accordingly refused to purchase it, but still some persons persisted in believing in its authenticity, and the picture was finally bought by Lord Bristol for 36,000 lire. It is not, however, mentioned by Waagen in his " Treasures of Art in Great Britain," and

has apparently, like so many of these disputed works, disappeared.

Coeval with paintings of a purely joyous character, are two works painted between the years 1519 and 1521, which treat of sad and painful events in the life of Christ. One of these represents Christ before Pilate ("Ecce Homo"). The engraving of this picture by Agostino Carracci in the year 1587 gives us undoubted proof that such a painting was then existing in Parma in the palazzo of the Count Prati. Scannelli also deposes to its being in the possession of the same family in the middle of the seventeenth century.[1] The high value at which it was esteemed in former times is proved by the admiration of the Carracci; Agostino engraved it and Lodovico copied it. This copy is now in the National Gallery in London. The original painting seems to have been overlooked in the admiration excited by this copy, the genuineness of which has only very rarely been questioned.[2] Such excellent judges as Waagen and Mündler, indeed, both recognized the master's touch in this work, and attributed the somewhat insipid colouring of the body of Christ to cleaning and over-coating.

The manner and style in which Correggio has depicted this painful episode are thoroughly characteristic. The space is quite filled with half-length figures of life size; but the incident is

[1] Ramdohr, however, notices it as being the best picture by Correggio in Rome in 1784. It was then in the possession of the Colonna family.

[2] It is doubted by Viardot, "Les Musées d'Espagne, d'Angleterre et de Belgique," Paris, 1843, p. 231.

fully portrayed within the narrow limits of the frame, and the
pathos of the subject expressed in the most forcible manner.
Before the figure of Christ, who is standing in an almost front
position, with bound hands and the upper part of his body
uncovered, is the Virgin Mary. Her face and a part of her
body only are visible, as she sinks fainting into the arms
of S. Mary Magdalen, whose face is bent over her head.
Behind, on one side, looking out of a window, is Pilate, who
evinces his little sympathy with Christ by the expressive play of
his hands; on the other side, in profile, is seen the face of
a soldier. The simplicity of this concise composition, in which
the story is told by the animated gestures and attitudes of a few
figures, is not without grandeur. But the divine vocation of
Christ, His noble resignation to his sorrows, which lends a
religious meaning to the event, will be sought here in vain. It
is simply nothing more than the representation of human grief
felt deeply and poignantly, but borne with self-command and
noble resignation. The same effect is expressed by the loving
female figures represented in the painting. Even grief itself is
sensualized. But the depth of the pathos, and the excess of
gentleness mingled with the sorrow, calms the sensibility of the
spectator, and raises the work by purely human agency to the
ideal. Waagen himself thinks there is great pathos expressed in
Jesus' bound hands. The chief effect, however, is produced by the
youthful Madonna. There is something extremely charming
and graceful in the manner in which she sinks back unconscious,
overcome by grief, before it shatters her delicate frame. The

ECCE HOMO.

CHRIST CROWNED WITH THORNS.

In the National Gallery.

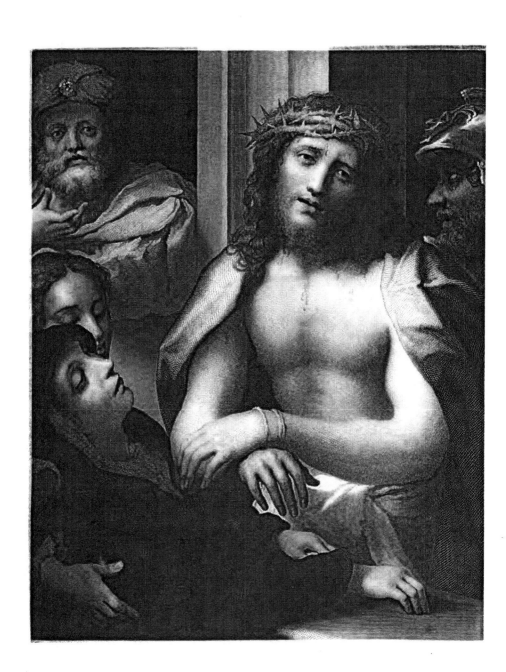

group of Mary and the Magdalen, is also the best preserved, and reminds one most of Correggio. Mündler writes to us :— " Mary, supported by the youthful and beautiful form of the Magdalen, is an unequalled master-piece. Never have we seen depicted a face destitute of every drop of blood, hands that suddenly stiffen in the temporary death in life, in so effective a manner. There is not the slightest exaggeration, no striving after effect, yet it is not without an artistic observance of the pleasing and graceful." Waagen holds quite the same opinion respecting the merits of the painting, but dwells perhaps a little more on the realistic character of the composition :—" Her lips seem still to tremble with weeping, but the corners of the involuntarily opened mouth are just beginning to stiffen ; the rounded eyelids are about to fall over the closing eyes ; her hands loosen their grasp on the balustrade which separates her from Jesus." The figure of the half-visible Magdalen expresses the deepest sympathy. The unforced, natural manner in which Correggio blends the delineation of grief with a delicate beauty of conception, excluding all 'exaggeration and distortion, constitutes the true charm of the master. The deep and vivid tones of the colouring correspond with the style of the composition. Mary's paleness is increased by the contrast with the deep blue handkerchief which envelops her head. The original was unquestionably produced at the period of the master's full maturity ; and, as he had reached this about his twenty-sixth year, we may fix the date of this picture in the year 1520. In this opinion Waagen and Pungileoni coincide.

The other painting, " Christ praying in the Garden of Gethsemane" (of small size), is generally supposed to have been painted about this time, but seems to us to have been produced at a later date. According to an old tradition, mentioned first by Lomazzo,[1] Correggio is said to have painted this picture in payment of a debt of four or five scudi that he owed to a certain apothecary, perhaps his own. The story is also found in Scannelli; but it does not appear to us to be more trustworthy than the other fables about his poverty.

The otherwise painful impression created by the scene is brightened and softened by Correggio's management of the light. A ray of light falls from the heavens upon the form of Jesus, who, attired in white with a blue cloak, is seen kneeling in the foreground. This light is managed in such a manner that the other objects in the picture are illumined thereby, especially the ministering angel who hovers over him and points with his right hand to the cross and crown of thorns, and with the left to heaven.[2] The group stands out in bright relief from the dark background, in which the eye gradually discerns the richly wooded undulating landscape, the sleeping disciples, and, quite in the distance, the approaching soldiers. Everything, even the light which rises in soft gradations from out the depths of the surrounding shades, tends to convey the impression of a

[1] " Idea del Tempio," &c., 1589, p. 115.

[2] The light is represented in this picture, not as emanating from Christ, as in the " Notte," but as reflected off from him to the surrounding object. The angel is wholly illuminated by this transmitted light.—ED.

passionate but not overwhelming grief. Even in Jesus the agony and soul-struggle (*seelen-kampf*) is mitigated by a feeling of resignation. The upward-turned head is full of the deepest pathos, while the calm of renunciation as well as submission to the Divine will is expressed by the outstretched hands. Correggio has avoided representing the Agony, and it is also remarkable that he has not placed the cup in the hands of the angel, which usually figures in representations of this subject. His naïve and thoroughly human perception could see no use in depicting this tasteless symbol. Here, as in his other paintings, the religious meaning of the composition is lost in the charm of pictorial arrangement. The picture is finished with almost the delicacy of a miniature, and we must admire the artistic conscientiousness of the painter all the more, as he is said to have disposed of his painting at so small a price.

The chiaroscuro which distinguishes all Correggio's master-pieces is managed in this painting with the most consummate skill, being softened by the most delicate gradations. In this it resembles the "Notte." It was probably produced about the year 1525, before the latter painting. In any case the management of the chiaroscuro, upon which the whole artistic effect depends, indicates that it was painted at a time when Correggio's genius was fully developed.

This small picture has up to the present day been considered a master-work of Correggio, and the expression of so much pathos in so small a compass, as well as such great artistic effects, have elicited the admiration of Vasari and

Lomazzo in former times, and Mengs and Waagen at a more recent period. Vasari characterizes the picture as the most exquisitely beautiful work which the master has produced, and so true to life that it could not be better represented or expressed. Waagen considers it to be the most beautiful known representation of the subject, and states that he thought it unlikely that there could be an example extant that displays so much artistic skill in so small a compass.[1]

The picture " Bearing the Cross," in the Academy of Parma, is stated to have been produced in the year 1520, and is often ascribed to Correggio. But it most undoubtedly was not painted by him.

If we take a retrospective view of Correggio's works which are stated to have been executed from the years 1519 to 1521, and the greater number of which probably were produced about that time, we shall see that the small works were finished as carefully as the grander ones in S. Giovanni. His art displays itself with equal force in little things as well as in great, and the character of his genius adapted itself with equal success to the painting of the dome of a church or the delineation of pictures of a miniature-like delicacy.

[1] This picture, that formerly formed part of the Royal Collection at Madrid, was given by Ferdinand VII. to the Duke of Wellington. Since then it has been one of the chief treasures of Apsley House. English readers will scarcely need to be reminded that there is an excellent copy of it in the National Collection (No. 76). It has been frequently engraved. Unfortunately the original is now greatly blackened by time and dirt.—ED.

CHAPTER VI.

The Paintings in San Giovanni in Parma.

The frescoes in the Dome and Tribune.—Residence in Parma (1522).—Altarpieces in San Giovanni.—Martyrdom of the saints Placidus and Flavia.—Pietà.

AFTER the completion of the paintings in the Convent of S. Paolo in 1519, Correggio, after executing an unimportant work for the Benedictines of S. Giovanni, undertook, in pursuance of a contract drawn up on the 6th of July, 1520, the painting of the cupola of their church. The document itself is not extant, only the different vouchers for payment of Correggio's work, found by Pungileoni in the books of the convent. According to this, Allegri had the sum of thirty ducats advanced to him on the 6th of July, 1520, and on the 23rd of January, 1524, he was paid the last instalment with the reserve of twenty-seven ducats. It has been generally believed, in consequence of a statement of the Pater Maurizio Zappata, in the year 1690, that Correggio received a sum of 472 golden ducats for the whole of the paintings.[1] He

[1] Manuscript in the library in Parma: "Memoire cavate da libri del Monastero di S. Giovanni."

says: " I saw in the Libro Berettino, dated 1524 up to 1536, in folio 11, a clear statement that the disbursement for Antonio da Correggio's paintings in the dome, frieze, arch, on the pillars and other places in the chief nave" (" nave maggiore," which sometimes means the choir, and with which Zappata has included the dome), " consisted of a sum of 472 golden ducats." What the "libro berettino" was, is not very clearly expressed in the paragraph; but the book or register which contained the information which Zappata reports to us was not to be found even in Tiraboschi's time. It is very probable that Zappata read incorrectly 472 instead of 272, or made a mistake in the copying; for the way in which Correggio was remunerated for his paintings does not authorize us to believe he could have received so large a sum for his works in S. Giovanni. The vouchers which are still existing in the church in the " Libro Maestro" (chief book) and the " Giornale" state twice over—firstly, the sums which Allegri received from time to time, and, secondly, that which he was paid for work independent of the other; and both bring the sum to 272 ducats.

Taking everything into account, Correggio does not appear to have received more than the sum which we have stated. Instalments of 130 and 65 ducats were paid for the painting and ornamentation of the dome; five for the preparation of the gold-leaf for the frieze and profile; six for the decorative work on the pillars, particularly the adornment round the candelabras; and sixty-six for the friezework which went round the building and different other ornamentations. The first sum, 130 ducats, was

probably paid for the painting in the arch in the tribune; the whole sum is very small, and its insignificance is perhaps attributable to his youth, and the circumstance of his talents being only known in so small a circle; but Raphael, we must remember, only received 300 golden ducats yearly for his superintendence of the building of St. Peter's. According to the standard of 1269, 272 ducats would have been worth from 820 to 850 florins, and, according to the changes in the value of metal which have lately taken place, would be now worth 5,000 florins. For a supplementary work, namely, the ornamentation which went round the choir,[1] Correggio received on the 25th of October, 1525, twenty-five lire. A Parmese gold ducat is worth five lire. It also appears that Allegri received board and lodging in the Convent of S. Giovanni, while he was engaged on this work. Tiraboschi at least surmises that such was the case, and he seldom comes to erroneous conclusions. It was not, however, customary to supplement the stipulated sum for an artist's work in this manner, and Correggio probably only lived at the expense of the monks while he was alone in Parma. As soon as his wife came to join him there with her newly born son, he would naturally have his own house. Pungileoni states that he resided in the Pescara quarter of the town in the neighbourhood of S. Giovanni, but we are ignorant as to the sources whence he derived his information. Even then he may have obtained his provisions, &c., from the convent. He often

[1] Per la pittura fatta al Choro all' intorno p. di fuori; that is to say, on the wall inside the church which encircled the choir.

accepted this style of payment for his pictures, though, as before said, this fact need not be regarded as a sign of poverty, for about this same time he committed the extravagance of purchasing a young filly for eight ducats. This was after he had been paid one of the instalments on the 28th of April, 1521. He probably did this during the time that his family were in Correggio, in order to facilitate his travelling backwards and forwards from there to Parma.

As the first instalment of Correggio's money was paid by the Benedictines on July 6, 1520, it is probable that he undertook the grand works in the church soon after. It seems likely that he had finished the most important part of the painting in the dome in January, 1523, as he was paid more than 130 ducats on the 23rd of that month. The work was greatly interrupted before his family came to settle in Parma, and the war which broke over that town in 1521 must also have delayed its completion. Pungileoni makes the extraordinary assertion, that Correggio bought the filly in April in order to fly to his native town when Parma was besieged by the French, and remained there till peace was restored. The war, certainly, did not break out until August, but the fact of Correggio's presence in his native town in the summer of the year 1521 is proved by the date of the receipt of the dowry which, as we have stated, his wife received at that time. In September in the same year his son Pomponio was born. He also at that period engaged a new advocate to assist him in his lawsuit with his uncle's heir, and on the 8th of November we find him as witness to a legal document.

His residence in Correggio, therefore, appears to have been pro-
longed till the close of the year. His works in S. Giovanni
met with further interruption in the autumn of 1522, but in this
case only for a brief period. On the 14th of October he entered
into an agreement with a private gentleman in Reggio with
respect to the painting of a picture; but on the 1st of November
he returned to Parma, as there is evidence of his having at that
date signed a contract with the prior of Benedictines for the
painting of the frieze in S. Giovanni.

Correggio appears to have commenced his work in the dome
about the middle of the year 1521, and to have terminated it at
the close of the year 1522; so it must have taken him about a
year and a half. But the paintings must have been sufficiently
forward in May to have met with the approbation of the monks,
for on the 15th of that month they did him the honour to elect
him a lay member of their brotherhood. In the year 1523 he
probably painted the remainder with the exception of some of
the ornamentation, the frieze which went round the dome, and
particularly the cornices in the arch. A receipt in his own hand-
writing testifies to his having received the last instalment of
27 ducats on the 23rd of January, 1524. It is one of the few
documents extant in Correggio's handwriting. He states therein
that "he had received the full payment and remainder of his
reward for the works he had completed in the said church," and
declares himself to be "contented, satisfied, and fully paid;" (con-
tento, et satisfatto, et integramente pagato). It is signed, "An-
tonius manu propria."

The paintings in the dome were doubtless sufficiently far advanced in 1522 to have been partially visible to visitors to the church. That such was the case is indeed proved by the master having obtained a new and important commission to paint the chief church in Parma, the Cathedral. The canons and prebendaries thereof would not most certainly have confided the work to him without having seen the result of his labours in S. Giovanni. His work, therefore, must not only have met with the approbation of the Benedictines, but have been admired in more extensive circles in Parma as well.

This new commission doubtless decided the artist to settle in Parma with his family for good. According to Pungileoni he took up his established residence there in the spring of the year 1523, after the lawsuit with his wife's relations had been concluded and the property made over to him. But there are no grounds for supposing that he brought his wife and child there at so late a date. It seems much more likely that he set up housekeeping in Parma in the middle of the year 1522, as he was even then much engaged and had the promise of further work.

The greater number of the paintings in S. Giovanni are still existing, but in a very bad condition. There are probably none of the great frescoes of the Cinque Cento which have been left more exposed to the destroying hand of time, dust, and damp than Correggio's works in S. Giovanni and the Cathedral. We have already alluded to the indifference evinced by the Parmese to our master's works after his decease, and the feeling seems to have remained unchanged until the discovery

ANGELIC CHOIR. (I.)

In the Cathedral, Parma.

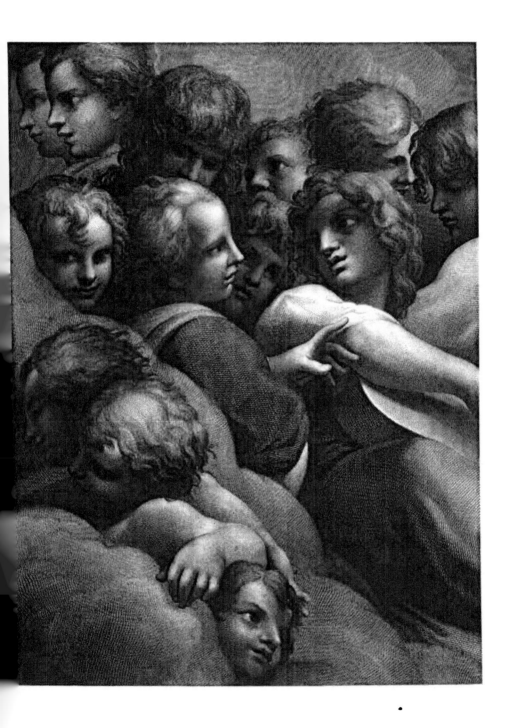

of these treasures by the Carracci. Since their time they have been a subject for study and admiration down to the present day.

The conception of the painting of the dome is thoroughly original. Unlike most fresco-paintings of that time it is not architecturally divided into panels, which in consequence of the dome form presented peculiar difficulties. One entire representation occupies the whole space. It is the Ascension of Christ in the presence of his apostles, who are sitting upon clouds, and the whole is supposed to be a vision of the grey-headed St. John beneath. A number of figures of colossal size are distributed about on the extensive surface of the dome. Christ is seen floating amidst clouds of glory, the edges of which are bordered with innumerable angels' heads, which shine in the light which comes from above. Lower down, where the dome widens, the apostles, in groups of two together, are represented sitting in easy attitudes on clouds, surrounded by angels, or rather boy-genii, who carry on a joyous, childish game amidst the clouds, and seem to carry the grave figures floating above them.

There is nothing here suggestive of the sacred earnestness of religious worship, or the consecration of the House of God, which distinguishes the representations of the older masters. It is rather a glorification of physical beauty released from the trammels of the austere rules of art, and elevated by the expression of ecstasy and enthusiasm. The forms hovering in space are represented with an almost illusive appearance of reality, and the positions of their bodies are so arranged with regard to the

point of sight as to seem as though they were really moving upwards. The foreshortening from beneath to above (di sotto in su) is carried out in the boldest and most masterly manner. It appears to us, however, that this representation of real life is somewhat out of place in a composition that treats of the spiritual glorification of life. The form of Christ, with his outstretched arms and legs drawn upwards in such a manner that the knees appear almost under the body, reminds us in its action of a rope-dancer, and the great animation of expression destroys the solemnity of the scene. The apostles, who are less ecstatic and only depicted as inspired spectators, have a much better effect, and it is undeniable that Correggio has succeeded in representing in them a noble conception of lofty manhood. But neither can they be pronounced exempt from an excessive display of motion. They are represented almost naked, the small pieces of garment which are thrown over them serving rather to display than hide the forms of their bodies. In this innovation Correggio has shown himself as regardless of the traditions of the Church, as he was of the antique in his delineations of the mythological figures in the Convent of S. Paolo. The religious and sacred character of the subject is completely set aside to give greater prominence to the games of the genii, and the whole scene is seized upon as an opportunity for showing off the joyous playfulness of children who make the fullest use of the elasticity of their charming limbs. They ride upon clouds, romp with them, float sometimes above, sometimes below, seem to carry them or be carried by them, play hide and seek behind them,

and to modern notions convey the idea that their sentiment of religious ecstasy is only assumed playfully. Such a thought, no doubt had no place in our master's mind, but there is nevertheless a struggling under-current of free thought apparent in the work.

The general effect of the painting is enhanced by the light which permeates through everything. The shining figures rise from out a brilliant background, and all the shadows are lit up and illumined. The power and brilliancy of the effect proceeds in no small degree from the full, warm masses of colour in the latter, particularly in the shading of the flesh. It is especially noticeable in the delicate, warm glow of the naked body. No painter has understood better or expressed with greater mastery the endless capability of the human frame to receive light and emit it than Correggio: for the Venetian method of painting a warm local colour over the flesh, bringing out the glowing tones of the under coats, is quite another thing. Correggio has also softened the light even in places where its power is strongest, while, on the other hand, it seems to permeate through the deepest shadows. The chiaroscuro, which always lends its peculiar charm to Correggio's paintings, is here managed with the most delicate discrimination, and carried to the greatest perfection. The bold relief in which the figures stand out from the background, has never, as Mengs justly observes, been depicted with equal success by any other master.

While, on the one hand, we have in this painting a picture of real life, we have on the other the representation of a supernatural,

fabulous creation of the mind. Architectural laws are still less regarded here than in the paintings of the "Convent of S. Paolo." Everything seems to rise through the air heavenward upon clouds which form a sort of basis for the figures. The dome is done away with altogether, and a sky with magic forms looks down on the church. This style of church painting, particularly the ornamentation of the dome, became the established model of ecclesiastical decorative art in the seventeenth and eighteenth centuries.

It may be easily understood that this work has been the theme of much conflicting criticism. Side by side with the censorious critic of our day who, regarding it from the standpoint of modern requirements, seeks for the spiritual meaning of the composition,[1] we have the enthusiastic admiration of former times. The words of De Brosses, who lived in the middle of the last century, are characteristic of this style of criticism: " This painting consists of twelve wonderful figures, which are drawn with unheard-of boldness, and with such perspective accuracy (seen from beneath to above), that they have no equals. Under these gigantic figures there are some not more than two feet high, and yet you see them from the sole of the foot to the crown of the head, just as if they were in reality floating in the air."[2]

The model under whose immediate guidance Correggio

[1] T. Burckhardt, " Cicerone," 2. Aufl. Leipzig, 1869, pp. 964-969.

[2] " Lettres Historiques et Critiques sur l'Italie." Paris (an vii.) iii. 375.

attained to such mastery in his delineation of the human form in all its movements and positions, has been sought for everywhere. Mengs holds the opinion that it must have been Michel Angelo, and affirms that it was his works in the Sistine Chapel that led Correggio to adopt this style of art. But it will be remembered that Allegri never visited Rome ; and, independently of this, his method of foreshortening is quite distinct from Michel Angelo's. The latter never attempted Correggio's characteristic device of foreshortening from the point of sight of the spectator, in order to produce an illusive appearance of reality. Correggio differs from him again, insomuch that he always endeavours to bring out the whole beauty of the human form. Michel Angelo's figures are of heavy and powerful build, and, although delineated with surprising truth, are suggestive of being governed by great strength of will and an almost tragic spirit of heroism. Correggio, on the contrary, invests his creations, in compositions even of the most elevated character, with an airy lightness and freedom of motion. The Florentine delineates his forms with the firmness of plastic art, while the Lombard, although he expresses form and movement with great clearness, softens the austerity of his outlines in a shimmer of light and air. They resemble each other in so far that they both use a freedom in their representations which sometimes borders upon licence, and seem to take a pride in endowing their figures with an unconventional style of action, that is occasionally carried further than the nature of the subject renders desirable.

The painting in the cupola is terminated by representations of the Evangelists, each with a Father of the Church—Luke with S. Ambrose, Matthew with S. Jerome, John with S. Augustine, and Mark with S. Gregory—all sitting upon clouds. The ecclesiastical figures are foreshortened in such a manner, that they look from beneath as if they were floating slowly upwards. In order to distinguish them from the apostles, they are attired in flowing garments, and appear as if they were the mediators for the congregation of the Church. They are noble figures, and Correggio has succeeded in giving them a look of dignity and grandeur. There are plenty of joyous boy-genii here also, who tumble about merrily in the clouds, or play with the symbols of the Evangelists and Fathers of the Church.

The frieze encircling the dome is divided by four round windows, and displays the emblems of the Evangelists with *putti* playing among wreaths, ribbons, and festoons. Correggio shows, in the charming *mélange* he has here produced of arabesques and figures, that he thoroughly understood architectural requirements. The fact of his so seldom applying this knowledge in monumental works merely proves the originality of his invention, which, instead of combining painting with architecture, made the whole effect of the representation depend upon the former. The remainder of the ornamentation of the church is painted in grey on grey. The frieze is formed of genii, who in groups of two stand at the sacrificial altars. The execution of this decoration is ascribed to Correggio's pupils, particularly to Francesco Maria Rondani and a master Forelli. That it was

designed by Allegri is proved by an entry in a book in the archives
of the convent, in which Correggio engages himself to the Prior
Basilio on All Saints' Day in the year 1522, to paint the frieze
round the body of the church, including the pilasters and archi-
volte, for the sum of sixty-six ducats. The arabesques are based
upon models from the antique, that is to say, are copied from
bas-reliefs, although in a somewhat free manner, like the paint-
ings of S. Paolo. But they are quite different from the
ornamentation of the Renaissance, and those in Rome done by
Raphael and his school; and this again shows how little Cor-
reggio was swayed by Roman influences. They remind us much
more of the style of adornment before Alberti and Mantegna's
day, of which some few traces are still to be found in Mantua.

Correggio's painting in the arch of the tribune is quite
destroyed. In the course of the sixteenth century, the church
became too small for the increasing congregation; so the choir
was obliged to be extended, and the old tribune was in conse-
quence broken up, and in its place a spacious choir added to the
building. An attempt was made to remove the painting from
the wall, but it proved abortive. The chief group was,
however, preserved with difficulty, and is now in the library in
Parma. Before it was destroyed, the most important parts of
the representation were copied by Annibale and Agostino
Carracci,[1] and were painted again on the new dome by

[1] Annibale's copies, as well as the chief group, two large paintings, are now in
the museum in Naples.

Cesare Aretusi (finished by Ercole Pio and Gio. Ant. Paga-
nino). The subject of this painting was the coronation of Mary
amidst saints and angels, who are represented as deeply moved
spectators of the ceremony, the sacred signification of which
Mary herself appears to feel with the most passionate fervour.
The genii flutter round the middle group in festive joy, and
appear to be in a whirl of music, play, and bliss. This expres-
sion of joy cannot be pronounced free from affectation. It may
possibly be the fault of the copying; but there is a violent,
almost nervous, excitement expressed in the attitudes, as well as
too much action in the figures. The bearing of the Madonna,
charming as she is, is wanting in simplicity, and Christ, who is
crowning her, is deficient in dignity. There is a religious, or
rather ecclesiastical meaning peculiar to this painting, which
does not seem in accordance with it. It is neither a naïve
picture of real life, nor yet the representation of a conception
which is purely ideal. The solemn repose which distinguishes
the Madonna of S. Francis and some of Correggio's early
works would be quite in place here, but all trace of it had long
since disappeared.

In the same church Correggio painted in fresco John the
Evangelist, writing with a book upon his lap, in a free,
charming attitude, with his face looking up for inspiration. It
is in a lunette over the door which leads to the cross passages
of the convent. Some few connoisseurs, especially Mengs, have
thought to discern in this figure, as well as in "The Evangelists
and the Fathers of the Church," Raphaelistic influences, as

THE CORONATION OF THE VIRGIN.

PAINTED FOR THE CHURCH OF S. GIOVANNI.

Now in the Library at Parma.

the charming repose of the action, the noble and well-sustained rhythm of form, and the arrangement of the drapery reminded them of the master of Urbino. But there is really no connection beyond that which is often seen in the works of distinguished masters of the same artistic epoch. They represent and bring to perfection the whole art of their time, and although in many points different, they must necessarily have some traits in common, which they appear to borrow from one another.

In addition to the frescoes in the church of S. Giovanni, Correggio painted two altar-pieces for a chapel. According to the assertion of Pater Resta he was to have painted a picture for the high altar, but it was never done in consequence of the expense. The church certainly has possessed no painting for the high altar since the sixteenth century. But we know we must not confide in Pater Resta's statements. He also asserts that he had a cartoon of the proposed painting, probably the one now in Mr. Richardson's cabinet. We have already given our opinion respecting the drawings which were in the possession of Pater Resta.

The chapel was founded by the Benedictine Don Placido del Bono, the father-confessor of Paul III., and it is not improbable that the two altar-pieces had been ordered by him. It seems scarcely likely that Correggio should have chosen such subjects of his own accord. Both pictures are now in the gallery in Parma. One of them represents the martyrdom of the saints Placidus and Flavia, the other is a " Pietà." Both pictures are painted on a sort of coarse linen. The manner in which

x

Allegri has treated the sanguinary catastrophe of the martyr-picture is very characteristic. The legend informs us that Placidus, the son of the patrician Tertullus, newly converted and instructed in the Gospel by St. Benedict, of Nursia, resolved to teach the same, and went to Messina with that intention and founded a convent. His sister Flavia, and the brothers Eutychius and Victorinus, also animated with Christian zeal, followed him there. Soon after a ship landed an Arabian horde which laid the country waste, and prepared a fearful death for the Christians. It was this Correggio was engaged to represent, in order to glorify the patron saints of the founder, Don Placido. Correggio chose the moment when Placidus and Flavia were sinking under the strokes of the executioners, after Eutychius and Victorinus had already fallen. Excellent as the painting is, we can nevertheless see that the master is out of his element. The executioners, in a fanciful costume that power-fully displays their figures, do their work as if it were their accustomed business, and the saints bear their fate like an every-day occurrence, with an expression of happy resignation, as though no pain could touch them. With pierced bosom and open arms Flavia appears to await the last death-thrust quite quietly, with an upturned face full of enthusiasm, while Placidus, undismayed, with a gaping wound in his neck, stands in expectancy of the second blow. To the right of the picture lie the two trunks and heads of his already decapitated brothers. The division of the picture into two almost equal parts, breaks up the composition and weakens the effect of it. It will be thought

that the disadvantage of this arrangement might have been atoned for by the pathos of the subject. But the artist here shows himself to be a stranger to the Christian conception of the pious elevation of the soul by means of the martyrdom of the body. He seems to make the beauty of the composition his chief object. The tragical scene is enacted in a rich, charming landscape, and a lovely angel, with a branch of palm and a wreath, hovers over the beautiful Flavia, whose head the executioner pulls back by its flowing hair. Her beauty shines out all the more conspicuously in consequence of the death-stroke which threatens her blooming life. But we cannot deny that there is a want of pathos, and the struggle of helpless beauty with so dreadful a fate produces little effect. Correggio in this delineation of the agony and death of Christian martyrs, has nevertheless become, in one respect, a model for later artists, namely, in his preservation of the beauty of the form at the last moment before death ; but other artists have endeavoured, in the current of counter-reformation, to produce a favourable effect by giving an expression of pious ecstasy in the midst of torture. The composition of this picture is very good, and good effects are produced even in such secondary matters as the reflection of the form of the executioner, whose back is presented against the light blue background ; and the harmony of the bright and yet softened colouring is full of beauty. The very shadows emit light and bring out the form in strong relief. The charm of chiaroscuro is again shown here ; the figures seem to float, move, and breathe in light.

The other picture, the " Pietà," represents the corpse of Jesus reposing in the lap of Mary, in the moment immediately following the descent from the cross. Our master has not quite succeeded in portraying the expression of deep mental anguish resulting from a tragical scene the horror of which still vibrates through the victim, although it is opposed by the counter-strength (*gegenkraft*) of a resigned mind. On the contrary, he carries too far his representation of the merely physical results of grief, particularly in details such as the cramped hands and feet in the corpse of Christ. The right balance of the expression of inner feeling is not everywhere maintained here. The weeping Magdalen at the Saviour's feet seems to be thoroughly overcome with grief. Anguish is also depicted in the faces of the two other mourners at the head of Jesus, with a degree of exaggeration which almost borders on disfigurement. The effect of the swooning Madonna, on whose knees the corpse of her son is reposing, is full of beauty, the contrast of the expiring life and the soul, which appears just about to leave her body, with the completely soulless form of Christ, is very striking, and the expression of vanquished suffering in the head of the latter is noble and peaceful. In the middle-ground, in a beautiful landscape, stands the cross with a ladder which Joseph of Arimathea is descending. This picture also is finished with great artistic skill, and the brilliant harmony of the colours and the manner in which the luminous shading throws up the lighter portions of the picture, is very effective.

This Descent from the Cross clearly indicates the limits of

Correggio's talents. The chief group, consisting of Mary and
the Saviour, supplemented by the already mentioned scene in
the middle distance, conveys a pure and deep impression, for it
is not the moment of intensest anguish which the painter depicts
here, but the time when the repose of dissolution comes, after
the overwhelming struggle between the body and the soul in
death. This sinking of life, which comes as a gentle release
after violent grief and marks the last struggle of the body with
the departing soul, Correggio has depicted with as much truth-
fulness and charm as any of his joyous scenes of happy animated
nature. But the beings he creates are unable to sustain exces-
sive grief. It overcomes them thoroughly, and they submit to
it unresistingly. These charming beings, only created for the
sunshine of life, cannot bend before the storm, it breaks them.
Even the style of their faces excludes the idea of their being
able to stand the wear and tear of pain and sorrow. The truth-
ful portraiture of nature, which usually invests our master's
creations with so much charm, is detrimental to the effect of this
picture. The representation of inordinate suffering is not con-
genial to Correggio. But having undertaken it, he depicts it
with a realistic truth, even to the disfigurement of his art.

This realistic representation of grief was copied by succeed-
ing artists—not only by those whose naturalistic tendencies in-
clined them to give expression to it, but by mannerists and
Academicians, who made it their aim to unite beauty of form
with naïveté of expression. It was considered in their eyes a
masterly accomplishment to represent tears and a woman's

weeping face as naturally as possible, but yet gracefully. This union, which is in reality impossible, they imagined to have found in the Magdalen of the " Pietà." Hence the exaggerated praise which Scannelli bestows upon this figure "who weeps so gracefully," and whose lamenting voice one seems to hear. According to him, Guercino da Cento, one of the most distinguished masters of his day, is stated to have said: " This Magdalen of Correggio is a wonder without equal in art; she really weeps without the slightest disfigurement of the face." These masters in their realistic representations of overwhelming grief, have even sought to outdo their great predecessor; but while Correggio always remained within natural bounds, they fell into exaggeration, and the effect they produce is all the more faulty, as in consequence of their desire to depict a certain grace of form, they are unable to produce anything beyond a very insignificant show of feeling.

CHAPTER VII.

The Dome of the Cathedral in Parma. Correggio as Sculptor and Architect.

Two small fresco paintings.—The Annunciation and the Madonna della Scala.—Commission for the cathedral.—Paintings in the dome.—Correggio's acquaintance with the plastic arts.

DURING the time that Correggio was occupied on the works in S. Giovanni, he painted two smaller frescoes in Parma, probably about the year 1520. One of these, representing the Annunciation, was originally painted in a niche in the old church of the Annunciation ;[1] and when this church was pulled down during the reign of the duke Pier Luigi Farnese, to make room for a castle which was built in its place, the painting was removed to a vestibule in the new Church of S. Annunziata, where it still remains, but in a somewhat bad condition, having suffered much from dampness. We can discern little now beyond the subject

[1] Not in S. Francesco, as Vasari erroneously states.

of the fresco; but in Tiraboschi's time Mary's face was still
well preserved, and the wonderful beauty which he attributes
to it has not yet quite vanished. The archangel seems to
be floating down from a cloud in Heaven towards the bending
Madonna. The shining countenance, open mouth, as if in the
act of speaking, and attitude suggestive of the Annunciation, are
highly expressive. Four airy-looking genii appear upon the
cloud; one of them holds a lily, while two others in shade carry
on a joyous, frolicsome game with the archangel's wings. Mary
is peculiarly charming in the sweet embarrassment expressed in
her two-fold action; kneeling at her prie-dieu with her face half-
averted in graceful bashfulness, she turns a look of love and
desire towards the angel, while her hands are clasped over her
heaving bosom. The graceful movement of the two figures is
often repeated in later pictures of a similar import. We possess
no information respecting the origin of the painting.

The other painting, entitled the Madonna della Scala, is in
better preservation. Mary is represented with the child sitting
on her lap; both are in the most affectionate attitudes, and above
life-size. This work was probably originally placed over the
eastern gate of the town, called the Porta Romana, or else on the
exterior wall, or in a room in the gateway near the Church of S.
Michele dell' Arco. Vasari's way of speaking leads us to suppose
that he saw it in the old place, "over the gate." During some
architectural alterations made in the church in 1555, under the
Pope Paul III., the wall, which was left standing in consequence
of the valuable fresco painted on it, was used as a back wall to a

THE MADONNA DELLA SCALA.

PAINTED FOR THE CHURCH OF S. MARIA DELLA SCALA.

Now in the Gallery at Parma.

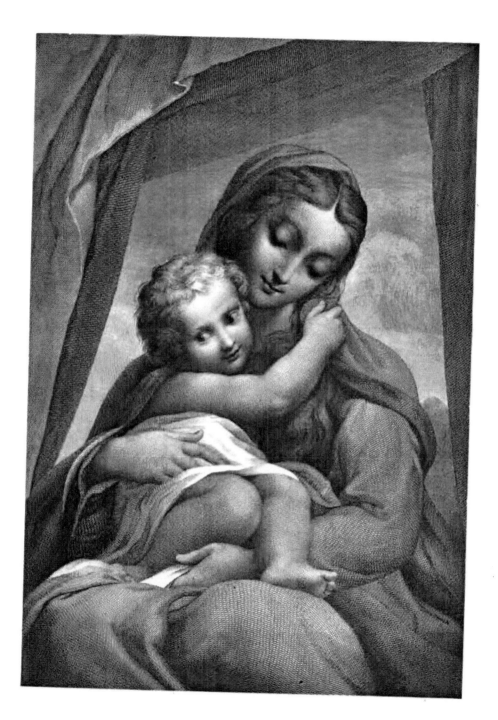

newly built little church. As the painting was carried up rather high, the building was also raised and steps erected to lead up to it, hence the name of the Madonna della Scala. In 1812 this little church was pulled down, and the painting removed from the wall with the greatest care by the architect Pietro Bicchieri, and with the permission of the French préfet, placed in the Academy. It bears many traces of injury, arising for the most part from the offertory gifts made to it in its character of altar-piece, such as placing a silver crown on the Virgin, which she wore as late as the eighteenth century. The tender playfulness of the Mother and Child and sweet Correggesque smile are rendered here in the most attractive manner by a few mastertouches. Vasari particularly praises in this picture the beauty of the colouring in the treatment of the fresco, and adds that the painting was always admired in the highest degree even by strangers who knew nothing of Correggio, and became acquainted with his works for the first time. This leads one to imagine that the painting must have been on the exterior wall of the rampart; which Vasari's words, " sopra una porta," taken in their strictest sense, appear to indicate; in that case, it would have been visible to every traveller entering on this side. The fact of Correggio having been selected to paint a picture which was intended as a protection to the town and a welcome to travellers, shows the great estimation in which he was held in Parma.

However matters may have gone with him afterwards, we have another and more signal proof of the high artistic position he enjoyed in Parma during the time he was engaged on the

works of S. Giovanni. In the autumn of the year 1522 he
received the commission from the Chapter of the Cathedral in
Parma to paint the choir (including the chapel) and the dome of
the Cathedral. Correggio appears only to have commenced this
work some years later, after he had finished the paintings in S.
Giovanni. A number of oil paintings, which we shall describe
presently, were also done previously to this date. But the agree-
ment was concluded with the clergy and architectural inspectors
of the Cathedral on the 3rd of November, 1522. It is specified
therein that " Antonio de Carigia " should adorn with paintings
on given subjects, with imitations of bronze or marble according
to the style required, everything pertaining to the dome, arches,
pillars, vaults, and niches, exclusive of the chapels, " according
to the place and the nature of the architecture, or the style
(*ragione*) and the beauty of the painting demand." The archi-
tectural inspectors engaged to pay the said Master Antonio
100 ducats for the decorative work of these paintings (pro-
bably in gold), and 1,000 golden ducats for the paintings
themselves. They also agreed to provide the scaffolding and
the plaster on the walls at their own cost. It is stated, on Cor-
reggio's part, " that having considered the work in question
which he was required to do, he felt that he could not for the
honour of the place, and their own honour (that is to say, for that
of the patrons as well as of the painter), accept less than 1,000
ducats ; " he also, in addition to other things, required the use of
a large room or closed chapel for the preparation of the draw-
ings. The manner in which his allusion to the payment is

worded inclines us to the belief that Correggio had, in the first instance, demanded a higher sum than the patrons would agree to. There is, moreover, still existing in Parma a document in the handwriting of our master, in which the sum of 1,200 ducats is specified; but it is erased and that of 1,000 put in its place. There appears, therefore, to have been some disagreement about the conclusion of the commission, but that Correggio at last gave way, or else was compensated in some other shape. According to Tiraboschi, the painter asked 1,200 ducats inclusively, and agreed to pay 100 out of it for the necessary gilding, but consented to 1,000 ducats for the whole work, and 100 for the expenses. We conclude, therefore, that Correggio took off 100 ducats. But even then the sum was very considerable for those days, and much higher than that which he received from the monks of S. Giovanni. According to the standard of the present day it would be about equal to 10,000 thalers.[1]

Such a demand on the part of Correggio shows that he had become perfectly cognizant of his own merits; while on the other hand, the agreement to pay the sum, with only a small deduction, proves that he was then considered the most important master in Parma. In accordance with the example of Rome and Florence and other large towns before them, the Chapter regarded the adornment of the Cathedral as a most important affair. We see this clearly in the extensive commissions for the ornamentation of their churches, which the clergy

[1] Or in English money £1,500.

confided to the best painters in Parma. In November, 1522, the
services of Parmigiano, Franc Maria Rondani, and Michel An-
gelo Anselmi were likewise engaged, and in December those of
Alessandro Araldi. This master was much older than Correggio,
consequently the three younger masters attached themselves to
him and painted more or less after his method, and as the chief
work was given to him, he was considered the chief master. We
shall see that, in the strict sense of the word, Correggio had not,
and could not, form a school; but he had his hangers-on and
imitators, and the youthful talent of the country developed itself
under his influence. This took place even in his own day, and
is a fresh proof of the high consideration with which the master
was regarded in the circle of his labours. That he could under
such circumstances have struggled with poverty is quite im-
possible; the myth is clearly disproved by the foregoing facts.

On the 29th of September, 1526, Correggio received seventy-
six ducats from the architectural director, as a remainder of the
payment of the first quarter of the stipulated sum. This,
according to the document, was 275 ducats, which, reckoning
the ducat at five lire, seven soldi, would constitute 1,400 lire.[1]
He had already received 189 ducats, probably early in the year
1526, when the work was commenced; for it was customary, in
matters relating to the painting of the church,[2] that every artist

[1] Tiraboschi, according to Affò, computes the sum at 1,471 Parmese lire and
five soldi.

[2] As shown by the contract with Giorgio Gaudini, called del Grano, dated
May 19th, 1536, for the painting of the choir, which Correggio had been unable
to complete.

should be paid a quarter of the sum stipulated before he ascended the scaffold and commenced his work. The second quarter was paid to him on November 17th, 1530. The paintings in the dome must consequently have been, at that time, in a fair state of progress. The paintings in the choir were never completed by our master. The reason why he left them in an unfinished state, we shall give later on. The clergy belonging to the Cathedral seem to have expected that they would have been finished ; for after the death of the painter, they laid claim to an indemnification of 140 lire from his heirs, in consequence of Correggio's having died without quite finishing the work in the choir. The master, however, received for the frescoes which he had completed in the Cathedral, 527 ducats. If we abstract the aforesaid 140 lire, equivalent to about twenty-three ducats, we may say 550 ducats, for it was not likely the above-mentioned sum was ever refunded. It is, moreover, a sum which corresponds to the conditions of the original contract, as only half of the work was completed. The agreement with Giorgio Gaudini, surnamed del Grano, in which the painting of the choir (Cappella Maggiore) is confided to him, proves that the architectural directors had counted upon Correggio's finishing the other half. The contract was drawn up on May the 19th, 1536, after Correggio's death. Gaudini undertook the work for 350 golden scudi (the scudo was equal to the ducat), a much lower price than that at which Correggio's services had been secured.

The frescoes in the dome of the Cathedral have suffered

much more than those in S. Giovanni, and are now hardly recognizable. Even in the eighteenth century artistic travellers complained that not one figure was in perfect preservation. According to Ratti's report they were not only injured by the smoke of the wax tapers, but had suffered by the dampness which had penetrated through the roof in consequence of the theft of the copper plating. Two documents, dated March 27th, 1533, and November 29th, 1538, which are still existing, prove that every precaution had been taken against such an injury by weather, by the covering of the roof of the dome with copper and lead plating, but this had been stolen.

The subject of the painting in the dome is the Assumption of Mary. Correggio depicts this incident at its culminating point, when the Virgin, borne aloft on luminous clouds by numberless angels, reaches the heavens, which are wide open, where she is received by joyous groups of angels and saints. The Archangel Gabriel comes boldly forward to greet her with a halo floating round him, suggestive of his having descended from an illimitable sea of light. The two are surrounded on all sides by endless hosts of angels, who, with music and exultation, come flying through the air in attitudes illustrative of the freest and most unconstrained action. Below, where the circumference of the dome widens, is a sort of parapet which appears to form an encircling socle to the dome. Here are depicted the apostles standing between the windows, mostly in groups of two. Their attitudes are quiet, and they gaze upwards towards the heavenly scene which is enacted before them with a

look of ecstasy. Behind them, on the upper cornice of the balustrade, are genii in the tender transitional age between boyhood and youth. They are placed in different attitudes and positions, and appear to act as ministering attendants at the portal of Paradise. They pour perfumes out of vases, swing censers, and hold candelabra. Lastly, in the four divisions of the dome stand the four patron saints of Parma, SS. John the Baptist, Thomas, Hilary, and Bernard. They likewise are carried upwards on clouds by genii; but their attitudes are suggestive of their ascending more slowly.

The masterly way in which the greatest difficulties, especially the drawing upon a domed surface, are almost playfully overcome in this representation, has elicited, at all times, the warmest admiration, particularly in the seventeenth and eighteenth centuries. "We find here united those qualities," observes Scannelli, "which the best masters usually only offer us separately. Antonio Allegri has given expression to the most divine idea that has ever emanated from the human mind." Mengs considered the dome to be the most beautiful that had ever been painted, and d'Agincourt held it to be a model of unattainable beauty. It has exercised even greater influence on the painting of the seventeenth and eighteenth centuries than the frescoes in the dome of S. Giovanni. The Carracci had already drawn attention to its merits, and the admiration with which these artists regarded it is best expressed by Annibale. " I remained transfixed with astonishment on seeing so great a work," he writes to Lodovico from Parma on the 18th of April, 1580, "so

well carried out in all its details—so excellently foreshortened from beneath to above (*di sotto in su*), with such austere accuracy, and yet delineated with so much delicacy, grace, and truthfulness of colouring exactly like flesh." It was, doubtless, the union of general technical skill with grace and boundless freedom of representation which won the admiration of these artists.

This artistic freedom, in conjunction with another quality, contributed to exercise an extensive influence over Art in the eighteenth century, and released it from the ecclesiastical severity and solemnity which distinguished painting up to the year 1500. For, although these forms ascend up to heaven in pious ecstasy, they appear to be animated by the most unconstrained joyousness of robust life. They seem as if they were about to burst open the dome, and fly out of the walls·of the church into the open air. No religious formality constrains the lightly moving limbs; and the drapery floating around them, far from disguising them, only increases, by contrast, the charm of the rounded, naked flesh. Correggio, indeed, with Michel Angelo, and even in a more signal manner than the latter, was the first to release Art from conventionalism. In the literal sense of the word, he struck off the last ecclesiastical fetters from her hands and feet.

But although in these frescoes Correggio's art appears to have reached its culminating point, the deficiencies inseparable from his mode of representation are very apparent. This enchanted land of floating figures is intended to appear as if the spectator saw in reality the scene before him. The system of

foreshortening from beneath to above is carried out here to its greatest development. We see little else but the legs and feet of some of these heavenly beings, depicted as if in active motion. The Madonna, not excepting her upturned face, is also much foreshortened. Almost everywhere the lower limbs appear drawn up to the bosom, and the noble beauty of the slender upper body is consequently lost. The grace and symmetry of the individual form are likewise destroyed. The arms and legs of the joyous beings who form part of the crowded groups which are supposed to be in full action, cross one another, and are huddled together in such a manner that it is almost impossible to make them out. This defect has already been commented upon, and gave rise to the tradition that some of the Parmese greatly blamed this medley of limbs, and characterized by it a saying, that was first set on foot by a mason's boy, that Correggio had painted nothing better on the dome than a hash of frogs (*guazzetto di rane*). The anecdote has been enlarged upon at a later date, and De la Lande relates in his "Travels in Italy" (1765, 1766), that Correggio, in order to escape this reproach, painted the figures in the dome of S. Giovanni much larger, less in number, and far more distinct. We know, however, that these frescoes preceded those in the Cathedral. Tradition also relates that the canons were very discontented with the painting, and would have had it all effaced, but that Titian, when he was in the suite of Charles V., happened to pass through Correggio (it must have been in the year 1530), and asked to see the paintings, and was so charmed with

z

them that he lost no time in convincing the priests of their error respecting them. According to another version of the story, Titian was the first to attract the attention of the Parmese to the beauty of the dome of their Cathedral. He is said to have exclaimed, " If you had filled it with gold you would not have paid what it was worth."

It is not unlikely, however, that the Parmese, either from religious scruples or from the prosaic nature ascribed to them by Annibale Carracci, may have taken offence at such an un- usual display of limbs and so new and bold a representation of a sacred subject, and the Chapter may in consequence have ex- pressed their dissatisfaction to Correggio. There certainly ap- pears to have been some misunderstanding between the two, as we shall see. But we have no positive account respecting it, and are uncertain whether the disagreement arose through the paint- ing, or merely had reference to some modification in the design.

The dome in the Cathedral is treated in the same manner as that in S. Giovanni in its monumental arrangement. The architectural space is broken through and the extension repre- sented as the vault of heaven, in which the joyous crowd of figures seem to rise up to illimitable heights. There is also some resemblance in the composition, only here the free floating figures are endowed with still greater appearance of life and action. Correggio has carried the expression of movement as far as it was possible in the individual groups and figures. This is very noticeable in the apostles and genii on the lower circle of the dome, whose participation in the Ascension ought to have

been of a solemn and spiritual nature. The enthusiasm of the apostles is evinced not only by the expression of their heads, but by their bodies and the fluttering of their garments ; and the boy genii fulfil their sacrificial duties with their supple limbs flourishing about in every manner of position. The boldness of the composition of this fresco greatly surpasses that in the dome of S. Giovanni. The master does not strive here, as in the former painting, to produce his effect with a few large figures, but depicts joyous groups of angels and saints, and hosts of heavenly beings who accompany or receive Mary, and seem multiplied *ad infinitum;* while quite alone in the middle of the boundless field of light, the Archangel comes floating down to meet her. It is impossible to make out clearly the figures and groups in the large middle picture, and this has, doubtless, given rise to the satire of the "hash of frogs." The artistic effect is produced by the masses of light and colour, while the eye, wandering through this tumultuous host of hundreds of beautiful forms, is charmed first by one and then the other. We are delighted by the grace and realistic appearance of these floating youthful forms, and fascinated by the variety of their movement. Here as elsewhere the truthful delineation of real life seems to militate against the ideal character of the representation. The full rounded proportions of the forms are depicted with illusive reality, while the impression produced by their shining limbs is almost intoxicating to the senses.

But the charm of the light which plays around them restores the purity of their beauty. Greatly as the painting is spoilt in

the present day, the effect is still wonderful. The arrangement, as regards the setting of the figures against the clear background with the light quivering through the darkness, is the same as in the painting in S. Giovanni. The pulses seem to beat in this transparent flesh, and the light penetrating through the shadows pours the warmth of life over the bodies. It is, nevertheless, undeniable that there is a certain sensuousness in the conception.

This host of genii and angels, blooming boyish figures who unite the unconstrained joyousness of life with the beauty of immortal youth, are the very embodiment of pleasure and beatitude. " Inexpressible joyousness and smile of paradise as Antonio can alone depict it," remarks Scannelli with regard to the dome in the Cathedral ;[1] and Annibale Carracci writes : " Correggio's genii breathe, live, and laugh with such a grace and reality, that one feels ready to laugh and rejoice with them. In reality, maidens and boys have never been depicted so naturally and almost sexless, so full of real life, and yet representing ideal youthfulness and health. Not less charming than these graceful forms are their curly heads, and the sweet child-like expression of their faces. Truly they may be called God's own children."

The apostles, on the other hand, testify to the master's inadequacy to the representation of the solemn and sublime. Their agitated bearing is not in accordance with that repose of demeanour with which Correggio ought to have invested them, and the variety of their positions makes them appear wanting

[1] " Allegrezza indicibile, e riso di Paradiso, che il solo Antonio per ogni parte, ed in ogni tempo allegro ha saputo sopra d'ogni altro esprimere a maraviglia."

ANGELIC CHOIR. (II.)

In the Cathedral, Parma.

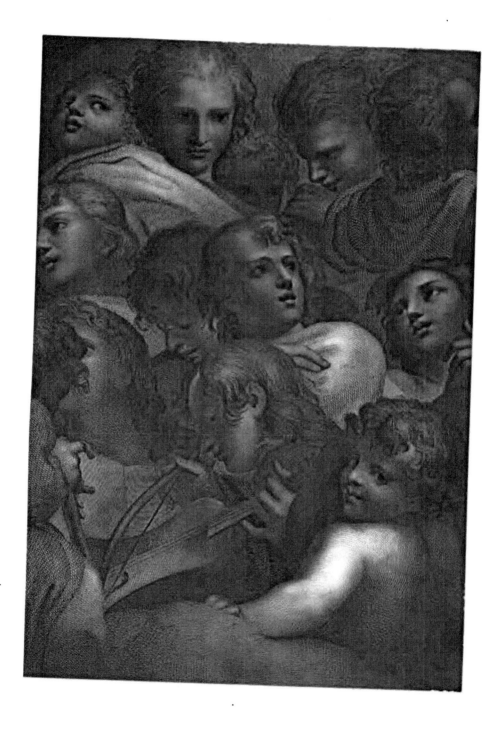

in dignity, while the boldness of their action is deficient in simplicity.

The painting in the dome has given rise to the interesting question as to how far Correggio was acquainted with sculpture. The illusive degree of reality with which his figures stand out round and full from the painted surface, is not attained by foreshortening and modelling alone, but rather by a masterly observance of the changeful play of light and shade. Owing to the difficult position in which the figures are placed, it is impossible that he could have sketched them from life. On the other hand, great as his knowledge of the human form must have been, it seems impossible that he could, unaided, have depicted such bold, free action. It has been thought that Correggio modelled his forms out of clay, and then placed them in the required light. But this necessitated a thorough acquaintance with plastic art. The supposition—for it was nothing more—has likewise been put forth that our master was acquainted with the well-known sculptor, Begarelli, of Modena, who also worked in Parma, and that they mutually aided one another. As far as we know, Scannelli was the first to start this hypothesis, without, however, naming Begarelli; he only mentions it as a report that Correggio obtained small models from a friend, who gained his livelihood by sculpture, and by these means perfected his talent, and was enabled to produce such excellent paintings. Soon after, Lodovico Vedriani amplified this report in his short biographies of Modenese artists; but whether he had any grounds for so doing, or whether it was only an idea of his own, does not

appear.[1] He states that "Correggio was in despair as to how he should represent such a number of figures in the dome; for it was impossible to place men, women, and children in the positions requisite for the foreshortening. So Begarelli encouraged him, and moulded figures for him in the necessary gestures and attitudes so well, that Correggio, having placed them in the right light, and given them the requisite foreshortening, was enabled to paint them, and having been assisted in this wonderful manner, rose to immortality." According to Vedriani, the genii with the candelabra behind the apostles in the encircling frieze, were also modelled by Begarelli in clay before Correggio painted them. It would be superfluous to show the error of this assertion; he who cannot discern the individual character of the master in the invention, delineation, and attitudes of these figures, has no eye for Correggio. Vedriani appears to have had no other reason for making the assertion, except the glorification of his countryman, who was certainly an excellent modeller. It is not only possible but probable that Begarelli may have assisted Correggio in preparing his models for painting; but certainly only in working from his designs, and under his guidance. Other facts are also brought forward to show that Correggio was a sculptor as well as painter. He is said to have himself modelled in clay for Begarelli three of the statues in the Descent from the Cross (at present in San Domenico in

[1] "Raccolta de' Pittori, Scultori, et Architetti Modonesi." Modena, 1662, p. 50.

Modena). This statement, again, seems to have been put forward by Vedriani. Richardson also considers these clay figures to have been executed by Correggio, and enters into closer particulars by informing us that it was Mary supported by women that was the work of our master, and these figures were much better than Begarelli's.[1] When the whole group was removed from its original place, it is further stated that the letters A. A. were found engraved in the arm-pit of St. Jerome; so, according to that, this statue also must have been executed by Correggio. The assertion is, however, unsupported, and the contemporary chronicler, Lanzilotto, ascribes the whole of the work to Begarelli. Certainly the modelling of the figures offers no indication of different hands. The two letters A.A. are not discoverable in the above-mentioned place; but Borghi, the restorer of the group, found the same signature on the book held by St. Jerome. But even so their signification remains very doubtful. The co-operation of the two masters has, however, been often affirmed. Even Cicognara and Mengs are of opinion that Begarelli must have assisted Correggio in getting up his models for the painting in the dome.

But all this testimony reposes on the uncertain statement of Scannelli, and, consequently, is without importance. Whatever opinion one may hold with respect to the connection between the two artists, there is undoubtedly an unmistakable likeness in their styles. Begarelli as sculptor, is naturally firmer and more

[1] " Description," &c., ii. 675.

decided in his representation of form; but he gives an idea of movement like Correggio, and possesses the same graceful qualities. They must have been well acquainted with each other. According to the existing documents, Begarelli worked a good deal in Parma, only at a later date. He executed in the corner of the vault, in the shape of a cross, four statues in the same dormitory of S. Giovanni, where Correggio is said to have painted St. Benedict in one of the little domes. It is more likely that our master should have influenced Begarelli, who was about the same age as himself, than that Begarelli should have influenced him. Correggio certainly modelled in clay—almost all painters understood the art in those days—and he undoubtedly left no means unturned that could conduce to the attainment of mastership in art. He no doubt made models himself, and as he required a great number for his flying genii, Begarelli may have helped him. We are also informed that Mantegna used models prepared by himself in order to help him to foreshorten on a flat surface, understand the fall of the shade, and make his figures stand out prominently in the light. Models were highly necessary to Correggio to enable him to render, with desirable effect, the free, unconstrained attitudes of his figures, and the play of light. It is unlikely, however, that he should have executed finished figures for the friendly sculptor's group, and, above all, have modelled sculpture in clay which was intended to be permanent.

There is also evidence in a document which was found in the Church of the Madonna in Parma, called the Steccata, of his

having some acquaintance with architecture. According to this
document, which was drawn up on the 26th of August, 1525,
the congregation of the old church had summoned seventeen of
the most celebrated artists in the country, with Antonio Allegri
at their head, to a council, in order to deliberate as to how the
impending danger resulting from the cracks in the wall of the
newly built church was to be encountered. In the same docu
ment, our master, together with the little known sculptors Filippo
da Gonzale and Marc Antonio Zucchi, received a commission to
design some beautiful ornaments for the altar of the Madonna.
This commission also proves what a distinguished position
Correggio must have held at this time in Parma.

Pater Resta has also attributed to our master a considerable
share in the buildings in Parma, particularly in the Church of S.
Giovanni, but this is entirely without any foundation, for the
architect of this church was Bernardino Ludedero. It is less
probable that Correggio should have studied architecture than
that he should have prepared models with Begarelli. He was,
moreover, deficient in the requisite knowledge and culture.
The independence of the two arts of painting and architecture
which he was the first to bring about, thereby confining each
artist to his own particular kind of art, carried painting to its
highest development, but was necessarily a loss to the other art.
He certainly shows some knowledge of architecture in the archi-
tectural surroundings of some of his Madonna pictures, but
whether he could have undertaken to plan a building is quite
another question. The cultivation of painting in combination

with architecture, as we see exemplified in the works of Raphael, had become more and more neglected. The Venetians give sufficient evidence of this, although they are very successful in the architectural backgrounds which decorate their pictures. We shall see later the effects of the disunion of the two arts.

CHAPTER VIII.

Altar-pieces of the period when Correggio's art had attained its Highest Development.

La Notte.—S. Sebastian.—Madonna della Scodella.—S. Jerome.— S. George. —The reading Magdalen.

IN the beginning of the year 1524, Correggio, after he had completed the works in S. Giovanni, painted several oil paintings while he was engaged on the frescoes in the Cathedral, which may be reckoned among his best works. One of these had been ordered some time previously by Alberto Pratonero of Reggio. The document in which our master engaged himself to fulfil this commission, dated Oct. 10th, 1522, is still in the possession of the Marquis Giuseppe Campori, in Modena.[1] In this document, the patron agrees to give Antonio da Correggio, painter, 208 lire, according to the old Reggio standard, in payment of the work representing the birth of Christ, and a few figures of the size of

[1] Given in Bottari, " Raccolta di Lettere ;" Tiraboschi, Pungileoni, and other writers.

those in the drawing which the master Antonio da Correggio
had submitted to him, "the whole to be done excellently well."
There is also a codicil engaging to pay 40 lire of the old stan-
dard on the same day, and a receipt in Correggio's handwriting
testifying to having received the same.

The sum stipulated to be paid for the picture has generally
been considered extremely mean, and certainly it is very low in
proportion to other prices that Correggio received for his paint-
ings. But owing to the insufficiency of our knowledge respect-
ing the value of the ancient lira of Reggio, it is rather difficult to
estimate what sum in our day the price represents. Antonio Gras-
setti, librarian of Modena, in a letter to Gherardo Brunario,
of March 29th, 1716, computed it, according to certain infor-
mation, at about 50 golden scudi, and did not consider the sum
by any means small, as in those times a painter would, in his
opinion, hardly have been remunerated higher by private indivi-
duals. This is an error ; nevertheless, the price was not extra-
ordinarily small, and undoubtedly would not have been paid to
an unknown master. Tiraboschi comes to the same conclusion,
deriving it from Antonioli's treatise on the coin of Correggio.
According to that, the golden ducat was worth in 1522, 4 lire,
7 soldi and 6 denare, current coin of Correggio, which was about
the same as the old standard of Reggio. Consequently these
208 lire were equal in value to 47 golden ducats or $\frac{1}{2}$ zechini,
3 soldi and 9 denare. Such a price, according to Tiraboschi's
opinion, though not in accordance with the value at which the
master's works were estimated in his time, was not very much

out of proportion to the payment which Correggio generally received in his own day. De Brosses, according to the information he obtained at Modena, considers the sum to be about 600 French livres, and Guhl estimates its highest value to be from 136 to 140 Prussian thalers. The three estimates coincide very fairly, only Guhl has depreciated its value rather than the reverse. Taking into consideration the difference in the value of money now, compared to those days, we are of opinion that the price was as high as could have been expected by a master of moderate reputation. Correggio, however much he might have been looked up to in his own circle, and among his brothers in art, did not enjoy, during his life time, the reputation of a master who could command his own price, however exorbitant. Moreover, when he received this order he had not been favoured with the commission for the dome of the Cathedral, nor any other commission of importance, so he may have been all the more ready to content himself with a small price. But the long space of time before it was delivered proves that he could not have hurried over his work, possibly in consequence of the smallness of the payment. At all events, the picture was not placed in the chapel of the Pratoneri in the Church of S. Prospero, at Reggio, till the year 1530. An inscription, which was still preserved in the chapel at the beginning of this present century, testifies to this: ALBERTVS ET GABRIEL PATRONERII HÆC DE HIERONYMI PARENTIS OPTIMI SENTENTIA FIERI VOLUERUNT AO. MDXXX. It referred as much to the foundation of the chapel as the painting.

This work, known under the name of " La Notte," or the Night, is now in the Dresden Gallery. It represents the newly born Child in the midst of the shepherds in a peculiar flood of light, which has rendered the picture up to this time a subject of particular admiration. The event is supposed to take place in a dilapidated building almost open to the landscape, about the break of day, when the first rays of dawn are softly perceptible on the horizon. The Child, who lies in the manger upon a bed of straw, is affectionately held in both arms by Mary, who is kneeling before him, while an old and a young shepherd and a maiden regard him with admiration and wonder. Joseph is more in the background with the ass, and a little further on are several shepherds sleeping. In the upper corner to the right a host of winged angels are rejoicing and adoring as they fly downwards. Both the figures themselves and the composition of the work are as simple as possible. The especial charm of the picture consists in the light, which is made to proceed entirely from the Child, and next to this is the very graceful head of the Madonna, who is bending over her Babe. The light, which falls strongest on the immediately surrounding objects, grows by degrees fainter and fainter as it falls in the distance, till it is lost in the obscurity around. The idea of making the surrounding figures illumined by the light emanating from the Child is not a new one, as has been generally thought. In the well-known triptych of Hugo Van Goes in S. Maria Nuova in Florence, the centre picture of which also represents the birth of Christ, the angels flying in the shade are in the same manner lighted up by the rays proceeding from

THE ADORATION OF THE SHEPHERDS.

("*La Notte:*" "THE HOLY NIGHT.")

In the Dresden Gallery.

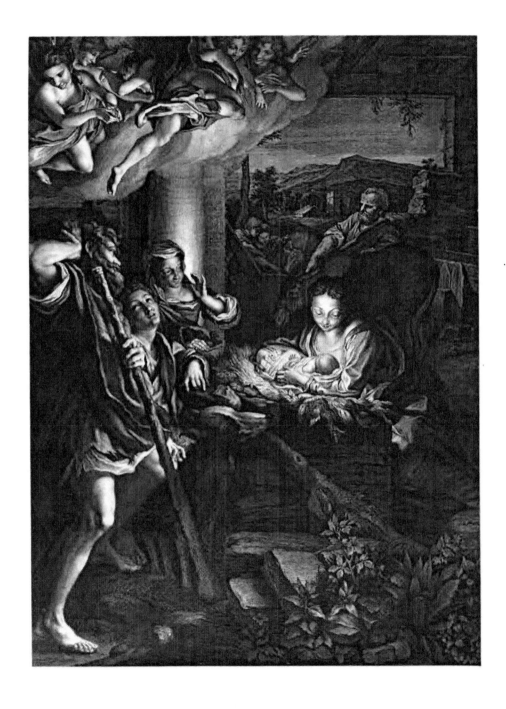

the Infant Jesus. But the manner in which Correggio has man-
aged the light, making the Child the brilliant focus from whence
it is emitted, is thoroughly original. The surprised attitude of
the maid, holding up her hand before her eyes as if she could
not bear the brilliancy of the light, proves that Correggio consi-
dered this himself to be the main point in the picture. It mat-
ters little whether he was acquainted with the apocryphal gospel
(Protevangelium Jacobi), in which Joseph returns home and finds
the new-born babe, and sees the rays which proceed from him
lighting up the countenance of the mother, or whether, as many
have wrongly supposed, he meant to signify the light of the
Christian religion. His primary object was undoubtedly the
artistic play of the light. It is, however, worthy of note
that the picture does not belong to the usual style of so-called
night pieces. The effect of the light is not in the least like
that produced by the lamps and wax-lights commonly used
in modern German and Italian pictures, but it is a white,
brilliant light of a peculiar character, streaming as it were
upon the new-born babe from an enchanted or ideal world, and
the effect is very marvellous and powerful. Very charming and
a real infant is the delicate little Babe lying on the linen, also
the half-illumined angel in chiaroscuro, whose action is free
almost to extravagance. The smiling, bending countenance of
Mary is one of supreme loveliness; but the remaining figures are
common and almost vulgar. The elder shepherd is a genuine Lom-
bard peasant of the stout sort, and the maiden with the gesture
of astonishment possesses every trait indicative of her station.

There is not a vestige here of the holy signification of the
subject, or of devotional solemnity. The people are copied
from real life, such as the painter had been accustomed to see.
Any symbolical meaning conveyed by the light is destroyed
through the girl holding up her hand to shade herself from
its brilliancy.

This opinion is certainly not in accordance with the unquali-
fied admiration which has been bestowed at all times on this
painting of Correggio's, above all in the eighteenth century. It
has been constantly the theme of enthusiastic praise in the numer-
ous descriptions of art-loving travellers. Even Lomazzo, who is
rather lukewarm in our master's praise, characterizes it as one of
the most wonderful of pictures. Vasari describes it very fully, and
appears much struck with the maiden who is holding her hand
before her face, as well as with the angel hovering over the hut,
" who appears to have proceeded rather from Heaven than a
painter's hand." He was above all captivated with the realistic
character of the composition. The management of the light
seems to have worked a truly magical charm upon later critics.
" Pardon, divine Raphael," exclaims De Brosses before the picture,
" if none of thy works have charmed me as much as this one : "
according to him, " Peter in Captivity," in the Vatican (with a
similar play of light), could not compare with " Night." Mengs
also bestows the highest approbation upon it, and appears to rank
it higher than any of the master's works. He rightly remarks
that Allegri used every means of producing a charming effect, as,
for instance, the deeply bending attitude of the Virgin, which was

necessary, so that the light should fall in such a manner as to prevent the upper part of her face being in shade.[1] In Dresden it is considered the most beautiful and valued painting of all those which were obtained from the Duke of Modena. Wonderful things also are related of it. It is said that, when illumined

[1] To these enthusiastic criticisms may be added that of our English artist Sir David Wilkie, who saw the picture in 1826, during his travels on the Continent, before it was cleaned and restored by Palmaroli. He writes of it thus:—" But the ' Notte' of Correggio is what I expected most from, and the condition of which gives me the greatest disappointment. Yet how beautiful the arrangement! All the powers of art are here united to make a perfect work. Here the simplicity of the drawing of the Virgin and Child is shown in contrast with the foreshortening in the group of angels—the strongest effect with the most perfect system of intricacy. The emitting the light from the Child is, perhaps, the most bold, as well as the most poetical idea that the art has ever attempted; and this, though a supernatural illusion, is in this work eminently successful: it neither looks forced nor improbable. The light, unlike that of Rembrandt, does not imitate lamp-light; it is meant to be the pale phosphorescent light, as in the ' Christ in the Garden.' The flesh of the Virgin and white drapery of the Child are principal; the mantle bright blue; the bodice bright lake; and the sleeve lilac. The colours in the lights and half-tints are chiefly cold, and all the warm tints are in the shadows, which preserve throughout a rich colour. The least successful part of the picture is the character of the shepherds—inferior to the subject and to Correggio's general run of figures. But this great work, though shorn of its beams from the treatment it has met with, is, in its decay, still not less than an archangel ruined. It is in idea the most original and most poetical of all Correggio's works."

Happily we may form some idea of this " archangel ruined " from the numerous excellent engravings that exist of it, which will preserve its fame even when the original shall have entirely disappeared. There are two or three reputed original sketches for this picture in different collections, one, a very rough little drawing in the British Museum. Kugler, in the " Kunstblatt" for 1838, spoke in high terms of praise of a small and highly finished study for the " Notte" then in the possession of a private gentleman of Berlin. Dr. Meyer, however, considers this work to be only a copy.—ED.

B B

with torches, all sorts of figures appear in the shade of the background which are not otherwise visible.[1]

It was the spiritualizing effect produced by the light, which was not only rendered in the most masterly manner, but seemed to emanate from the picture itself, which, combined with the rare beauty of both mother and Child, made this picture a very triumph in art! This mysterious power comes out all the stronger in contrast with the realistic character of the scene and the homeliness of the shepherds. Added to this we have the charm of the chiaroscuro, which is portrayed so forcibly that even an unpractised eye could scarcely help being struck by its beauty.

There is another picture in the Dresden Gallery, "The Madonna of S. Sebastian," which, although ordered at a later period than "Il Notte," was finished sooner. The commission for it was given to Correggio by the Brotherhood of S. Sebastian, an archery company in Modena, in the year 1525, as some allege in fulfilment of an oath made after the plague had visited that town.[2] This idea, doubtless, originated in the circumstance of S. Sebastian being selected, who was the Saint to whom such oaths were addressed, but the name of the Brotherhood is quite sufficient to explain his being chosen.

[1] This fable was first circulated by Alf. Isacchi, "Relationi intorno l' originale solennità, Translationi et Miracoli della Madonna di Reggio." Reggio, 1619. 4. The Madonna di Reggio is the "Notte," which painting is fully discussed in this very strange pamphlet.

[2] Lodovico David, Mengs, and more recently Martini, entertained this idea.

The picture was painted for the altar of the Chapel of S. Geminianus in the Cathedral at Modena, which was finished in 1525. It is one of Allegri's most beautiful creations. Mary is represented, enthroned in an easy sitting position upon clouds, with a naked little Boy on her lap seen in front view, in a flood of warm light, gradually toned down into a bright haze, out of which appear delicate angels' heads. She is surrounded as it were by a half-wreath of genii, who carry on a merry game in the clouds beside and beneath her, or point with child-like joyous devotion to the Infant Jesus, or bend down towards the group of saints consisting of a naked S. Sebastian, a blooming youthful form who is tied to a tree with bound hands, but who half turning round gazes up to the mother and Child with a charming expression of face.[1] At his feet is a beautiful young maiden, half reclining and but little draped, holding the model of the cathedral in her hands. On the other side is S. Roche, a bulky figure in a pilgrim's dress, leaning against a stone sleeping ; his powerful limbs have fallen during repose into the most natural attitudes. In the centre, between the two, kneels the bald-headed S. Geminianus in a magnificent voluminous bishop's cloak, half turning to the Madonna and pointing up to her with one hand, while the other, as well as his glance, is directed towards the congregation.[2] In spite of this twofold movement the figure is

[1] This noble figure of S. Sebastian, with its expression of utmost adoring love, is one of the most perfect creations of Correggio's art.—ED.

[2] When a saint is represented in this attitude, he is supposed to be drawing the attention of the spectators to the Virgin, or interceding for them, as is the case

the calmest of the group. Correggio has not succeeded in uniting dignity and enthusiasm here any more than elsewhere. The action is otherwise well balanced, and the effects produced by the wonderful play of light and chiaroscuro as charming as ever. The Infant Jesus in rays of glory is almost in full light, although a little deeper in tone. From him the light proceeds in gradations to the surrounding figures, and is softened off, till it blends with the luminous shade. It is brighter on S. Sebastian, darker on the child with the church, and falls with greatest charm on the countenance of Mary. The broad masses of local colour harmonize powerfully with the different effects of light on the flesh, namely, the red dress and blue cloak of the Madonna, and the green of that of S. Geminianus.

There is a certain solemnity in the arrangement of the picture, Mary sitting high enthroned amongst the clouds with the groups of saints at her feet; but the prevailing characteristic of Mary and the sprightly Child, and the genii playing around her, is that of loveliness. The sweet modest maiden reclining at the feet of S. Sebastian, the guardian angel of Modena, has always been considered one of Correggio's most charming creations. Scannelli praises her grace, amiability of expression, and modest smile which surpasses every other charm.[1] The young girl at that tender transitional age between childhood and youth is certainly one of the most interesting little beings imaginable. She

with St. Sixtus in the Madonna di San Sisto, and St. Francis in the Madonna di Fuligno.— ED.

[1] "Microcosmos," p. 290.

THE MADONNA AND HOLY CHILD

ENTHRONED IN CLOUDS.

S. SEBASTIAN, S. GEMINIANUS, AND S. ROCH.

In the Dresden Gallery.

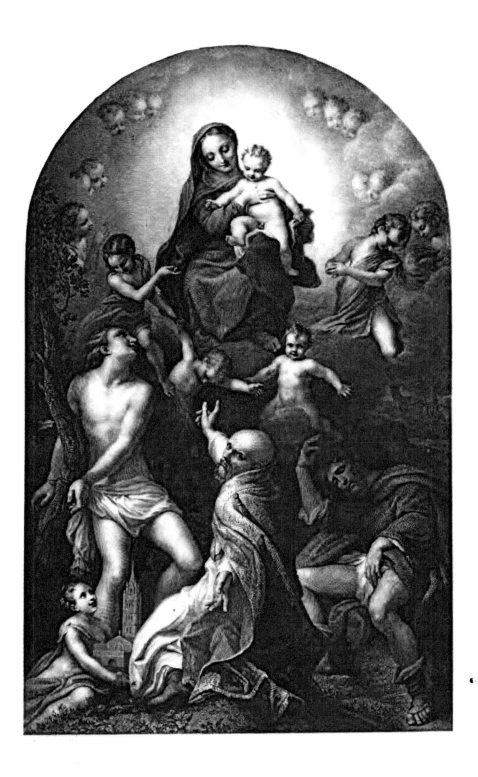

seems wholly ignorant of the sacredness of her calling, and looks full of joyous, innocent mischief, quite unconscious of the beauty of her soft, ripening form. The laughing angel-boys, who surround the Virgin, also look wanton enough, although one has his hands folded in prayer. Two of them tumble among the clouds as if they were toys, and another sits astride upon one of them, as if he were on horseback. The picture has consequently been jestingly and with a slight admixture of censure compared to a riding-school. We shall not, however, quarrel with the master for making the sacred character of the incident a vehicle for sport and frolic.

Next comes the so-called " Madonna della Scodella," in the gallery in Parma. According to Pungileoni, this was commissioned in 1526 for the Church of the Holy Sepulchre in Parma (S. Sepolcro), the expenses being defrayed by private persons. Allegri appears to have executed and completed it between the years 1527 and 1528, according to a document which Pungileoni found among the archives of San Salvatori, in Parma. The inscription on the frame, "19th of June, 1530," must in that case be erroneous, unless it refers to the day when the painting was put in its intended place. That it was paid by voluntary contributions is proved by the will of one Christopher Bondini in the year 1524, who bequeathed 15 lire imperiali towards the payment of the altar-piece of S. Giuseppe, so called in consequence of the chief figure in the painting being Joseph. The books of the convent also testify to the master having received part of the remuneration in " different kinds of things."

The painting, in almost life-sized figures, represents the Rest after the Flight to Egypt. The Holy Virgin is seated on the ground under a palm-tree in a charming landscape, and holds sideways with one hand a plate (hence the name of the picture), in order either to give it to an angel who is cowering among the foliage on the margin of a brook, or else to keep it playfully out of the reach of the Infant Jesus. A little further back stands Joseph on a slight eminence, with one leg higher than the other, which is foreshortened in the most masterly manner. Leaning slightly forward, he pulls down with one up-lifted hand the branches of palm, and gives the Child the fruit with the other. Four or five lightly moving genii, half hidden among the branches of the tree, appear to be assisting him. Christ, who is reclining sideways upon his mother's lap, turns round his head and reaches out for the fruit in the easiest and most graceful attitude, while he clasps Mary with the other hand. More in the background, and almost hidden by Joseph, a boy genius—angel we can scarcely denominate this jovial being—is tying the mule to the trunk of the tree. The theme of the picture appears to be the legend from the apocryphal gospel,[1] according to which a date-tree bowed itself down to the weary Holy Family, and offered its fruit, while from the dry earth sprang forth a fountain. Correggio has created the most charming idyll out of this tradition. There is much more ideality here, expressed

[1] " De Infantia Salvatoris," s. " Codex apocryphus Novi Testamenti collectus J. A. Fabricio." Hamburgi, 1719, i. 187.

in the figures and arrangement of the sacred scene than in the
" Night." The picture is joyous throughout, the action moderate,
and the whole bathed as it were in sunlight. Clear and brilliant,
with the softest transitions from light to shade, the forms stand
out from the dark background of wooded landscape, the prevail-
ing tone of which is a rich greenish brown. The Madonna, a
beautiful ripe brunette, rather a girl than a woman, expresses the
warmest love in her eyes and the graceful turn of her head.
The fair Infant Jesus, a charmingly mischievous little fellow
without the slightest pretence to Divinity, looks almost modern
in his somewhat roguish amiability. Joseph, also, who in most
of the paintings of the cinque cento is represented with a
morose, submissive seriousness, has the appearance here of a
happy, jovial man. Correggio has released him from the burden
of an ambiguous position and superfluous spectator, which is
the rôle he is usually made to play.[1] Everything seems to
express enjoyment of mere existence and the pleasures of a
life free from care, and the frolic of the genii is in perfect har-
mony with the joyful character of the scene. And, although
the incident is portrayed with so much reality, it still remains

[1] Sir Charles Eastlake remarks of this figure of Joseph : " The old man Joseph,
without having anything repulsive in his appearance, and with a head and expres-
sion sufficiently agreeable, is, however, far from being happy in the *tout ensemble*.
There is something unpleasant in his dress, and in the arrangement of his drapery,
and certainly a want of dignity. . . . The two boy-angels, the Virgin and the young
Christ," he goes on to say, " are, however, extraordinary specimens of expression,
and create that delight that perfection alone can communicate."—*Literature of the
Fine Arts*, second series.—ED.

a fable inclosed within the realms of the world of pure pictorial fancy.

The picture has suffered a good deal in general harmony of tone, although it is not quite as much spoilt as was formerly stated. The azure tints seem to have been partly rubbed off. Enough, however, remains of the beauty of the painting to enable us to see the charming effects of sun and colour it must once have possessed. The rich blue garment of Mary, contrasted with the lustrous brownish green of the trees, the sober green of Joseph's dress, the brilliant chrome-yellow and orange of the drapery, and transparent lustre of the flesh, although somewhat faded, still constitute a charming effect.

Although the altar-pieces we have just described belong to the period when Correggio's artistic talent had received its highest development, and may be reckoned among the best productions of the cinque cento, they are, nevertheless, surpassed by the "S. Jerome."[1] This is a work that unites the most perfect grace with a truly enchanting pictorial effect, and is one of the greatest masterpieces which painting has produced. It is at present in the Gallery in Parma.

This picture was commissioned in 1523 by a certain Donna Briseide Colla of Parma, the widow of one Orazio Bergonzi, for the price of 400 lire imperiali. So, at least, we are informed by early authors, who testify to having found an account of the

[1] Called also "Il Giorno," or the Day, because of the full daylight that streams down upon the picture, and also, probably, to distinguish it from "Il Notte," the Night.—ED.

transaction in the archives of the Church of S. Antonio Abbate in Parma. The document had disappeared in Tiraboschi's time, and could not be found anywhere. We have consequently no further authority for its authenticity. There is, however, no reason for doubting the assertion. The report informs us, moreover, that the lady was highly pleased with the work when finished, and made the artist several presents, which, according to his own request, consisted in two cart-loads of faggots, a few bushels of wheat, and a pig! This information shows us the narrow, bourgeois circumstances in which Correggio must have lived, although he might have been by no means poor. He was satisfied with such a substantial addition to the stipulated price for one of his most beautiful works, at a time when contemporary artists in other places held a distinguished position among the rich and great. The sum paid for the picture was by no means small. Tiraboschi reckons it at 80 scudi, as formerly 5 lire went to the scudo, and it is in accordance with the price which Correggio received for the frescoes in S. Giovanni and the Cathedral. The sum is almost double that which he was paid for the "Night," and belongs to the highest prices that he obtained for his easel pictures.

The time when Correggio executed this work, for which he received the commission in 1523, can only be stated approximately. Bottari informs us in his edition of Vasari that a sketch of the painting was found in private possession, dated 1524, which makes it probable that the picture was completed soon after; but the statement has no other evidence to support it, and

is consequently doubtful. Pungileoni considers that the work
was painted about the year 1526, but gives us no reasons for so
thinking. When the dame Colla disposed of her property on
the 5th of April, 1528, she bequeathed this picture to the
Church of S. Antonio Abbate, for which from the first she had
destined it as a votive offering; it was most likely placed in the
church about that date. It was probably finished, at the latest,
at the beginning of the year 1528, and as, according to the
document we have already referred to, Antonio took about six
months over it, it must have been begun in 1527. It certainly
belongs to Correggio's best time, beginning from the year 1525,
and even exceeds the Madonna of S. Sebastian in beauty; we
may, therefore, consider ourselves justified in believing that it
was produced between the years 1527 and 1528.

Under a red cloth, spread out over the branches of a tree
in tent-fashion, Mary is represented sitting in a blooming land-
scape with a naked Infant Jesus on her arm. To her left is the
Magdalen in a half-kneeling attitude before the Child, who is
playing with her hair. Her head is leaning over his foot, while
her hand is supporting it as if she were about to kiss it; behind
her stands a boy with a box of ointment. On the other side of
the Virgin turning towards the Child stands S. Jerome, a power-
ful figure with a long beard, and no other drapery than a cloth
bound round his hips. In his left hand he carries a book supported
by an angel standing between him and the Madonna, and to
which the Infant Jesus points.

As may be seen, the invention is insignificant, and the com-

position simple. It is only in the action that there is anything out of the common. And yet this picture, compared even with the great master-works of Raphael and Michel Angelo, is in the highest degree captivating and charming. It is in speaking of this picture that Annibale Carracci expresses his great admiration for Correggio, comparing it to the S. Cecilia of Raphael, which he had seen shortly before; but he finds the S. Paul of the latter, which he previously regarded as a wonder, to be wooden and hard after that "beautiful old man," S. Jerome. This latter figure, he says, is "graceful as well as grand." But this is somewhat going beyond the bounds. S. Jerome is wanting in the serious earnestness of manly dignity which constitutes nobleness. He is in reality the weakest figure in the picture. Annibale was doubtless charmed with the flexibility of the limbs, variety of movement, and the masterly way in which it is painted. But, although Carracci selected this particular figure in consequence of its possessing the ease and grace of the Correggesque manner, he was doubtless influenced by the charm of the whole picture, and this is indeed so great that one feels well disposed to overlook a few short-comings; the flood of light which is thrown over it penetrates everywhere, illuminating the deepest shadows and softening off the half-shades, bringing out the rich tints of the local colour, particularly the brilliancy of the drapery (sometimes almost too powerfully), and then melting again into the light, glimmering tone of the whole. All this is expressed with such wonderful truth, that the work has with perfect justice been styled the "Day." The open,

bright day shines in it, as in reality, with its fairest light. The name would be suitable if Correggio had never painted its companion "Night." And the effect is all the greater, as this, of all the master's works, is the best preserved, and we are enabled to realize the charm of the original freshness of his paintings.

That which deepens the impression made by this work is the manner in which the light harmonizes with the grace of the female figures, the Infant Jesus, and the angel. The master himself has not excelled this in any of his paintings. It is softened off into chiaroscuro in the Child, who, full of spirits and childish frolic, is sitting in riding fashion on Mary's arm, while in her it brings out the charming expression of holy sentiment.

But nothing can equal the indescribable loveliness of the Magdalen in this picture. Travellers from Rome even, whose minds are full of the deep impressions made by the many creations to which painting has there given birth, stand in wonder before this picture, overpowered by the exceeding grace of this form. Any unprejudiced person would exclaim, "It is the perfection of painting; nothing more beautiful has been produced." No work of the cinque cento, not even the "Madonna" of the Sistine Chapel, produces this peculiar, and, at the same time, fascinating and overpowering effect. Even antique art offers us no production of Grecian sculpture of such beauty and perfect finish as this, achieved in painting, the art of modern times. Whoever chooses to study it, compare it, and pull it to pieces, and to say it is deficient in the depth of Leonardo, the harmonious symmetry of Raphael, the power of Michel Angelo, and that its very grace belongs to a

THE MADONNA AND HOLY INFANT.

S. JEROME: MARY MAGDALEN.

(" *Il Giorno :*" "THE DAY.")

In the Gallery at Parma.

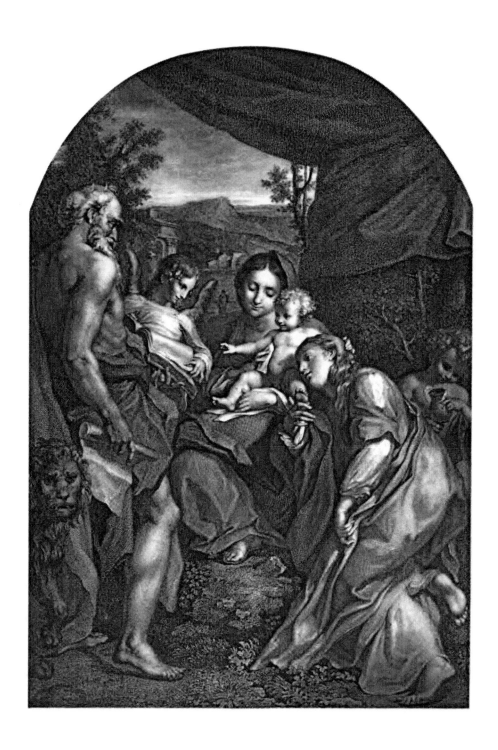

lower style of beauty, that man's eyes are closed to the real meaning of art. He will be, above all, unable to understand that this life-like blending of soul and sense, this brilliant union of light and colour, is the very perfection of art.

Here, as elsewhere, art, when it reaches its zenith, is always original. We shall refer later to Correggio's connection with the antique ; although there are some traces of its influence here, he is much more independent of it than the painters of the Florentine and Roman Schools. His Magdalen has nothing of the antique either in the contour and expression of her face, the animation of her deportment, or her drapery which falls in broad, voluminous folds. We only see a trace of the antique, using the word in its widest acceptation, in the free flowing outlines of her form which, devoid of all hardness and free from every constraint, show every movement as in nature. This graceful figure, with long fair hair of an enchanting colour flowing down her back, who turns full of love and charm to the Infant Jesus, is modern in the best sense. Her face is expressive of the pleasures of life, and of being dreamily lost in the joy of the moment. It is impossible to describe the manner in which the light is made to fall and play upon this figure, and the beauty and artistic effect produced by this means.

Mengs observes, " Although the whole painting is wonderful, the head of the Magdalen surpasses every other in beauty, and we may well say, that whoever has not seen it is ignorant of what the art of painting can achieve." His eclectic criticism discovers therein the most charming qualities of Raphael, Titian,

Giorgione, Vandyck, Guido Reni, and Paolo Veronese, but none of these, he says, ever succeeded in imitating that softness and grace, "which the great Correggio alone possesses." And, in the same way as De Brosses apostrophizes " Il Notte," Algarotti exclaims before the Magdalen, " Pardon me, oh, spirit of Raphael, if I break troth to thee before this painting, and am tempted to whisper to Correggio, ' Thou alone dost charm me.' " In the present century the English artist Wilkie, one of the most gifted painters of his day, and a very discerning critic, said with respect to it, " The Magdalen in character, colour, and expression, is not only the most excellent of all Correggio's works, but the highest achievement of painting itself."[1]

We shall now bring to a conclusion our remarks on Correggio's sacred works. With respect to the time of their production we have not only no trustworthy account, but are hardly able even to form any idea concerning it. The " Madonna of S. George," in the Dresden Gallery, stands next in the list. According to Vasari and Tiraboschi this painting was executed for the Brotherhood of San Pietro Martire in Modena, and remained in their church up to the year 1649. The fact of

[1] Critics are not, however, quite unanimous in their praise of this lovely Magdalen. Ruskin calls her the " lascivious Magdalen of the ' Il Giorno,' " and in truth her voluptuous beauty is almost too overwhelming for a religious picture. It is surprising that it did not shock the pious sensibilities of the religious orders. The brothers of Santa Maria were scandalized, we are told, at the bold style of Titian's " Assumption," which he painted for their church ; but the grand Virgin of Titian is spiritual in her supreme beauty compared with this Magdalen of Correggio.—ED.

S. Peter the Martyr being represented in the picture in the character of mediator for the congregation proves that such was the case. The statement which is sometimes given out that the picture was destined for the parish church of S. Giorgio di Rio of Correggio is quite incorrect. Pungileoni considers it probable that the work was painted in 1531 or 1532, as, according to an account in the " Chronicles of Lancilotti," the Brotherhood had their school (which meant " oratory" in those days) painted at that date. But the supposition is as little worthy of credence as the tradition that S. George is a likeness of Correggio himself, and the rest of the saints his children. The myth is perfectly untrue, as it is not in accordance with the information we possess concerning his family.

The " S. George" is more solemn in character than most of Correggio's paintings. The Madonna is represented in an architectural inclosure consisting of a chapel in the rich Renaissance style, through the round arched entrance of which peeps a sunny landscape. This framework was made to correspond with the painted architecture of the surrounding wall (according to Mengs, who judged from a sketch in the possession of Mariette), so that the picture in the midst of this architectural setting presented an illusive appearance. Mary is depicted seated with her Child, strongly foreshortened from beneath to above on a high throne, of which the richly ornamented pedestals are only visible, and in such a manner that she appears in the middle of the open arch reflected against the bright sky of the background. At her side, to the left of the foreground at the foot of the throne, stands the

knight S. George in shining armour, which displays his power-
ful frame to full advantage. He rests one leg on the head of
the dragon ; behind him stands S. Peter the Martyr, turning to
the Virgin and pointing to the congregation. To the right of
the foreground is the youthful S. John the Baptist, covered with a
fur cloak, and behind him the aged S. Geminianus in the act of
receiving the model of the church from off the shoulders of a
boy angel. The naked Infant Jesus stretches out His little
arms longingly for this model. The joyous angels and genii
are this time represented on the ground. Two of them are in
front near the socle of the pedestals close to S. George, frolic-
ing and laughing ; a third tries on the gigantic helmet of the
knight, while a fourth, quite in the foreground in the middle,
endeavours to draw his sword. In a similar manner Putti
are represented playing with the weapons of the Macedo-
nian king in the beautiful representation of the Marriage of
Alexander with Roxana in the Villa Farnese, in Rome. The
amusing little episode which Sodoma introduces into the
classical subject, Correggio makes no scruple of depicting in a
work the theme of which is strictly sacred. He did not choose,
moreover, to miss his representations of frolicsome children up
above, so he brings in two statue-like genii as if made of stone
in the corners of the architectural framing. They serve to
support the ledge of the dome, which is ornamented with a
wreath of leaves and fruit. Wreaths of flowers in front of the
genii are festooned from arch to arch. Correggio seems to have
taken the idea of his plastic and architectural ornamentations

CHOIR OF ANGELS.

In the Dyce Collection, South Kensington Museum.

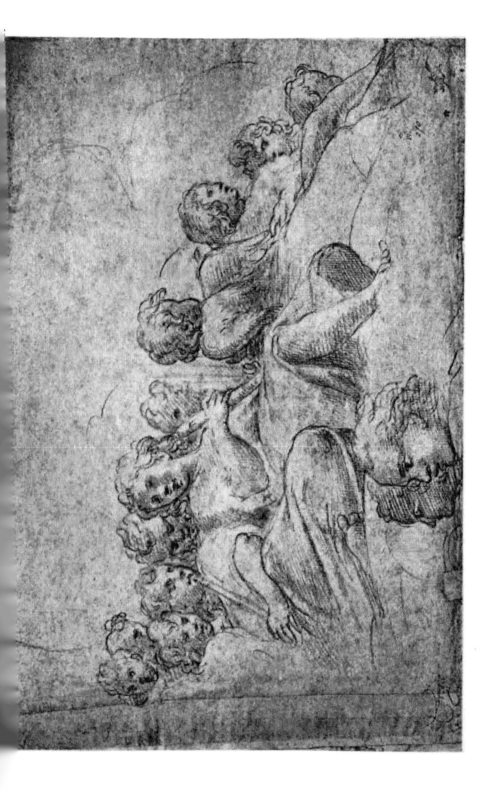

from a remembrance of the school of Mantegna. A similar statue
of a genius is discernible in the pedestal of the throne. The
manner in which he combines life with the architectural decora-
tions is very charming, and the whole is invested with a rich
festive character which is not common in Correggio's altar-
pieces, which are usually represented in an idyllic landscape
setting.

It appears to have suffered much in cleaning, and, although
the effects of light are still preserved, a great deal of the
harmony of tone that it doubtless once possessed is now lost.
This is, however, not sufficient to account for the meagre
admiration which has been felt for this work in modern times.
The figures of the men who play the chief *rôle* in the picture
have none of the inspired look and earnestness of expression
one might expect them to wear at a moment of such import.
The beauty which characterizes them according to their dif-
ferent ages is not free from a certain coldness. They are sup-
posed to be the mediators between the congregation and the
Madonna; but she seems to respond with very little sympathy,
and they appear to be impressed only in a very moderate degree
with the holiness of their calling. The indifference which
Correggio felt with regard to Christian matters and religious
subjects betrays itself here; it is a trait to which we shall revert.[1]

[1] F. von Schlegel considers that Correggio intended in this picture, as in many
others of his works, to set forth the struggle between the powers of good and evil,
light and darkness; but all such symbolical interpretations of his meaning seem
very doubtful. More probably, he merely endeavoured to clothe his artistic idea

This is less noticeable in his other altar-pictures, as he invested his Madonnas with the greatest feminine charms, and treated his conceptions of the Virgin among the saints as a truly human episode in an ideal world. In this painting, however, the male characters occupy the most prominent position, and yet the figures are deficient in internal meaning. The figure of S. George is expressive of noble, manly beauty, but we can discern nothing in his expression beyond innocence, while a consciousness of victory is displayed in his attitude. S. John is still more deficient; just entering into adolescence, his limbs are depicted with almost feminine softness and roundness. Their sensuously enamelled flesh appears through his reddish brown garment lined with fur. The playful boy genii are, on the contrary, truly beautiful. The mischievous little arm-bearer, as well as the quieter-looking putto with the church, are beings as natural as they are beautiful. It was these Putti, Scannelli informs us, which so greatly charmed Guido Reni. When any Modenese gentlemen went to visit him in his studio in Bologna, he would ask them if the Putti had grown up, and whether they were still in the picture with S. Peter the Martyr, where he had left them; for they were so life-like, and the flesh looked so real, that he could scarcely believe that they were still children, and he should like to satisfy himself again on that subject. The play of chiaroscuro upon their delicate bodies, the light shades

in the most beautiful language, without troubling himself very much about its exact significance.—ED.

and the half-tones are very charming. How the soft effects of light spiritualize the appearance of the flesh! The maidenly head of Mary turned sideways is also very graceful, although the foreshortening gives a strange look of rotundity to her figure. This was by no means necessary; her knees seem to touch her waist, and, although perfectly accurate as regards the view from beneath, we do not look for this effect in a picture, and the eye is not accustomed to such distortion.

The Dresden Gallery also possesses the famous " Reading Magdalen." With respect to the first destination of this picture we have no reliable account. Pungileoni thinks it was the master's last work, and was produced in the year 1533, but he gives us no proof of this. The certainty of the execution and masterly handling make it probable that Allegri painted it when his art had reached its full maturity. It was a considerable time in the possession of the Dukes of Modena, who guarded it with great care and valued it most highly; it is, in consequence, in excellent preservation. This little picture, which many connoisseurs do not hesitate to pronounce Allegri's greatest masterpiece, is distinguished by the charm of representation as well as by its softness of handling and delicacy of finish. In Mengs' opinion it contains every beauty belonging to the art of painting. " Correggio's other pictures are excellent," he says, " but this one is wonderful." The beautiful penitent, with long, flowing golden hair, lies in a hollow under dark foliage, quite retired and peaceful. She supports her head on one hand, and holds a book, which is lying on the ground, with the other, in

which she reads with a meditative, dreamy expression in her face. Almost the whole figure is enveloped in a deep blue garment. Her charming feet, the upper part of her bosom (which almost touches the book) and her dazzling arms are alone visible. The contrast between the brilliant yet delicate flesh-tones and the dark *entourage,* and especially the brightness of her countenance, which, lying half in shade, is lit up by the reflection from her arm and book, produces a very good effect. There are certainly very few traces of repentance and grief in her very lovely features ; she seems much more as if she were enjoying a peaceful reverie. Correggio has neglected nothing which could impart the greatest charm to this composition ; the minutest details are finished with the greatest care. Mengs cannot find words to express his admiration for the hair. The painting of it is rich and brilliant, deep and clear as if it were an enamel painting. It is really painted on copper, and some say the surface was prepared by a wash of gold or silver in order to enhance the transparency and brilliancy,—an expedient which Allegri is stated to have made use of on more than one occasion.

The Magdalen has been frequently represented by Correggio. In the " Madonna of S. Jerome," as we have before stated, her form is a perfect masterpiece of art. In " Noli me tangere," " Ecce Homo," and the " Descent from the Cross," she likewise appears. But in no other case except the present has he made her the sole subject of a painting. Mary Magdalens certainly have been falsely ascribed to him, but these have long since disappeared. Veronica Gambara, however, refers to one

in her letter to Beatrice d'Este, of Mantua, on the 3rd of September, 1528, which must undoubtedly have emanated from our master. She writes thus :—" I should consider myself very remiss if I omitted to allude to a master-work in painting which our Antonio Allegri has just completed, as I know your Highness, who is such a connoisseur in such matters, would be so pleased with it. The picture represents Magdalen, who has fled into a dark cavern in a desert in order to do penance. She kneels to the right, and with her clasped hands raised up to heaven implores pardon for her sins. The beauty of her position, the expression of sublime although intense grief, and her very charming face render her so lovely, that everybody marvels when they see it. Correggio has in this work given full expression to all the sublimity of an art of which he is so great a master." This is the only existing account of a work which has long disappeared ; for a Magdalen in a similar position, which was formerly ascribed to him in the collection of the Duke of Brucciano (Livio Odescalchi) in Rome, and passed from thence into the Orleans Gallery, was undoubtedly spurious. As far as we know, even this has disappeared. The engraving of it exhibits very little of Correggio's manner.

But the above letter is a proof of the interest the lords of Correggio's native town took in Correggio's works and career. The picture alluded to was undoubtedly painted in Parma in 1528, when the master was engaged upon the dome of the Cathedral. It would not appear by the wording of the letter that it had been painted for Veronica. We possess unfortunately no authenticated

account of Allegri's personal relations with this gifted lady, who in her day was represented, together with Vittoria Colonna, as being a poetess " almost equal to a man." It is possible that in his youth he painted a few of the apartments in her palace, but we have no real grounds for the supposition, as we have already mentioned. He does not appear to have been much engaged by her later in life, and there was no work by him mentioned in the catalogue of her art-treasures after her death. We shall, however, see later that it is very probable that she exerted herself in obtaining important commissions for him during the latter period of his life, which is at any rate a proof that her interest in the great master was deep and lasting, and that there was some sort of intimacy between them.

CHAPTER IX.

Return Home and Renewed Industry.

Last events in Parma.—Death of Correggio's wife.—Return to Correggio (1530).—Relations with the Princess Veronica Gambara and the court of Mantua.—The commission for the Emperor Charles V.

BESIDES religious themes, Correggio often, especially in his latter days, treated mythological subjects in his paintings with the greatest success; but, before we give these works our attention, we will take a cursory glance at the last events of his life.

It would appear that Correggio, after he had finished the greater part of his work in the dome of the Cathedral, became tired of living in Parma. This may be attributable to two reasons, the death of his wife, or the cold reception given to his paintings. The spiteful comparison of his great fresco in the dome of the Cathedral with a dish of frogs is, as we have already remarked, undoubtedly a myth; but there is clear proof in a letter of the painter Bernardino Gatti, called Sajaro, a contemporary, some say pupil of Allegri, and who certainly painted in his style, that the chapter of the Cathedral were for some

reason or other not satisfied with his work. Gatti, who belonged
to the fraternity of the Church of S. Mary, the so-called Stec-
cata in Parma, and had been asked to execute some paintings
in the above building, sought to excuse himself through fear of
arbitrary conduct and exaggerated expectations on the part of the
patrons, and in a letter to one of them, named Damiano Cacconi,
he reminds him how much harshness and injustice Correggio
had to endure with regard to the frescoes in the dome of the
Cathedral. It was well known, indeed, throughout the town that
there were misunderstandings between Allegri and his patrons.

It matters little now, whether the misconception arose in
consequence of adverse criticism on the part of the chapter of the
Cathedral with respect to the nearly completed works, or from a
misunderstanding regarding their completion. Correggio's plea-
sure in his paintings was gone. Only half the work that he
had undertaken to paint in the Cathedral was completed, and the
other half he appears to have chosen to give up doing of his own
accord. The priests, indeed, seem to have hoped that he would
continue his work, as it was not until after the master's death
that they put in their claim for a compensation of 140 lire for
a small unfinished portion of the work in the dome. Correggio,
it is evident, did not choose to finish the paintings, although
there was so little left undone that it is impossible to discern the
new hand. Such reluctance was not natural to him ; all his
works appear to have been completed off hand as it were, and
were finished with the greatest care. His work in the Cathedral
must have been rendered thoroughly unpleasant to him. And, as

Lomazzo assures us that he was by no means sensitive to blame, the priests must have hit him hard to have driven him so far. The Parmese certainly do not appear to have been able to appreciate his painting. They took but a very slender participation in the great revolution in art which made itself felt so extensively throughout Italy, in the large towns as well as the small, and appear to have stood far behind the age in all artistic matters. The insensibility which Annibale Carracci ascribed to them towards the end of the sixteenth century may have existed at an earlier date and manifested itself towards our master.

The death of his wife, which took place in Parma somewhat about this period, very probably about the middle of 1528, doubtless caused him still greater grief. Two documents, dated respectively the 20th and 22nd of March, 1528, prove that she was still living at the beginning of this year. They also prove that the husband and wife lived in Parma, both before and after this date, and that Pellegrino, the father of our Antonio, protected the interests of his son's wife Girolama in their native town, Correggio. The lawsuit which the latter had carried on with her relations was brought to an arrangement somewhat about this period, and the opposition party engaged themselves in the first document of March 20th to make over several acres of land. This is also a proof of the increasing prosperity of the family; but we hear nothing after this respecting Girolama, and, as there is no report of her death in the Church Register of Correggio, we conclude she must have died in Parma, and certainly before the year 1530.

E E

Before the close of this same year, 1530, immediately after he had received the second instalment for the painting of the dome of the Cathedral, our master returned to Correggio, in order to take up his residence and pass the remainder of his days there. He could not have gone thither in May, for on the 13th of that month, his Father Pellegrino, acting probably for his absent son, let a house in the Borgo Nuovo, situated near the Church of S. Francesco, that had doubtless come into the possession of Girolama after the termination of the lawsuit, to the married couple Giovanni and Lucia Merlini (possibly relations of his wife), for the sum of 12 lire yearly. On the 29th of November, 1530, Correggio himself bought an estate from one Lucrezia Pusterla of Mantua, the widow of Giovanni Cattania of Correggio, for 195 scudi and 10 soldi. It was probably purchased out of his savings in Parma, particularly from the money which he received for his work in the Cathedral, which he probably disposed of in this manner, as being a safe investment and a means of increasing his capital. In February, 1531, he returned to Parma, but only for a short time, for the purpose of making some arrangement with the architectural inspectors of the Cathedral, but we have no very clear particulars concerning the transaction. In 1532 we find him once more in Correggio in the character of witness on the 26th of October and the 28th of November; likewise on the 7th and 15th of January in 1533. On the 8th of September, 1533, he also bought a few acres of land. On the 24th of January, 1534, he had the honour of being cited as witness to the payment of the marriage portion of 20,000 golden

scudi which Clara of Correggio, the daughter of Gian-Francesco, the then lord of the territory, received on the occasion of her marriage with Ippolito Gambara.

The numbers of times that Antonio was summoned as witness proves that he again took up his residence in Correggio after the close of the year 1530. He probably lived in the house which he had inherited from his uncle. At all events, his son Pomponio sold a house in December, 1550, which was situated in Borgo Vecchio, the old suburb, for the by no means inconsiderable sum in those days of 109 golden scudi. It looked out on one side on the town-wall, and on the other into the public street, in the quarter which in Tiraboschi's time was called " Le cà rotte." It is likely that Pomponio inherited it from his father, and that the painter resided in it, while the other which was his wife's property was probably let; for it is not possible that Pomponio, who we shall see by and by was a bad man of business, should have purchased the house. An artist who was thus proprietor of two houses as well as several estates clearly lived in good circumstances.

When Correggio entered upon this new residence he was still young, in the very prime of life; and yet this return to a small country town had all the appearance of a retirement from the world, a retreat from the more extensive field of action he had found in Parma. Who can tell whether it was dissatisfaction caused by events which had taken place latterly, annoyance occasioned by the difficulties which are inseparable from commissions, or, as is more probable, grief for the loss of a beloved

wife that led to his desire for retirement, and induced him to return home? We have no knowledge of his state of health, or changes of mind and disposition.

His love of work as well as his aptitude for it were at least undiminished. He does not, it is true, appear to have produced many paintings during the last four or five years of his life. But that does not seem surprising when we take into consideration the exceeding care with which he finished all his works. Although it must be allowed that he displayed more industry in his early years, his later works testify to his having employed his newly gained leisure greatly in preparing new artistic themes.

We only possess accurate information with respect to the origin and destination of two of these works. Correggio must have painted these while he was residing in Parma, or shortly after his return home. Vasari relates, "Among his works are two paintings, which he executed in Mantua for the Duke Federigo II., which he intended to send to the emperor; the works are worthy of such a prince." Vasari probably obtained his information from Giulio Romano, who, as is well known, was much employed by the duke, and long resided in Mantua; it may therefore be regarded as trustworthy. Mengs remarks, "Vasari informs us that the duke intended to make a present of the two pictures to Charles V. in honour of his coronation, in the year 1530." But we do not find these exact particulars in Vasari; Mengs has added a little thereunto. He did not, however, invent the statement, as it reposed on a tradition

that had long been in circulation. According to this, Giulio Romano, wishing to find an artist worthy of painting such a distinguished present, recommended our Antonio to the duke. But, even so, it still remains doubtful as to whether the pictures were meant to be offered in commemoration of the emperor's coronation. Pungileoni inclines to the idea that they were painted later, in the year 1532, and that Federigo II. sent them as a souvenir of the emperor's residence in Mantua. It does seem rather improbable that the paintings should have been ordered immediately so as to be ready for the coronation. It is much more likely that Correggio should have received the commission soon after; or, what is still more likely, in consequence of Federigo's elevation to the rank of duke, with which he was invested on the 8th of April, 1530, after the coronation, in consequence of his fidelity to the emperor. Charles V. may have seen the pictures for the first time on his return to Mantua, in 1532, before they were sent to him in Germany. Their history seems to prove that they were originally destined for the emperor, for in the sixteenth century they were found in Madrid in the possession of a man who was a court favourite of Philip II., and stood on terms of the closest intimacy with him.

One thing, nevertheless, strikes us as being suspicious in the account—Giulio Romano's recommendation and instrumentality. Why should he have allowed so praiseworthy and honourable a commission, which might have led to such brilliant results, to have been transferred to another? It might have been the means of bringing a very dangerous rival into Mantua. The

duke, moreover, was in frequent communication with the Vene-
tians, particularly Titian, who sent him two pictures in 1531 ;[1]
and, if he objected to employ Giulio, why should he not have
engaged the services of one or other of the Venetian masters?
Why should he have thought of Correggio, who left Mantua
when he was a mere youth, and, as far as we know, had had no
intercourse either with the Court or the town ever since? We
hope to be able to offer a more specious elucidation of the
transaction.

Veronica Gambara was on the most friendly terms with the
ladies of the house of Este, two of whom had intermarried with
the Gonzagas and resided at the Mantuan Court. She also
corresponded with them, as is proved by her letter of the 3rd of
September, 1528, to Beatrice d'Este, in which she speaks so
warmly of Allegri's new painting. Isabella d'Este took even
greater interest in the fine arts than Beatrice. She was mar-
ried to Gianfrancisco III. of Mantua in 1490, and was the
mother of Federigo II. She had in her collection not only
costly antique and modern sculpture, but paintings by the most
distinguished masters of her epoch ; among others, two works
by Correggio, to which we shall allude further on. We have
already seen how indefatigable she was in procuring the works
of the most celebrated contemporary artists, and it is very

[1] A "Magdalen" and a "S. Jerome," according to statements in the duke's
own letters to Titian, written during the same year. He also corresponded
with Titian in 1535 and 1539, and received other pictures from him.—*Carlo
d'Arco.*

probable that her friend Veronica Gambara attracted her attention to Correggio, and that in this indirect manner our master became known at the Mantuan Court. The foregoing consideration, as well as the admiration which Veronica so openly expresses for him whom she proudly styles " our artist," induce us to believe that it was through her instrumentality that Allegri received the commission from the Duke of Mantua. We know that she resided in Bologna in 1529 and a part of the year 1530. Her brother Uberto had been nominated vice-regent by Clement VII. It is therefore probable that she went to Bologna to assist at the coronation of Charles V., at any rate she was brought into connection with him through her brother Brunario, who was chamberlain and general-in-waiting to the emperor. Her house in Bologna was a *réunion* of all distinguished men, particularly literary men. It was an Academy, writes a young contemporary,[1] where every day Bembo, Capello, Molza, Mauro, and many other celebrated men who belonged to the Imperial or Papal Court, were to be found discoursing with her upon questions of the highest interest.

Her house indeed formed a centre of intellectual life, and also a sort of court for the reception of princely guests. There is no doubt but that she met Charles V. here, and furthermore that he promised to stay with her at Correggio on his return to Germany. Tiraboschi, indeed, informs us from old sources,[2] that

[1] Rinaldo Corso, in his sketches of the life of the princess, to which we have previously alluded.

[2] " Storia della Litteratura Italiana." Modena, 1786, vol. viii. iii. 48.

Veronica after she had returned home received and entertained Charles V. in her own palace. He appears to have stayed about two days (end of March, 1530). But the story that is also told of the princess, that as soon as she had received the promise she hastened back to her palace in the suburbs of Correggio, where she intended to receive the emperor, and engaged Correggio to adorn it with paintings, has been proved to be a mere fable; and the report of the emperor having paid Veronica a second visit in the year 1532, when he is stated to have remained several days in Correggio, also appears to be unfounded, at least Tiraboschi knows nothing of it. This second visit, if it could be proved, might lead us to imagine that Antonio probably had an interview with the emperor and received the commission direct, which he executed for this great prince during the last years of his earthly career.

Correggio was absent from his own home during the emperor's first authenticated visit to Veronica. But it is highly probable that the princess, either in Bologna or her own town, attracted the attention of her distinguished guest to the native artist, and afterwards informed the Duke Federigo that the emperor would be pleased to receive two paintings by Correggio. There is much to substantiate this hypothesis. It is much more likely that Veronica should have obtained these commissions for Allegri, or even merely suggested them, than Giulio Romano. But whether it was through her instrumentality that other pictures by Correggio came into the emperor's possession is a question we may touch upon but cannot answer; there is no

evidence to support it. We know also next to nothing as to whether any sort of intercourse subsisted between the distinguished widow and the artist, although we have some few reasons to incline us to that belief. We must leave the task of relating the story of a friendship between them, like that which subsisted between Vittoria Colonna and Michel Angelo, to the feuilletonist. We can only remark that it is highly improbable she could have stood on confidential terms with the retired and exclusive Correggio.

Correggio also appears to have painted two pictures for Isabella Gonzaga, probably after he had executed the commission for Federigo. They are mentioned in a catalogue of art-treasures belonging to Isabella d'Este, Marchesa of Mantua, drawn up about the middle of the sixteenth century. As the Marchesa died on the 13th of February, 1539, a few years after - Correggio, it is probable that she received the paintings direct from him. It is also likely, as they are specified as being " over the door," to use the words of the catalogue, that they belonged to the decorative portion of the apartment.

Several paintings by Correggio, some few of which were mythological, are mentioned in the inventory of the art-treasures of the dukes of Mantua (inherited from Duke Ferdinand) which was drawn up in the year 1627. But it would be erroneous to imagine that they had been destined in the first instance for the Gonzaga family. We have no authority for supposing that they were sent to Mantua fresh from the artist's hand. Up to the years 1628 to 1630, when the collection of the

Gonzagas was scattered, the family had been ever anxious to add to the collection of works of art which they already possessed. Correggio's pictures might have been acquired later, for with the exception of the commission referred to we have no account, no anecdote or tradition even, to support us in the belief that Allegri had any intercourse with the court of Gonzaga, or was employed on any further commission for the family.

Everything, indeed, tends to refute the supposition that any intercourse existed between the duke and Correggio during the time that the latter studied in Mantua. Neither in the Mantuese chronicles nor archives, which are by no means destitute of information relating to those times, do we find any memorial of Allegri. Pungileoni made many fruitless endeavours to find some particulars respecting Correggio among the local chronicles extending from the year 1530 to 1532, and Pasquale Coddé's researches were equally unproductive. The investigations as to his residence in Mantua from 1511 to 1513 also brought no result. We possess, nevertheless, internal and external evidence respecting this, while everything militates against the hypothesis of a subsequent visit to that town. Pungileoni certainly found a cash-book amongst the secret archives of Mantua dated 1538, containing two entries referring to one " Antonio da Corezo" which he endeavoured to connect with our master. But they are dated 1537, and do not seem to refer to any earlier period; so, as Allegri died in 1534, they doubtless relate to another Antonio da Correggio, probably Antonio Bernieri, mentioned in a letter of Veronica's in 1537.

He was recommended to her by Pietro Aretino, and perhaps also through his instrumentality obtained further introductions in Mantua. As far as our knowledge extends, no account whatever has been handed down to modern times respecting our master's sojourn in Mantua; neither ancient nor modern writers allude to it. There is no doubt, however, that he worked for the Duke Fredrigo, but he enjoyed no intimacy with that prince, who regarded Giulio Romano as his friend, and corresponded with Titian. After he left Parma he lived quietly in Correggio, and remained there never to leave it again. He commenced his career in Mantua and terminated it by executing an honourable commission for the lord of the territory; but, as far as we are enabled to judge, this constituted his sole intercourse with men of distinction and princes.

We shall duly describe the subjects as well as the kind of works Correggio painted for Charles V. when we come to consider the master's mythological works collectively. We shall find many among these latter of exceeding beauty and rare artistic value as well as great originality. Besides which, the remarkable incidents which befell them impart a peculiar interest to them.

CHAPTER X.

Mythological Paintings.

"Jupiter and Antiope."—"School of Love."—Two representations of "Ganymede."—"Io."—"Leda."—"Danae."—"Virtue and Vice."

AMONG the mythological paintings which have been attributed to Correggio, we shall first mention a work which, like the "Apollo and Marsyas," was long supposed to have been by his hand, although the real originator was also often named. This is the well-known "Cupid Cutting his Bow." It has many facsimiles; but the original painting is in the Belvedere Gallery in Vienna. It is undoubtedly the work of Parmigiano, whose Cupid Vasari has alluded to. Eastlake is of the opinion that the invention belongs to Correggio, as the conception and character of the figure are in accordance with his style; but there is no foundation for the supposition. Everything, on the contrary, tends to refute it. In cases where Parmigiano imitates his master somewhat closely, his figures naturally wear a look of relationship.

It is very difficult to define the period of production of

DESIGN FOR A FRIEZE.

In the Dyce Collection, South Kensington Museum.

Correggio's mythological paintings, as, with the exception of those he executed for Charles V., we have no historical account of their origin. They were chiefly found in the possession of the Gonzagas of Mantua. We have, unfortunately, no idea for whom these mundane productions were executed, for we possess nothing beyond Vasari's scanty and vague statement that "Correggio executed other pictures and paintings in the same style for many noblemen in Lombardy." The biographer had been alluding previously to Allegri's sacred paintings, but engrafts on to his former observation another about the commission for the duke. It is, therefore, possible that he means by the expression, "other paintings," secular paintings in the style of those which he painted for Charles V. There is nothing improbable in this, as the district lying between Mantua and Parma was included in Lombardy, and the master had attained to a considerable degree of reputation within the circle of his labours.

We shall place the well-known painting, entitled "Jupiter and Antiope," now in the Louvre in Paris, the first in the list of these mythological representations. It was found, in 1627, in the collection of the dukes of Mantua. We have no account whatever of the time it was produced, nor of its original destination. Pungileoni's idea that it was painted in 1521 has no historical foundation, though the picture may have been done about that time. It possesses the same warmth in the flesh tones and high lights that is observable in the " Marriage of S. Catherine " of the year 1518; and, as the " Antiope " displays still grander effects of

light and greater certainty in the technical handling, it may very possibly have been executed a few years later. The title of the painting is founded upon no historical tradition, and the name of " Jupiter and Antiope" has been given to it quite lately. It formerly went by that of " The Sleeping Venus." In the inventory of the Gonzagas of 1627, it was simply designated "Venus, a Sleeping Cupid, and a Satyr." It is, indeed, improbable that Correggio intended to represent the myth of Antiope and Jupiter. The bow in the hand of the sleeping woman seems much more to imply that she is simply a wood-nymph, who is resting after the fatigue of the chase in a retired thicket, and the presence of the sleeping little genius of love is well accounted for by Correggio's partiality to the introduction of such figures. The fable does not in the least help us to understand the painting, it is rather an obstacle. We have already remarked that the master troubled himself but little concerning the meaning of the mythological figures he introduced into his paintings; he was probably, indeed, ignorant of it, and simply made free use of their beauty in depicting a sensuous, joyous representation of ideal nature. The picture explains itself, and there is no need to trouble ourselves as to what particular Grecian fable it is intended to represent.

The sweet repose of sleep has, perhaps, never been more gracefully portrayed. In a warm thicket, with the light breaking through the foliage, lies a nymph on rising ground, quite naked, with her arms thrown into an easy position expressive of rest. The light falls full upon the broad surface of her body,

which stands out in bright relief from the blue cloth upon which she is lying. Upon her head, that reclines on her arm, a half-shade falls, investing her with such a life-like appearance that one almost seems to hear her breathe. Beside her sleeps the most charming winged Amor, as soundly as it is only possible for a child to sleep. On the other side, a little farther back, under the shadow of the trees, is a cloven-footed satyr, a fabulous being, but real flesh and blood for all that. He stands close to the tree against which the nymph is resting, and holds the garment which he seems to have lifted in order to display the nudity of her form. All around is a lovely wooded landscape with a vista, through which we discern a distant view, and upon which the light is thrown in such a manner as only Correggio understands. The grand outlines of the forms, the light glimmering through the foliage, and the perfect realism of the whole representation render this a most masterly work. The warm shades in the darker flesh of the satyr, and the full, rounded contours of the limbs finished off with the greatest delicacy, are perfectly natural. The work is undoubtedly one of the finest that Correggio produced during the middle period of his art.[1]

The " School of Love," or " Education of Cupid," now in the National Gallery in London, is also mentioned in the catalogue

[1] F. von Schlegel points out that this picture requires to be looked at from a level with the eye or even lower, whereas most of Correggio's church pictures have their effect heightened by being looked at from below. He thinks it was probably painted for some rich patron, who required it to fill a particular position in his house.—ED.

of the Gonzagas in 1627. The time of its production and its
original possessor are utterly unknown. There is, however, no
question whatever with respect to its authenticity, although in its
present state, injured as it is by cleaning, we can only partly
judge of its pristine beauty. The picture represents a little Cupid
taking a lesson from Mercury in the presence of Venus. The
composition and the grouping, that Correggio usually studied
less than other points, are rendered here with charming effect.
Surrounded by a lovely landscape, through the upper part of
which appears the sky, are three blooming figures delineated in
flowing outlines. Mercury, who is in a sitting posture, helps
Cupid, who is standing near him, to decipher the letters of a
paper that he holds in his little hand. He is very zealous this
time ; the winged God of Love and his unwonted efforts are
displayed with charming naturalness in the constrained position
of his delicate limbs. Close to him, in a front view with her left
arm resting against a tree, and pointing roguishly to Love with
her right hand, stands Venus also winged, looking down archly
upon the spectators. Graceful and easy, the attitude of her
slender limbs is suggestive of rest, although she is standing.
Her rounded and delicate form, though not derived from the
antique, is yet of great beauty. The face is less so, and its
wanton expression is suggestive of a lower type. The wings of
the goddess show what liberties Correggio took with the
antique. He must have known that she was never represented
winged by the ancients any more than the Parcæ, and yet, as we
have seen, he also gave them this adornment in the paintings of

S. Paolo. He certainly never intended to convey any particular meaning, as some think, by depicting Venus in this style; but merely considered that the wings enhanced the charm of the conception by lending to it a supernatural character. It was always his endeavour to unite sense and ideality, nature, and fable, into one artistic whole. And the masterly manner in which he adapted wings to the human form has been universally acknowledged. Mengs declares that they are put on the body in so natural a manner, that they look as if they were really another member of the human frame, and he reports an observation made by a former possessor of the " School of Love" —namely, the Duke of Alva, who said that Cupid's wings were executed so beautifully that the child looked as if he had been born with them. The three figures are perfectly naked, with the exception of Mercury, who has a light garment thrown across his loins, and stands out in bright, glowing colours from the deep rich green of the landscape; and, in spite of the injury the picture has sustained through restoration, the effects of light and the toning off of the shades invest the forms with statuesque rotundity.[1]

[1] This picture at one time formed part of the noble collection of our Charles I., who bought it with the rest of the pictures belonging to the Duke of Mantua in 1630. After the dispersion of the Royal Gallery, it was bought by the Duke of Alva for £800. At the time when Madrid was taken by the French it fell into the possession of Murat, and was thus, when that general was made king of Naples, restored to Italy. It was afterwards, however, purchased from the ex-queen of Naples by the Marquis of Londonderry, with the " Ecce Homo," also in the National Gallery, and was finally sold by the marquis to the nation in 1834.—ED. *Vide* Catalogue of the National Gallery.

Another representation of Venus and Cupid and a satyr, in which the goddess has snatched away the bow that the child vainly strives to regain, has numerous facsimiles, and the invention is ascribed to Correggio without its being possible to attribute the original to him. The design is not in his style; at the most, it can only be said to reveal his influence.

The two secular paintings we have just mentioned are the only ones in that style produced before the year 1530. It would appear that, with the exception of the works in S. Paolo, the master only found leisure and opportunity for mythological representations at the latter part of his life. During his early years he was chiefly engaged with commissions for sacred pictures, and the subjects of the small pictures he painted for private individuals were all taken from the Bible. It was after he had given up the paintings in the dome of the cathedral, and had left Parma, that, weary perhaps of monkish and priestly arrogance, he was glad to turn away from sacerdotal art for a time. It was then he appears to have been favoured with new commissions, and to have turned his attention mostly to secular subjects. The nature of his talent leaves no room for surprise that he should have distinguished himself equally well in this branch of art.

Two representations of Ganymede carried up to Olympus by an eagle are attributed to Correggio, without, however, any traditionary evidence to support the statement. It is easy to understand that the master might have chosen this subject from the fact that there was a natural necessity for foreshortening the

youthful form borne upwards, as well as the expectant gods in Olympus. It is supposed that he painted this theme in fresco, in an apartment in the Palazzo Rocca, belonging to the Count Gonzaga di Novellara, about the year 1530. The lords of the little territory of Novellara were a collateral branch of the Gonzagas of Mantua. Count Alessandro I., who reigned from the year 1515 to 1530, married, in 1518, Costanza, the daughter of Giberto da Correggio, who was distinguished by her intellectual endowments. The flourishing town of Novellara was not a little indebted to her. We see that there was some likelihood of the master having been acquainted with this princess. There were also found, in the catalogue of the Count's collection of pictures compiled in the year 1600, several works ascribed to Correggio. They all seem to have disappeared, so we cannot speak with regard to their authenticity; but it is quite possible that Allegri worked for this branch of the Gonzagas, and painted a ceiling in one of the apartments of their palazzo. As far as we can judge from the dilapidated state of the medallion which has been preserved, and is at present in the Gallery of Modena, it is possible that the painter was Correggio, but more likely a pupil or successor of his.[1] It represents Ganymede borne aloft by an eagle. He seems to be sleeping, and the upper part of his body reposes on the bird's wing. Jupiter, sitting upon the clouds, is waiting to receive the ravished youth. A little to his

[1] A pamphlet has been written respecting it, entitled, " Notice sur les fresques trouveés dans la Salle du Casino nommé *di Sopra*, propriété anciennement des Gonzagues, Contes de Novellara." Par L. M. M. Livorno, 1850.

left are two quite youthful goddesses, likewise sitting upon clouds, and watching the scene in graceful attitudes. All the figures are in full motion, strongly foreshortened from beneath to above, and exhibit a certain relation to the paintings in the dome of the cathedral. But so few of the details have been preserved that it is impossible to recognize the master's hand. It is the same case with the foreshortened boy-genii, which have likewise been removed from the ceiling of the apartment in Novellara, and are now in the gallery in Modena.

There is also an oil-painting representing the ravished Ganymede, but it has no Jupiter or goddesses. It is now in the Belvedere Gallery in Vienna. The eagle is flying through the open air with the youth. Beneath is a bird's-eye view of a charming undulating landscape, and on a rock stands the youth's forsaken dog, which is barking anxiously for his master.[1] The picture might well be accepted for a genuine Correggio, but we shall show when we relate its history that it was sent to Madrid at an early date, and was considered there to be by Parmigiano. The characteristics of our master are certainly less strongly defined than in the other paintings of this kind. Great skill is apparent here as elsewhere in the representation of form and the rendering of action, but the natural charm is wanting which Correggio usually imparts to his mythical themes, giving them all the realistic character of every-day life. In general treatment the work resembles the picture of " Io," to which we shall refer

[1] Dr. Meyer is mistaken in calling this animal a dog. It is really a horned stag.—ED.

later, and therefore it is probable that it was produced as well as that painting about the year 1530. We have no account whatever concerning its origin; all that we know is that it came, together with the "Io," into the possession of the Emperor Rudolph II., having been sent to him from Spain. It was then taken to Prague and afterwards to Vienna. It is not unlikely that the Emperor Charles V. ordered these paintings after he had received those which had been presented to him by the Duke of Mantua, for they form together a small series of the love-stories of Jupiter. It has at all events been frequently stated that "Io" was painted for the emperor, or came first into his possession. But we have no reliable account whatever respecting either the one picture or the other. Correggio's paintings changed hands so often in the sixteenth century, that these may well have found their way into Spain, and so have come into the possession of Antonio Perez, where they were first remarked. As they appear to be contemporary productions, and are both about the same size, they were most probably companions. The connection between the subjects is, however, only external. The whole character of the composition of "Io" belongs to quite a distinct class of paintings.

The original "Io" is at present in the Belvedere Gallery in Vienna, but there is a very good old copy which has often been considered genuine in the Museum in Berlin. The adventures that befell this picture whilst in the possession of the hypocritical Duke of Orleans render it interesting.[1]

[1] See Appendix.

It is impossible to carry the representation of sensuous joy and beauty in art further than Correggio has done in this painting. " Io," perfectly nude and almost turning her back on the spectator, is sitting on a little hill with her body slightly thrown back. She seems actually to shine forth out of the misty clouds that surround her and throw a haze over the landscape. The head of Jupiter, whose lips are raised to meet hers, is scarcely recognizable in the enveloping cloud. His hand just emerges from the mist in order to clasp her round the waist. Her lovely face, turned bashfully aside, is charming in its expression of sweetest sensibility, and the golden hair and delicately coloured cheeks are exquisitely beautiful. If deserving of censure at all, it is, according to Mengs, only in consequence of the too great truthfulness of the expression.

Close to the margin of the picture a hind's head is visible, bending down to drink at the dark stream. This cannot certainly be meant as an allusion to the transformation of " Io " into the white cow, nor yet, as some have supposed, can it signify love's desire. It is probably merely put in to give an additional look of every-day life and reality to the mythical scene. This is further carried out in the treatment and realistic character of the composition. The sensuous lustre of the local colour is softened off in the delicate tones. The light and tender glimmer of the chiaroscuro play brilliantly on the beautiful form, and more effective than the expression even is the light on the figures, in which the warm tones of the flesh look almost spiritualized in contrast with the surrounding darkness enveloping the

figure of the god in its shadow. Unhappily the picture has suffered much, and it is only by a few portions of it that we are enabled to judge of what it must have been in its pristine state.

The two paintings executed for Charles V. Vasari informs us were " A naked Leda " and a " Venus." He adds that Venus was represented in a wonderful landscape, such as Correggio only could paint, together with a few little loves trying the points of their arrows on a touch-stone, while the goddess bathes her feet in a clear brook of water running over stones. Vasari clearly makes a double mistake here. The description of the loves proves in the first place that it was not Venus but Danae who was depicted in the work he meant, which is now in the Borghese Gallery in Rome. But there is no landscape in this picture, only in the "Leda," and it is she who is represented as washing her feet. The latter painting is now in the Museum in Madrid. The history of these two pictures and their wonderful adventures, detailed in the appendix of this work, proves how diligent fable was in throwing a halo of romance over Correggio's pictures, even long after his death.

The painting of " Leda " has suffered greatly both as regards its delicacy and harmony of tone. It is said that it was almost destroyed, and that it was only by the greatest trouble that the injured fragments were sewn together. It was not quite so bad as that, but it certainly has sustained considerable injury, especially by retouching. This must be borne in mind in order to do justice to the original beauty of the painting. The com-

position is richer and more varied than in most of Correggio's paintings. Leda and her playmates are represented frolicking with the water, in a luxuriant, undulating, wooded landscape. The swans appear to have surprised them and given a new impulse to their game. Leda, who sits in the centre of the picture on undulating ground under the huge trunk of a tree, in the midst of glistening foliage, is washing the tips of her feet in transparent water. A swan has softly found its way up to her lap, and caressingly nestles its supple neck in her bosom. She does not shake it off, but supports it by placing her out-stretched hand under its wing, so as to maintain it in the position in which it has placed itself. With the other arm she rests on the rising ground, leaning a little to the side, which gives her delicate youthful frame the most graceful attitude. One of her companions, a maiden in the dawn of womanhood, standing to her left, with the water reaching beyond her knees, is keeping off a young swan that is swimming towards her with outstretched wings. Another, who is out of the water, gazes after a swan that soars proudly away with a peculiar expression of mingled joy and satisfaction. Standing further back is a waiting-maid, who is quite drest. Between the latter and Leda is a second waiting-maid leaning against the trunk of the tree, and looking with an arch smile at the frolic of the young girls, who do not make any very strenuous efforts to keep off the swans. There is no doubt but that Correggio has distinctly portrayed love in its different phases, namely, the approach, the embrace, and departure, in this allegorical work. On the other side of Leda,

turning his back to her, and standing more in the shadow of the leaves, is a winged boy-genius on the threshold of manhood. He is playing happily upon his lyre, apparently quite unconcerned at the scene that is passing before him, and is a perfect specimen of that joyous life that characterizes Allegri's creations in real life as well as in the world of fable. At his feet and quite to the left margin of the picture are two merry little horned Putti playing music. The whole idyll is represented in a charming richly wooded landscape, which, together with the bright distance, is favourable to the play of the chiaroscuro, and brings out the brilliancy of the flesh tones. It is exactly like a scene in nature, the figures in the landscape are arranged just as if they were in their own homes, and their action and whole bearing is replete with the natural ease the occasion demands. Many of them, especially the waiting-women, are such as we are accustomed to meet with in every-day life. Yet there breathes throughout the whole the charm of an ideal and happy world, ignorant of the dark side of sensuous pleasure. If the hypocritical Duke of Orleans mutilated the picture and burnt the face of Leda because he could not endure the voluptuousness of her expression, it merely shows that the impurity lay in the eye of the spectator, and resulted from his heated imagination, which clouded his mind in religious matters as well.

The "Danae" in the Borghese Gallery is better preserved and consequently more effective than the "Leda." Danae is

resting with her back leaning sideways against the cushion of a
richly furnished couch. Across her limbs a white cloth is
thrown, upon which a trickling shower of gold falls. On the
lower end of the bed sits Love, or Hymen, in an easy position,
with outstretched wings just as if he were about to fly. He is
just between manhood and boyhood. With one hand he is
about to pull away the cloth from her lap, and with the other he
points to the shower of gold. There is no mistake in the
meaning of his gesture and expression, although both are
charming in the highest degree. The expression of her
maidenly face is quite indescribable. There is a smile upon it,
as if she were in expectation of a yet unfelt joy, and tranquil
desire is blended with a coyness which is beginning to give way.
Beneath her at the foot of the bed, in the corner of the picture,
are two charming little Loves, both very intent and busy in
sharpening their arrows upon a whet-stone, or trying the efficacy
of their golden points. The effect here is greatly enhanced by
the charm of the chiaroscuro. Danae is lying almost in half
shade, and her body looks dark in contrast with the white cloth.
But the flesh gleams by means of the play of the reflected light
that shines through the shadows, or breaks them up into
numerous half shades and tremulous soft lights. Not less beau-
tiful is the painting of the light that falls on the lifelike Putti,
and on the body of Love, who is in full light. The closer the
resemblance the figures and their respective attitudes bear to
real life, the more valuable do we find the idealizing influences
of the light, and the profound manner in which Correggio carries

out this truly artistic effect is not the least of the charms of the " Danae." [1]

In addition to the above representations Correggio executed two works of an allegorical character, which, as we have before stated, were probably first ordered by the Court of Mantua, that is to say, by Isabella Gonzaga. They are now in the *cabinet de dessein* of the Louvre. They are painted in gouache or tempera on linen, and by the lightness of their colouring were doubtless intended to harmonize with the decorative arrangements of the apartment they were intended to ornament. They are the only allegorical works of Allegri which have been preserved, although that style of painting was so fashionable in his day.

One of these paintings represents the " Triumph of Virtue." Virtue is a figure of noble and youthful beauty, armed cap-à-pie

[1] The " Danae" is perhaps the most perfectly beautiful of all Correggio's mythological paintings. Giulio Romano, who saw it in its pristine glory, declared—if we may believe Vasari's testimony—that he had never beheld colouring executed with equal perfection; and a critic of the present day, Iwan Lermolieff, in his " Galleries of Rome," characterizes it as being, in spite of the many injuries it has sustained, " the most thoroughly Correggesque work of the master (*Correggeskeste werk des Antonio Allegri*), a triumph of aerial perspective and chiaroscuro;" and " although not suitable, perhaps, to be hung in a girl's school," the latter writer goes on to say, " I look on the ' Danae' as being so true to life, *wahr und mensch-lich*, so chaste, in the true sense of the word, so far removed from the immodest prudery of the present time, that I consider no work of modern art has more right to be placed with the great creations of the Greeks." Ruskin claims for the great Venetians that their paintings " never excited base thoughts," otherwise than in base persons anything may do so; and surely, if this is true of Titian, we may assert the same of Correggio. Although his paintings glow with intense sensuous life, they seldom fall into sensuality. His naked goddesses think no

like Minerva, and leaning upon a broken lance. She sits enthroned in the middle of the painting, with her feet upon the vanquished dragon. Above her is a winged Victory, who is crowning her. On the left is a stately woman, sitting a little below Virtue, clad in a lion's skin, with a serpent twined about her hair; in her hands she holds a sword and bridle. She is the emblem of justice, moderation, strength, and wisdom. On the other side, a little further back, is a youthful woman of graceful appearance; with one hand she is measuring a globe with a zone, while with the other she points to the distant landscape in the background. She is no doubt intended to represent Wisdom, who indicates by her gestures the necessity of the knowledge of earthly and heavenly things. Leaning against her and pointing to the globe is one of those naked Putti whom Correggio rarely omits to introduce into his paintings—a charming rogue, who by his childish playfulness introduces a vein of humour into the seriousness of the subject. Hovering over the whole group are three female winged genii. Two of them are lightly drest, the third is naked. They are the goddesses of Fame and Renown, floating in a sea of light, with lyres and trumpets. They are just in the dawn of womanhood, and are represented with all the graceful ease with which Correggio is so successful in investing

evil, and are clothed in their own serene majesty and womanly beauty. They are very different to the conscious meretricious beauties of later art. It must be admitted that the germ of sensuality in art was planted by Correggio and the Venetians, but it only took root and grew with their followers.—ED.

For the history, &c., of the " Danae," see Appendix.

his creations. They form a charming contrast to the sedate beauty of the three prominent female figures.

The companion picture to this of Virtue is " Vice under the Yoke of Passions." In a charming landscape, sitting, or half reclining, is a naked, bearded man, leaning against the trunk of a tree to the boughs of which his limbs are bound. Standing close to him a wanton, naked woman pulls the cord faster which is tied round his foot. She doubtless represents Habit. On the other side is Conscience holding vipers in both her hands, which are thrusting out their heads towards the bosom of Vice. Lastly, behind him, is a third woman, Voluptuousness, a sensual, stout figure, with a lascivious expression, who is blowing a flute into his ear. He seems listening to the tones which have ensnared his senses. Quite in the foreground, and looking over the margin of the picture, is the form of a laughing boy-satyr with a bunch of grapes in his hand. He is another messenger from the world of genii, a world that is ever present to Correggio. He neutralizes the grave and meditative style of the composition, and represents Vice under its gayer and more agreeable aspect. While his old companion is bowed down by the weight of his lusts, he is enjoying the cool juice of the grape.

A slightly altered repetition of the " Virtue " in the Doria Gallery in Rome certainly emanates from Correggio. This painting appears to have been executed in tempera, and not in oil-colours, and its unfinished condition makes it of the greatest interest with regard to the technical treatment of the master.

We possess no information respecting its destination and early possessor. It is possible death overtook Allegri before he was enabled to finish it, as it appears to be his last work. The canvas is prepared by a coat of a warm brown colour. The genii at the top of the picture are sketched in red; there is only one who has a coating of black and white, and the head slightly painted. The figure of Virtue is painted in white and a brownish black. The Victory is only partly finished; but, as the shadows on the flesh are rich and warm, it is easy to see that it has been prepared in the same manner. The head of the figure sitting near Virtue is quite finished and very graceful; it even surpasses that in the painting in the Louvre. The sky and foreground are clearly only painted *alla prima.* Mengs expresses his admiration at the knowledge, grace, and harmony of the master being shown in this mere design as clearly as in his most highly finished paintings. He produces, indeed, an appearance of reality in portions that are scarcely painted at all. Everywhere also there is the same certainty in the foreshortening. "There are many paintings by Correggio," he adds, "more beautiful than this, but none in which the master's greatness is more apparent." Mündler also was of opinion that this unfinished picture far surpassed the one in the Louvre in boldness and in the animation of the faces. Indeed, the paintings, and particularly the figures, even where they are but lightly touched, have all the grace and lifelike charm which distinguishes Correggio's most beautiful creations. Neither of the paintings, the finished nor the unfinished one, possesses that cold, prim look which so many

allegorical pictures have. Beautiful groups of charming women and genii enliven the painting, and are so numerous here that one might be tempted to believe that these forms possessed some hidden meaning, and communicated a spiritual character to the painting.

CHAPTER XI.

Death of Correggio.

Last commission.—Early death.—His son Pomponio.—
Decline of the family.

THE only inferences we are enabled to draw respecting the last years of Correggio's life are gained from the works which may, with justice, be ascribed to that period. These prove at least that his powers were in full vigour, and his representations of life as joyous as ever, during the time when his signature to a few legal acts is the sole proof we possess of his existence. The paintings intended for the emperor were probably completed in 1532. According to Pungileoni the " Magdalen" of the Dresden Gallery was finished in 1533. But that is only a supposition; all that we can say is, that it is most likely that it was executed during the latter period of his life. We have some authority for supposing that the tempera paintings which he executed for Isabella Gonzaga were produced in 1533. He probably also painted the half-finished facsimile of victorious Virtue, now in the Doria Gallery, about the same time.

SUPPOSED PORTRAIT OF CORREGGIO.

From a picture in the Gallery at Parma.

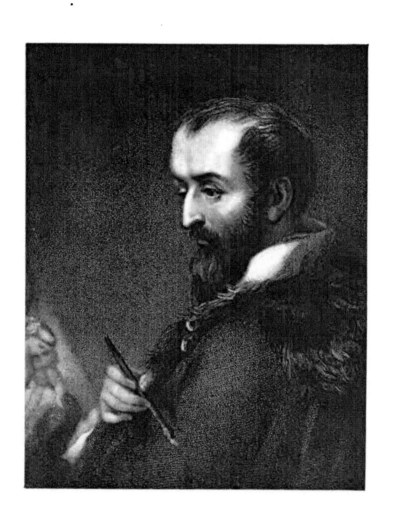

Soon after this date our master undertook to execute a painting for another patron; but death overtook him before he accomplished it. According to a legal document still existing, dated June 15th, 1534, it would appear that he had received an order for a grand painting for the Altar of S. Agostino in Correggio from a certain Alberto Panciroli (the son of the learned historian Guido Panciroli). But the same document records the restitution by old Pellegrino Allegri of the sum of twenty-five scudi that had been advanced to his son Antonio upon this work, in consequence of his death having prevented its accomplishment. His death is proved by the registers in the Franciscan Church of Correggio to have taken place on the 5th of March, 1534. He was buried on the following day.

We are ignorant as to the cause of Correggio's death, happening as it did in the prime of his life. We do not even know whether he died a sudden death, or lingered long on a bed of sickness. We are less able to arrive at a just conclusion in consequence of our want of information respecting his constitution and general state of health. Even tradition, which is so busy in giving us details of the poverty of his life, is silent on this point. According to the well-known fable, the master was struck down suddenly; but it is hazardous to accept fables as evidence. As he accepted Panciroli's commission, we may conclude, however, that he must have been in good health at that time. We could not, indeed, entertain the idea of his having been long in delicate health. The visible proofs we have of his

great industry during the latter years of his life preclude such a notion. The paintings which were produced at this period, both in character and execution, are sufficient to disprove it.

Raphael and Correggio both died about the same age, the one aged thirty-seven, the other forty. With respect to the former, we may almost affirm, with certainty, that he had reached the height in his art allotted to him to attain, and was beginning to decline from it. The grand and powerful artistic development in the midst of which he stood and held such an elevated position had reached its zenith ; art had become so conscious and secure of its power, that it began to degenerate into licence. Correggio had also, doubtless, attained the height which his genius and art permitted. It is not possible to imagine maturer conceptions than the "S. Jerome," the "Magdalen," the "Leda," and the "Danae." These last works of his are among the best he ever produced; and, although they were executed as late as the year 1530, they stand within the time of the highest development of art, while the "Transfiguration" of Raphael, however much people may glorify it, stands already on the border land of decline. Correggio's paintings are the productions of a master who invested art with the fullest freedom, although they may not belong to the most elevated style of paintings. We feel assured that Correggio, who was never led astray by foreign influences, nor by his own great powers, but always kept within the bounds of his quiet nature, would, if a few more years had been spared to him, have carried out the freedom and independence of art still further.

When Correggio died his parents were still living, and his son Pomponio was twelve years old. He was interred in a small chapel in an exterior cross-passage of the Church of S. Francisco, which was probably the family burying-place. A simple wooden tablet upon which the words ANTONIUS DE ALLEGRIS, PICTOR, were engraved, was the only ornament of his grave.[1] This plain, rude monument corresponded well with his simple life and obscure death. In 1612, after the memory of the master had been revived by the Carracci in Parma, as well as in his native town, the commonalty of Correggio resolved to put up a simple marble monument to his memory; but their intention was not carried out, for 100 scudi were required to defray its cost, and only forty-four were forthcoming. In the year 1647, however, the priest Girolamo Conti placed a stone with an inscription on it in the cross-passage in S. Francisco; and on the 25th of February, 1682, the commonalty of the town again took the resolution of erecting a suitable ornamental monument to his memory with the likeness of the master, and an inscription. The elders were even empowered to commence this work, and a sum of 600 scudi was subscribed for that purpose. On the 12th of June, 1687, also, a contract for the execution of the said monument was drawn up with the sculptor Gian Martino Baini. But then the affair, which had gone on slowly enough even up to that time, came to a sudden standstill, and the completion of the monument was once more delayed, doubtless owing to want of zeal. Next in

[1] According to the manuscript chronicle of Zuccardi.

1690, Pater Resta, whom we have so often mentioned, came to Correggio, and made every effort to have the monument erected, partly out of real veneration for the memory of the master, and partly to bring the painter into notice, who he pretended was the originator of his drawings. But his efforts were likewise fruitless, and Correggio's bust which he had had executed at a cost of 40 scudi, and begged the senate of the town in vain to accept, was sent in 1708 to his nephew, the Bishop Resta of Tortosa. In 1786, they at last sought for the bones of the illustrious dead, but by this time it was very uncertain whether those they found were really his. Zuccardi informs us, in his Chronicle, that the remains of the master, when the chapel containing his grave was pulled down, were put in another place, "a little way off." He certainly enters into a few further details, but it is only the report of a third person he quotes, who is not even supposed to have been an eye-witness.[1] We are also informed, in an "old little chronicle," that his bones were transferred to another place in 1641. With regard to the remains which were found, and proved to belong to the great artist, as was reported, "by incontrovertible testimony," the authorities sent the skull to the Academy of Modena, where it is still preserved, and the rest of the bones were placed in an urn in the senate-house.

Correggio's own life having been passed in such obscurity and his memory so quickly forgotten, it is not surprising to find that all record of his family was also soon obliterated. Every

[1] "Che parte ha veduto parte ha sentito da chi vede."

trace of his daughters, even the married ones, was lost at an early period. With regard to his son Pomponio, he became a painter like his father, but he did him little honour, and would have given him but small satisfaction. He was only a very mediocre artist, and the sole interest he possesses is that of being a descendant of the great master. He was born in Correggio in the beginning of September, 1521, as is proved by the baptismal register of S. Quirino, which names as his god-fathers the learned Giambattista Lombardi and one de Fassis. He doubtless received his first lessons in art from his father, but, as he lost him early in life, his example does not appear to have greatly influenced him. His character and life show him to have been quite different from his father; for, according to reliable information we possess concerning him, he gradually wasted and lost the fortune Correggio had so carefully gathered and saved up. The fortune he inherited from his father was further increased after his grandfather Pellegrino's death in 1542, and he soon after espoused Laura Geminiani of Correggio, who brought him a good dowry of 300 golden scudi. He must have been well thought of in his own town, probably out of love for the memory of his father, for the wife of his prince Ippolito,[1] the son of Veronica Gambara, stood as godmother to his first child in the year 1545. Everything seems to have gone well with him up to that date. On the 10th of May, 1539, he bought

[1] This is the same prince whose marriage to Clara of Correggio his father had witnessed in 1534.—ED.

an estate, as the document states, with the money of his grand-father Pellegrino, or rather under his direction as being his guardian, and in 1543 he purchased another estate with a house attached to it. But on the 27th of December, 1550, he sold another house, probably his father's, most likely in consequence of having wasted his landed property. He seems soon after to have settled in Reggio. In 1551, as we have already seen, Rinaldo Corso was security for him for an estate which he farmed himself. His requiring security proves that his affairs were not in a satisfactory condition. In the year 1551, also, mention is further made of the sale of this same estate, the last that he possessed in his native place, and which he sold to the priests of S. Quirino for 600 golden scudi; but he laid out 200 of this sum in purchasing property in Reggio to settle upon his wife. He did not, however, remain here; he went to Parma and found a good deal of work to do, but lost his wife whilst there in 1560. Her father, in his will dated Oct. 12th, 1559, bequeathed 100 golden scudi to each of Pomponio's four children, two boys and two girls, but nothing to his son-in-law; which seems as if he had not too much confidence in him.

Although living at Parma, he appears to have found plenty to do in Correggio as well. On the 5th of February, 1546, he received a commission, which is still preserved, to paint the chapel of Corpus Domini in S. Quirino, the church where he was baptized, for the sum of 50 golden scudi. The frescoes he executed here were whitewashed over in the 18th century. During the same year he received an order in Parma, certainly

not from any fame he had won by his own works there, but possibly the memory of the father created an interest in the son. Nothing came of it; it was an order for a wall-painting, but perhaps Pomponio was not able to go to Parma at that time. When he settled there, the architectural inspectors of the Cathedral confided to him the painting of the Capella del Popolo (particularly the flat dome). The accounts are still existing, showing that he received 80 golden scudi from the 30th of July, 1560, to the 29th of December, 1562. The part representing Moses receiving the tablets of the law, with the encampment of the people in the background, is still preserved. It is a painting, the mediocrity of which is all the more apparent in consequence of its proximity to his father's great works. Pomponio was much engaged in Parma in other ways. He executed several altar-pieces for the churches of S. Cecilia, S. Vitale, S. Francisco del Prato, as well as doing different paintings for the state obsequies of the Duke Alessandro Farnese and his wife. That he enjoyed some degree of reputation in Parma is also proved by the fact of his having been chosen umpire together with the painter Innocenzio Martini in the year 1590, with respect to a painting by Giambattista Tinti in the dome of San Maria degli Angeli. He signed himself in the document relating to this question, which still exists, *Pomponio Lieti*, Latinizing his name, as his father also did sometimes.

One of his altar-pieces is in the Academy of Parma, a " Madonna and child with Putti." The influence of his father in the invention and arrangement is unmistakable, but the figures are

coarse, the expression affected, and the colouring of a stony-like hardness; the whole is destitute of any charm. It proves how soon the great master's method degenerated in the hands of his successors. There is a "Holy Family and an Angel" in the Lochis Collection at Bergamo, which possesses the same qualities. It is probably with great justice ascribed to Pomponio. None of his works appear to have travelled beyond Parma. There is another altar-piece still existing by him in the church of S. Maria in Borgo Taschieri. It is a "Madonna and Child" between four saints.

Pomponio must have attained to a good old age. The Duke Alessandro Farnese, for whose obsequies, as before said, he painted several paintings, died in 1593, and Ranuccio Pico mentions, in a pamphlet which he published in 1642,[1] that he knew the painter Pomponio, and remarks at the same time that he was "very far" behind his father in art.

Lastly, there is an Antonio Allegri mentioned as a door and window painter, who is supposed to have been a son of Pomponio, which is not unlikely. If such is the case, it proves the decadence of the family, and that the name of the great master became lost among indigent and obscure descendants. It is perfectly true that Pomponio had a son called Antonio Pellegrino, after his father and grandfather, and in the maternal grandfather's will he is called her son Antonio. Antonio, the window painter, who is very possibly this son,

[1] Ranuccio Pico, "Appendice de' varj soggetti." Parmigiani, 1642.

carried on his trade in Carpi. In an old receipt, dated the 2nd of August, 1581, which Pungileoni saw, he signs himself "Antonio di Alegri pittore da Coregia," and deposes to having received the sum of 66 lire and 18 soldi for work done by himself and another painter in the same style, Alberto Contrafetti. This man died in Carpi on the 27th of June, 1590; in the burial register he is called "Mastro Antonio dipintore da Correggio." The family, however, did not become extinct at his death. He left a wife in great poverty and misery, and a certain Francesco Priori took her into his house and treated her with every possible kindness till her death. It is possible that Priori helped her in consequence of her connection with the great master. It seems rather strange that Pomponio, who was still living in 1590, should not have offered shelter to his daughter-in-law. But his own financial matters were not, as we have seen, in a flourishing condition, and perhaps also he had not been on good terms with his son, who had fallen into so low a position in art. There was, however, scarcely less difference in the relation between this son and his father as regards artistic merit than there was between Pomponio himself and his father.

Neither did Correggio transmit his talents to his immediate pupils and successors. We have spoken of the great influence his style of art exercised over the following epochs, but he never founded a school in the strict sense of the word. The greatest amount of influence that he exercised over his contemporaries is seen more especially in the works of Francesco Mazzola (Parmigiano), Francesco Maria Rondani, Giovanni Giarola, Michel

Angelo Anselmi, the little known painter Girolamo Bedolli, Giorgio Gandino, and Bernardino Gatti, called Sojaro, also Girolamo da Carpi, Federico Baroccio, Niccolo dell' Abbate, and the Procaccini. All these artists may be said to have followed in his footsteps, but they cannot be called his pupils in the usual acceptation of the term. The masters of the seventeenth century, who stood under the influence of the Carracci, and many of those of the eighteenth century, certainly formed themselves after his type, but they were only able to imitate his characteristics in part.

CHAPTER XII.

The Character and Significance of Correggio's Art.

Subjects of his works.—Relation in which he stood to Michel Angelo and his contemporaries.—His position in Christian art.—Perfection of sensuous beauty the latest goal in art.—Aerial perspective, foreshortening, drawing.—Light, chiaroscuro.—Approximation to Leonardo da Vinci.—Excellence in handling and technical skill.

IF we take a retrospective glance at the character of Correggio's compositions, we find them above all distinguished by boldness and simplicity. Whether he selects his themes from biblical history or classical myths, he always chooses simple incidents without elaboration of detail, or the delineation of different episodes in the same painting. Even his largest works, so rich in groups and figures, exemplify the same simplicity and unity. The "Ascension of Jesus" in S. Giovanni, the "Assumption of Mary" in the Cathedral, both alike depict the one particular event. The whole host of ministering angels, saints, apostles, and priests are merely the accompanying choir, whose voices harmonize with the same keynote. There is not one single group which expresses an inde-

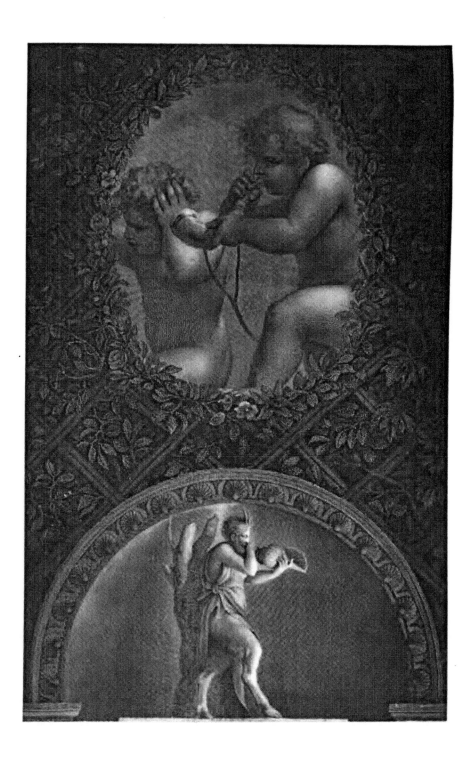

it were, by a gulf, consists in their conceptions of life. Michel Angelo, to whose artistic imagination human life ever presented itself in an earnest and serious aspect, expresses this earnestness in his monumental works in a series of pictures which personify in different degrees and under different forms the primordial, struggling powers of human life, as if they were, for the first time, brought into a distinct shape. It is this which constitutes the indescribable effect of the ceiling of the Sistine Chapel. The history of the Creation, the Fall of Man, the principal events in the history of the Israelites, &c., all these form a picture of human life in its profoundest aspect. The architectural framing and union of the different pictures with the plastic figures help to carry out the general idea. No such architectural and structural unity is discernible in Correggio, skilful as he is in his delineation of the heavenly hosts, genii, saints, and apostles, which accompany Mary in her ascent to heaven. Michel Angelo depicts the earnest side of life, Correggio the bright. The former embodies the conceptions of his mind in a variety of paintings which he unites together into one whole; Correggio treats his as a musician does the variations of his theme, making his different representations partake of the character of the one fundamental idea.

This same simplicity of thought is also discernible in Correggio's altar-pictures and mythological paintings. If sometimes, as in the " Leda," he appears to depict different moments of time, it is only that he represents the same sentiment in different stages. There is no doubt but that his artistic horizon like

his life was narrow and limited. He took but small part in the higher cultivation of his age, and did not stand in the central position which Raphael and Michel Angelo occupied in regard to the classical learning of the time. Far less than Raphael did he give expression to the ideas which influenced the century. His imaginative powers were also deficient in the richness which distinguished other masters of his artistic standing, such as Albrecht Dürer and Raphael. We may even consider him deficient in invention, if we understand by invention the capacity for representing different thoughts in different forms. Invention he had; but it consisted in the power of giving to his figures and groups an infinite variety of gesture and action. He had no fertility of idea.

Correggio consequently never attempts to deal with strong contrasts, or the contradictory elements of life. He does not succeed with scenes which involve struggle and discord. If he attempts to depict the frightful or the pathetic—as when he represents scenes in the Passion of Christ and the fate of the martyrs—he invariably fails. He certainly understood how to depict deep mental grief, provided the overwhelming moment was past, as is the case with Mary in the " Ecce Homo," and the " Descent from the Cross," or in anticipation of the event, as in " Christ praying upon the Mount of Olives." The tragical catastrophe itself, the crushing blow of fate, the master was unable to portray.

It is, therefore, only a limited scale of feelings which Correggio is enabled to depict successfully. Joyousness and plea-

sure of existence are the general subjects of his art, from the cheerfulness of happy every-day life to the ecstasy of a transcendental holiness, which raises its votary above earthly things. His figures are animated mostly by the mere pleasure of existence. They lead a life which knows neither want nor exertion, and are contented with the pleasures of the present moment unalloyed by any care for the future.

Correggio's works, moreover, possess another characteristic —the charm of physical beauty, shown in youthful figures with their budding or mature forms. Painting is able to set in an artistic light even plain forms and wasted figures, and often uses them as contrasts to heighten beauty. Correggio made no use of such contrasts. Some slight attempt is perhaps made in the " Notte," where the mystic light comes out in strong contrast with the homely forms of the shepherds. In general the inner life which the master represents is in natural harmony with the beautiful exterior, or rather it is one with the physical beauty of the body, and only exists with it and in it.

The beauty of form which distinguishes Correggio's figures does not depend upon an abstract conception of fixed rules. The artist neither sought to master laws by his own personal efforts, nor, like most of his contemporaries, strove to attain them by the study of the antique. He simply represented with perfect truth the graceful types he found around him. The individual form is depicted, moreover, in all its beauty without the defects of reality. It is this trait which invests Correggio's creations with so much attraction ; they possess all the freshness

and animation of nature, while bearing the ideal impress of a purer world.

This is especially seen in his women and children, who are distinguished by an amiability which never falls into affectation. He avoids this by the healthy fulness he imparts to their slender frames, producing thereby the proportions demanded by beauty. There is nothing mean in Correggio's conceptions, nothing of the frivolous charm of prettiness. Form presents itself to his imagination with the same grandeur of proportion as it did to Michel Angelo and Raphael. The type of his female heads is perfectly original, and bears no relationship whatever to the antique. The round oval contour of face, the strongly arched pencilled eyebrows over eyes set far apart, the small, delicately shaped nose, the mouth which seems formed for smiling, the soft chin which forms one line with the rounded cheek, the whole form possesses every requisite of beauty, and corresponds with the sentiments which animate Correggio's creations. It is probable that he copied the type of his female heads, which generally bear a close relationship to one another, from his wife. But the manner in which the expression of the faces is made to harmonize with the whole character of the composition proves the creative power of the master.

Correggio's male figures are, for the most part, of equal beauty, and are not less admired by artists. We have already remarked the animation that Correggio gave to them in the groups in which they played part. But they are deficient in that character and dignified simplicity which Michel

Angelo at all times, and Titian and Raphael in most cases, gave to their male figures. His figures also lack masculine strength.? ⟨ ⟩ This arises from the nature of the master's conception, which did not permit the display of any great muscular development. The curved serpentine lines proper to his conceptions are incompatible with the harshness of strongly rendered form, though well adapted to the soft, undulating grace natural to the figures of women and children. We have already noticed how successful the master was in depicting the latter; no artist has so well understood how to represent childhood, not only in form, expression, action, and grouping, but in innocence and joyousness of life. All the happy-looking genii and angels of the seventeenth and eighteenth centuries betray their descent in direct line from Correggio's Putti.

It matters little whether Correggio's figures are taken from sacred history or mythology, they are all equally characterized by the bloom of youth and beauty. He paints his Madonnas with the same charm and grace of form and action as his women in Jupiter's love-stories, and their smile, which expresses boundless maternal love, evinces the same depth of tenderness as in his Danae. And whether his genii are the mischievous spectators of love-scenes, or form a joyous circle around an enthroned Madonna, they are ever the same merry troop, indulging in all sorts of fun and frolic. We may blame the master, and indeed he has been blamed, for introducing into sacred subjects as well as into mythological ones beings who seem devoid of any other feeling than that of mere enjoyment of

existence. With the exception of his first youthful work, the "Madonna of S. Francis," there is not the slightest trace in his altar-pictures of religious sentiment, nor do we observe in any of his Christs that expression of elevation and sublimity which exalts him above humanity. When he portrays the Saviour in his moments of deep sorrow, he inspires less veneration than sympathy. His Madonnas with the infant Jesus have no claim whatever to the Divine, nor do they suggest the slightest idea of the supernatural.

There is no doubt but that this secularization of Christianity, which was the essential character of the Renaissance, has never been carried out so completely by any master as by Correggio. So completely, indeed, that he only uses his Christian forms as suitable figures to express his ideal of life.

It is the more extraordinary that Correggio should have secularized Christianity so much more than Raphael and Michel Angelo, seeing that he was so little acquainted with the secular learning which might have been supposed to have enlarged his mind, and freed it from the trammels of superstition. He had not the intimate knowledge of the antique which the Roman masters possessed, though he could scarcely help being influenced by it to some extent, as the whole life of the age was pervaded by it ; but what we find in his art was derived from his study of the school of Mantegna. His studies in this direction terminated with his student years, and all that he learned was at third-hand.

Raphael and Michel Angelo, on the contrary, gave up much time to the study of the antique, and, without wholly yielding to

its influence, never lost sight of the principles inculcated by it. They, nevertheless, thoroughly perceived the difference in the manner in which heathen and Christian subjects should be treated, and consequently endeavoured, in all their religious compositions, to convey an idea of the holy and divine. They, moreover, lived in the very centre of ecclesiastical power, and ecclesiastical art, in spite of external and internal revolutions, still took an elevated and sacred character. In a word, they did not represent sacred history with naïveté. Mary was always depicted as a divine Virgin, while the features of the Child expressed its holy calling as Saviour of the world.

Correggio took quite a different course. Nothing hindered him ; he followed the bent of his artistic nature in sacred subjects painted for a devotional purpose without any effort or desire to represent the supernatural, such, for instance, as is apparent in Raphael's "Transfiguration." He did not stand in any close relation with the antique, and was far removed from the struggle which the Church waged in order to retain her power in art as well as in other matters, but, quite unbiassed, showed how art could triumph over religious themes and their signification. Consequently, taking as he did only the artistic point of view, he unintentionally accomplished in painting a complete loosening of the faith of Ecclesiastical Christianity ("Auflösung des Glaubens des kirchlichen Christenthums"). He, brought up in so narrow a circle that one would have thought he would have been more than ordinarily enslaved by the religious superstitions of former times, he, of all men, proves himself to be totally

free from them, and treats the themes he is called upon to represent as if they were purely human and natural, making their ideal signification to consist only in the charm of their beauty. It was through his instrumentality, therefore, that the art of the cinque cento gave the last and decisive blow to the narrowing influences of religious superstition, and the divine character of the figures of Christ. If art now depicts any divine personality, it is only with charms proper to human nature without any relation to the divine.

It follows, consequently, that Correggio has represented his Madonnas of the same nature as the women in the Grecian love-stories, and his infant Christs as full of playfulness as the heathen genii and Cupids. Even in his saints (the mediators of the congregation) the painter makes no effort to invest them with the dignity of demeanour suitable to their high calling. Raphael and Michel Angelo's figures of Christ, although full of physical beauty, transcend nature, and point to a superhuman origin. In expression, action, arrangement, they all show their descent from a higher world, although they are exempt from the old sacerdotal character. We cannot dispute the excellence of this style of conception. It will not, however, be denied that Correggio has treated the beauty of these materials in the manner in which progressive art must continue to treat them. He corporealizes their ideal world, and makes it what it really is, a picture of the ever-recurring relations of human life. The revolution in Christian conceptions which was carried out in painting was more profound than that accomplished in Grecian mytho-

logy by means of sculpture. The old gods had no spiritual forms, and owed their corporeal existence to the hands of the sculptor. Christianity, on the contrary, attributed a purely spiritual origin to her divinities above nature and reality, and the task of investing these beings out of cloud-land with a human and natural body, and endowing them with an appearance of the warmth and vitality of sensuous life, devolved upon art. Such representations were especially suited to painting, and it was Correggio who, more than any other Italian painter, accomplished the sensualization of the Christian ideal world, carrying meanwhile the art of painting to its highest development.

The two necessarily went together. It is only when painting has attained to perfection in all its requirements that it is capable of sensualizing religious figures. This is exemplified by Rubens and Rembrandt, the two greatest northern painters. It follows naturally, therefore, that when art has reached its highest stage of development, that is to say, possesses and uses every means of imparting vitality to its creations, she must necessarily depict what she creates in the most realistic manner. It especially lies in the character of painting to seize the actual appearance of objects, their fleeting, sensuous existence, and to present the inner forces of life. And she consequently communicates the warmth and vitality of the sensuous body to ideal materials. At the same time she divests these materials of the ideal meaning attached to them, substituting the traits common to humanity and the joyousness of enfranchized human nature.

Correggio was led, through the natural bias of his art, which

inclined him to joyous and sensuous representations, to execute
both the one and the other. It is true that painting, more than
any other art, is capable of depicting grief and anguish with
truth, and we have already seen that, when he handled these
materials, he did not shrink from a representation which was
almost exaggerated in its realism. But the delineation of calm
domestic life was the theme in which his art displayed itself to
the greatest advantage. More charming than all is the youthful
mother, endowed with every grace, playing with her Child, and
surrounded with sportive genii, innocent in their joyous sen-
suousness ; the Magdalen, also, still flushed with worldly
pleasure, but raised above all sin and repentance by her pure
beauty, as she is represented in the " S. Jerome," or repenting
in the midst of her charms in solitude.

How thoroughly the love of the sensuous side of beauty and
life lay in Correggio's art is manifested in another way in his
mythological paintings. He is not satisfied with depicting the
nude form, as Titian often did, and as even Raphael has been
reproached with doing, but he seems to have considered that
a lovely, passionate woman, ready to sacrifice everything for
love, was not less worthy of the most careful painting than the
Virgin and the Redeemer. It would be, however, wrong to
reproach the master either for his choice of material or the
masterly manner in which he handled it, and we shall see later
how artistically he idealized sensuality. We must observe,
above all, that he only accomplished in these works what was
regarded as the last goal of painting. As this art represents

the appearance and form of objects as well as the expression of the soul, so also it reveals the inner meaning of the event depicted. But then it cannot exclude the moment when the soul is given up to passion and stimulated thereby to its highest rapture. This rendering of passion is quite different from the blind expression of a mere coarse instinct; it is its opposite. Passion is spiritualized, emanates from the inner life, and is consequently exalted into the highest beauty—the beauty of passion without sin and repentance. The highest art ignores the fable of the expulsion from Paradise, the dark representation of sin and contrition. Correggio in this style of conception approaches the antique, while he departs far from Christian conceptions; yet he remains modern in giving full expression to the inner life. Painting here reaches one of her grandest effects.

Correggio's capability of conveying the expression of excited feeling, the deep agitation of the soul to which Kugler draws our attention,[1] is very striking in these paintings. The expressive movement of the hands and play of the fingers shows how successful he was in investing his creations with a lifelike sentiment. He is unsurpassed in the masterly manner in which he combines animation with perfect grace of form,[2] although we

[1] "History of Painting." Second edition. Berlin, 1847, ii. 8, 9.

[2] This is exemplified even in his earliest time, as in the hands of the saint in the "Madonna of S. Francis," as well as in those of S. Catherine and of the Baptist holding the cross. The outstretched hand of the Madonna is less beautiful than that of Mantegna's "Madonna della Vittoria," of which she, nevertheless, reminds us.

cannot deny that the exceeding elegance of the movement of his women's hands in some cases borders upon affectation.

We perceive how closely connected the individuality of the master was with the progress of painting, which received through him a distinct development in modern art. That he occasionally set aside architectural and plastic laws which had long determined the character of painting, was necessary to his style of representation. He has, nevertheless, not gone farther than painting has a perfect right to do. Nothing is more unjust in this case than to accuse him of the downfall of art. This emancipation from the laws of architectural and plastic arrangement is certainly a loss, insomuch as they form the groundwork of monumental art. The union of the three sister arts, which blends the respective qualities of each into one whole, exhibits in all ages the highest perfection of art, which, in the monumental sense of the word, embodies the ideal of the epoch. But it lies in the nature of painting that so trammelled she could not have reached her highest perfection. This emancipation, consequently, although it benefits art in one respect, injures it in another. In this sense we must admit that its attainment to perfection was the first step to its downfall : for Art soon suffered from this violation of rules.

Correggio was the first to introduce into painting the principles of aerial perspective. It is true that long before his time the rules of foreshortening and the toning of colours in light and air had been brought into practice, but the latter had not before been brought to perfection. In order to give an appearance of

reality to forms moving in space, he adopted a new style of arrangement and grouping. Before his time it was customary, when figures were to be distributed in space, to arrange them in planes, in order to mark the limit of depth of the picture. In this way a certain measured rhythm of lines could be given, which, coupled with the regularity of the architectural arrangements, had often much of the beautiful flow of plastic art. This rhythm of line (*linienrythmus*) was not given up by Correggio, but he placed it second to another principle of harmony.

The master treats the individual figure according to the same law. All his figures are endowed with more or less movement, a freedom of gesture and position and variety of attitude (corresponding with the variety of the arrangement of the whole composition), which is only to be found elsewhere in the works of Michel Angelo. Both masters in this respect differ from the more tranquil action which distinguishes Raphael and the Florentines. In this lies the pictorial charm of Michel Angelo's paintings, in which, however, there is always a more sculpturesque treatment of individual form. This animated movement breaks the severity of the line in the individual figure. The curved line predominates so much in Correggio's compositions, that he seems almost to ignore straight lines. It will clearly be understood that this style of representation excludes the statuesque repose which distinguishes the ancient delineation of the forms of saints.

As Correggio endeavoured to convey as great an appearance of reality as was possible to moving bodies, and to paint them

M M

as they would appear to the eye in nature from a given point of view, he foreshortened his figures in every detail. We have already remarked to what degree of accuracy he carried this out. The paintings in the domes in Parma, foreshortened from below, with their angels and saints floating in open space, offer a striking example. The system is partly justified, as all the figures are intended to appear as if they were rising upwards. But it is truer to nature than the eye requires. We are accustomed to see things in front of us, and scarcely care to have objects represented as if they were right above us. And, independently of the disadvantages of the system which we have touched upon, the illusion is carried too far.

The masterly science which Correggio displays in his foreshortening is little short of marvellous. Exception has occasionally been taken to his drawing. His freedom of outline has been termed uncertainty, and his soft modelling, which avoids the plastic delineation of the muscular system, inaccuracy. Nothing is more erroneous than to consider it a matter of necessity that the drawing in paintings should be distinguished by hardness of outline and the delineation of anatomical details. We certainly perceive nothing of the kind in Correggio's works; but his figures evince a knowledge of the structure of the human frame, a certainty of movement, a skilfulness in the representation of the limbs in difficult positions, which has not been surpassed even by Michel Angelo.

The idealization of themes of every-day life by the artistic arrangement of lights had been attempted before Correggio's

time, chiefly by Fra Bartolommeo and Leonardo da Vinci, and was in part successful. So far as was necessary for perfection of form and modelling, these masters and those of the cinque cento generally understood the gradation of tones and the diffusion of light by means of half tones. We also find in their paintings instances of chiaroscuro, which we have learnt to regard as a distinguishing characteristic of Correggio. Fra Bartolommeo and Leonardo went further; they observed that in nature the outlines of form melt into space, and that the accurate rendering of this gradation constitutes an element of great artistic value in painting. We must especially consider Leonardo as Correggio's precursor in this respect; and how greatly he influenced our master we have already observed. But the one has completed that which the other attempted and only carried half way.

Leonardo had already seen the importance of a correct delineation of the interplay of light and shade in painting, and that it even constituted one of its most essential points. By close observation of almost imperceptible gradations of tone he succeeded in producing the semblance of perfect roundness, and, avoiding hardness of contour, modelled his figures by means of delicate transitions of light and shade ("Sfumato"). He was also the first to introduce the half tones in the charming effects produced by the reflection of light in shade. But Leonardo, probably because of his experimental nature, stopped half way. He forgot colour in his effects of light and shade, and thought that shadow destroyed colour. Moreover, as he attached

the first importance to form, he deepened his shadows in order to produce greater relief, thus injuring the half tones by making them heavy, while they ought to be always as much softened off as possible. Hence his pictures have a peculiar greyness of tone, and his shades lack transparency and warmth of colour.

Correggio, on the other hand, not only attained what Leonardo strove for, but introduced new pictorial effects. Light, not only as revealing form, but in the peculiar charm it sheds on form and colour, was an essential element in his art. He was the first to observe that in nature light shines through darkness, and his pictures exemplify his artistic powers by making the light sometimes enhance the brilliancy of tones and sometimes soften them. It is in this that chiaroscuro plays its great part. Chiaroscuro consists in the blending of light and shade, in the balance of contrasts, in the softening of lights by endless gradations, and in the lighting up of darkness by reflections. Chiaroscuro is the true artistic expression of that " life in motion" which Correggio everywhere depicts. He never sets any figure in uniform light, never divides his lights and shades into broad masses, and never places a bright light close to a dark shadow. Everywhere chiaroscuro steps in, and softens, blends, and graduates the endless variety of tones into one whole. It is easy to conceive that this play of chiaroscuro is in harmony with the ever-varying movements of objects and their true positions, and replaces, to some extent, rhythmical linear composition. His lines elude us as in nature, for every thing melts into air.

Chiaroscuro possesses another advantage. When brought to

bear upon that most delicate combination of colours, the nude form, it brings out a peculiar beauty. The lustre of the flesh and the softness of its tints are greatly enhanced by the subtle gradations of light and shade, and the brilliant grey of the half lights. The fascination produced by Correggio's pictures and their sensuous charm are greatly attributable to this use of light, as we have already remarked with respect to the "Danae." In this picture all materiality is lost in the purifying influence of light. The form has not that full-blooded life which renders the creations of Rubens so realistic.

Correggio mellows down even the local colours of drapery and landscape by the effects of the light which permeates through everything. When a bright colour is necessary he breaks it up into numberless half tones, while, on the other hand, he gives to each shade the corresponding tone of the object which casts it. Brilliant colours in his paintings are only put in to enhance the gem-like lustre of the whole.

He treats his drapery in the same artistic manner. He never gives to each material its distinctive character as the Venetians did, who represented the sheen of silk and painted their velvets and brocades in the most gorgeous hues. The careful drawing and rhythmical fall of the drapery he seems to have studied less than the artistic arrangement into broad masses upon which the light could play in delicate transitions. This treatment of drapery has been much copied in succeeding epochs.

Correggio generally enhanced the charm of his paintings by the beauty of his landscape settings, in which respect, according

to Vasari, he was unsurpassed by any Lombard artist, and we
may safely add by any Florentine. As a landscape-painter he
certainly ranks among the first artists. Painters before his time,
even Leonardo, placed their Holy Families and mythical figures
in fantastic landscapes with far distances and unusual-looking
mountains. Correggio keeps more to nature, and generally
introduces rich clusters of trees with huge trunks and luxuriant
foliage, through the vistas of which we discern a distance
bathed in light, or a wooded grove through which shimmers a
mellow, harmonious light. The flesh tones come out in favour-
able contrast with the deep green of the background, which
borders upon an emerald tint, while the beauty of the broken
light of the inclosed landscape is enhanced by the mellow effects
of the chiaroscuro. If, however, he depicts his figures in the
open air, as is the case in the domes in Parma, he makes the
dark clouds form a background for the light figures, or paints
one group lighter than the other, which is thrown into shade.

Correggio is equally successful in the artistic effects he pro-
duces in his fresco-paintings. He imparts the greatest warmth
to his flesh tones, which seen near would look almost red and
glaring, but at a right distance, mellowed down and cooled by
the intervening air, look quite correct. The effects of light and
colour in these frescoes, when they were in a good state of pre-
servation, must have been wonderful. The stream of lights and
reflections, passing off in gradations to the darkest shades, which
are, however, still illumined, forms the connecting link among
the different groups. The English painter Wilkie observes with

respect to Correggio's domes, in which criticism he evinces a true feeling for colour : " The whole effect is greatly enhanced by the differently coloured lights and shades, which produce the grandest and most harmonious effects. In colouring it is the richest and most beautiful fresco I have ever seen."

Correggio's chiaroscuro is essentially different from Rembrandt's. In the works of Rembrandt a strong light is made to fall upon one particular part, while all others pass off by gradations into the surrounding shade. In this lies the mystic character of his pictures. In Correggio's paintings everything is light, even the deepest shades : it is only in the " Notte" and the " Christ on the Mount of Olives" that we find a Rembrandt-like effect. The difference between Italian and Northern art is well exemplified in the contrast.

Correggio produced his effects of colour by the play of light and chiaroscuro, and, bright as his colours often are, they are rendered still more brilliant by this means. This peculiarity increased when our master's individuality in art became more developed. One difference showed itself in his treatment of the nude figure. His early paintings, perhaps up to the time of the production of the " Madonna of S. Sebastian," have a warm, almost glowing tone, while his later works are distinguished by the broken lustre of that brilliant yet soft grey which may justly be termed the highest charm in painting, as the grossness of matter is destroyed by the spiritualizing effects of the light, while the character of the colour is preserved.

Such perfection in painting could only have been attained by

a complete mastery over every technical means. Correggio, in this respect, has surpassed all his predecessors. He, together with the Venetians, but in a manner of his own, carried oil-painting to its highest perfection. He certainly studied their method in Mantua while quite young, as well as the art-principles and novelties introduced by Leonardo, although it does not appear how he became acquainted with the latter. But his individual studies and individual genius enabled him to attain what Leonardo only strove for.

As we have already remarked, Correggio only made use of the most expensive materials. He is said to have used a certain varnish possessing a peculiar brilliancy, and it has often been stated, even at the end of the seventeenth century by the painter Benedetto Luti, that he occasionally prepared his paintings by an under layer of gold leaf in order to increase the brilliancy and transparency of his colours. This assertion is confirmed by a close examination of some of his pictures, such as the " Reading Magdalen " in the Dresden Gallery. It is highly probable that Correggio was very careful in the selection of his pigments; but the right use of. them, so essential to the finish of artistic work, depended upon his own knowledge and skill.

It would appear that Correggio, like Leonardo, carried his modelling of the nude form pretty far in light, cool, colourless tones. Then, like Leonardo, he went to work, artistically conveying the idea of roundness by the softest gradations of shade, and passing from light to shade by the most gradual transitions. This mode of proceeding is clearly perceptible in the unfinished

painting in the Palazzo Doria in Rome, which Mengs so much admired, because he discerned the greatness of the master, and his knowledge of form, even in the under painting. But while Leonardo completed his modelling by thin layers of colour, put on with so timid a hand that he never attained to the requisite strength and warmth of colouring, Correggio obtained the grandest effects of colour by his finishing coats with light tints. There is no doubt but that he mixed his oil-colours for this purpose with a somewhat strong medium or varnish. In his early pictures, which are distinguished by the golden tone of the flesh, this is quite perceptible. He puts in his lights with heavy, rich, and smooth coats of paint, which was not the custom previously. The light tints of the flesh, as well as the shades, are also painted in equally strong impasto. The accessories, also, such as drapery and landscape, he appears to have laid on first in local colour, and to have heightened the effect in the later coats with a strong medium. In this way the nude body, already laid in in light and shade, was finished with all its soft transitions, and he succeeded in producing tones which would harmonize with the other parts without sacrificing the softness. How quickly Correggio attained his individuality in colouring is partly proved by the " Madonna of S. Francis." In this the colour is so thick that not a single outline is visible. There is, moreover, not a trace of hatching perceptible in the shades, the tones all melt and blend one into the other.

There is no doubt but that Correggio used different varnishes for the same picture according to what he deemed requisite. In

. N N

his luminous shadows he probably used the common varnish which the Italians call " vernice liquida." Eastlake was led to adopt this opinion in consequence of the cracks peculiar to that sort of varnish which are observable upon his pictures. For his flesh, however, he used amber varnish, which was particularly smooth and firm. He appears to have laid on the first coat in a light, warm tone.

Lastly, Correggio imparted the most careful finish to everything he undertook. Not a trace is to be found in his works of the method of some modern virtuosi who attempt to produce effects by a few bold strokes of the pencil. His shades of colour, lights and half lights are all carefully blended together, while they are put in with a strong yet soft impasto as delicately as if it were enamel-work. We feel the hand of the virtuoso, but we do not see it, and this manifests the ideality of his art. In all his works he remains the master who, carrying his representations of nature to the verge of deception, and depicting life in its boldest form, yet sets his creations in a magic world of happiness and immaterial beauty, perfectly exempt from care.

APPENDICES.

APPENDIX A.

CATALOGUE OF AUTHENTIC MONUMENTAL PAINTINGS.

I.

THE FRESCO-PAINTINGS IN THE NUNNERY OF S. PAOLO, AT PARMA. "Diana" over the chimney-piece. Mythological and allegorical figures in the lunettes. Sixteen groups of genii in medallions on the ceiling. Date 1518.

2. FRESCO-PAINTINGS IN THE CHURCH OF S. GIO-VANNI, at Parma. Ascension of Christ, with His twelve Apostles, in the dome. The four Evangelists and four Fathers of the Church. Frieze and Arabesques. Date 1521—24. (*A water-colour copy of the paintings in the dome, executed for Paolo Toschi's engraving, is in the Pinakothek at Parma.*)

3. FRESCO-PAINTING REPRESENTING THE CORONATION OF THE VIRGIN IN THE SMALL CUPOLA OF THE TRIBUNE OF S. GIOVANNI. This is no longer in existence as a whole, owing to the erection of a choir in place of the old Tribune in 1587, but the principal group, the Coronation of the Virgin, given here as an illustration, and several fragments of it are still preserved. Two may be mentioned in the collection of Lord Ward, in London, that are believed by Waagen and Otto Mündler to be genuine. The principal part of the fresco was copied,

before its destruction, in oil, by Annibale Carracci, and is now in the Museum at Naples.[1] The copies of Angels' Heads in the National Gallery are also thought to be by Carracci. The original hangs in the library at Parma. 1524.

4. S. JOHN. Fresco in the lunette above the door of S. Giovanni.

5. THE ANNUNCIATION. Fresco-painting, originally in the old Church of the Annunziata, in Parma, but removed in 1546 to the new church of that name. No certain information as to its origin or history, but believed to be genuine. In bad preservation.

6. THE MADONNA DELLA SCALA. Said by Vasari to have been originally painted over the Porta Romana on the outside wall of Parma, but according to Tiraboschi it was in a room in the gateway. Now in the Academy at Parma. Much injured by weather, repeated removals, and restorations.

7. FRESCO-PAINTINGS IN THE DOME OF THE CATHEDRAL AT PARMA. Ascension of the Virgin in the presence of the Twelve Apostles. The Four Patron Saints of Parma borne by genii upon clouds. 1526—1530.

A sketch for the principal painting of the dome is in the Hermitage at St. Petersburg.

APPENDIX B.

OIL-PAINTINGS, AUTHENTIC AND STILL PRESERVED.

I.

MADONNA OF S. FRANCIS, in the Dresden Gallery. Painted on wood. On the wheel at the foot of S. Catherine is inscribed *Antonius de Alegris P.* This, the earliest authentic work by Correggio, was painted in 1514—1515 for the Franciscan brotherhood at Correggio. It was afterwards in the gallery of the Dukes of Modena, and was bought, with the other Correggios of the

[1] A copy was also made, in 1587, on the new tribune by Cesare Aretusi, who, according to Affò, received 200 golden scudi for his work—about three times the amount that Correggio was paid for the original.

S. JOHN THE EVANGELIST.

Fresco over the doorway in the Church of S. Giovanni, Parma.

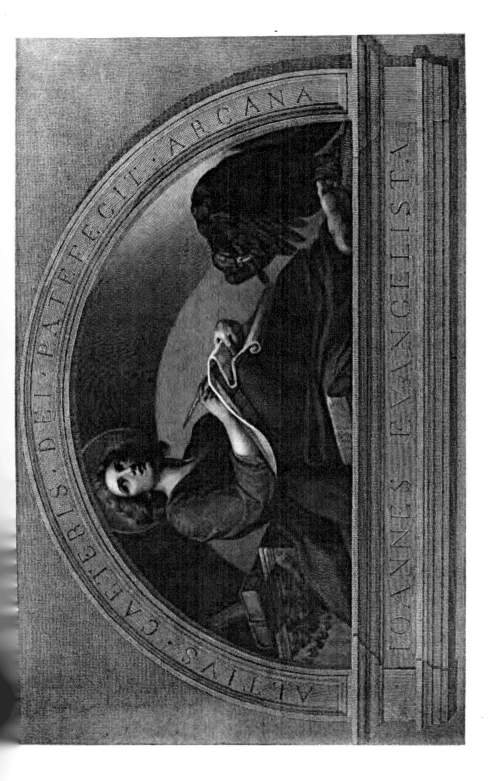

Dresden Gallery, from the Duke Francesco di Este-Modena, by the King August III., of Poland, about the year 1745. Restored in 1827 by Palmaroli.

2. MARTYRDOM OF SS. PLACIDUS AND FLAVIA.

3. PIETA. Both these pictures were painted for the Benedictine Don Placido del Bono, and were placed by him in the chapel he founded in S. Giovanni. They are now in the Academy at Parma. 1522—1524? Old copies of these two works are ascribed to Correggio in the Madrid Gallery.

4. LA NOTTE, or THE HOLY NIGHT. The commission for this picture was given to Correggio in October, 1522, by Alberto Pratonero, of Reggio, but it was not placed in the Church of S. Prospero, for which it was painted, until 1530. The Lords of Modena tried to gain possession of this picture in the sixteenth century, but did not succeed. In the following century negotiations were renewed, and, in the end, it was carried off secretly in the night out of the church of S. Prospero, and delivered over to the then Duke of Modena, Francesco I. This is stated in a document dated 1640, still preserved in the church. A copy was afterwards given to the church by way of some compensation. The "Notte" is now one of the chief treasures of the Dresden Gallery. It is in good preservation, only the azure tints of the high lights have somewhat suffered, and the shadows grown darker.

5. THE MADONNA OF S. SEBASTIAN. The Virgin is enthroned on the clouds surrounded with angels and cherubs. Beneath are SS. Sebastian, Geminianus, and Rochus. Painted for the brotherhood of S. Sebastian, in 1525. Now at Dresden. This picture has suffered much from repeated restorations and over-painting; but it was satisfactorily cleaned and restored by Palmaroli in the present century, so that its present condition does not appear very bad.

6. MADONNA DELLA SCODELLA, or FLIGHT INTO EGYPT. Very probably originally painted for the Church of S. Sepolcro, in Parma, where it remained for 270 years. Many attempts were made in the eighteenth century by princes and other persons to gain possession of this lovely work, but they were not successful. It was carried off to Paris during Napoleon's wars in Italy, but was restored, and is now in the Academy at Parma. Painted on wood. 1527 or 1528.

7. S. JEROME, or IL GIORNO. The Virgin and Child, S. Jerome and the Magdalen. This picture was commissioned in 1523, by a certain Donna Briseide Colla, who paid the painter 400 imperial lire for it—that is about £15 of our present money, and just double the sum that he received for the "Notte." It was placed in 1528 in the Church of S. Antonio Abbate, at Parma. Many offers were made for the purchase of this celebrated picture in the eighteenth century, but the municipality would not part with it, and on one occasion appealed to the Infant Don Filippo of Spain, who, for its better protection, had it placed in the cathedral under the care of the chapter, and afterwards in the Academy that he founded at Parma, where it still remains. It was carried away to France, however, in the time of Napoleon, and had a narrow chance of not being returned. It is said that the French Government offered a million francs for it. It was chiefly owing to the exertions of the engraver, Paolo Toschi, that it was restored, in 1816, to Parma. A great many copies of the "S. Jerome" are to be met with. One in the Bridgewater Gallery is supposed to be by Lodovico Carracci. 1527—1528?

8. MADONNA OF S. GEORGE. The Madonna between S. George, S. Peter Martyr, S. Geminianus, and the youthful S. John the Baptist. Painted for the brotherhood of S. Pietro Martire, of Modena, and placed as an altar-piece in their church about 1530—1532. The brotherhood appear to have held their altar-piece in great honour, for in 1578, when a young painter came, with high recommendations, to copy it, he was refused on account of the harm he might do the picture. Nevertheless, the Duke of Modena, Francesco I., contrived to gain possession of it in 1649, sending a copy to the brotherhood.

The "S. George" passed, with the other pictures of the Modena collection, into the possession of August III., and from thence to Dresden.

A picture-restorer in Milan, named Carlo Frigeri, claimed at the beginning of the present century to be in possession of a genuine repetition of the "S. George," and wrote a pamphlet about it. Nothing more, however, has been heard of this work. Vasari states that Girolamo da Carpi copied it, but, if so, his copy has disappeared. One by Cesare Aretusi still hangs in the Church of S. Barnabas, at Mantua.

APPENDIX C.

OIL-PAINTINGS, AUTHENTIC BUT NOT PRESERVED.

I.

THE FLIGHT INTO EGYPT, WITH THE KNEELING S. FRANCIS. This was painted for the Minorite church of S. Francesco, at Correggio, and hung over the altar of the Conception. In 1638, however, this altar-piece disappeared, and was replaced by a copy; a circumstance that caused such a commotion in the little town that the bells were rung, and all classes of people assembled and brought their complaints about the robbery before the town council. It appeared that some time before a painter named Giovanni Boulanger, in the Duke of Modena's service, had gained permission to copy the Franciscan altar-piece, and, doubtless, with the connivance of some of the fathers, had succeeded in substituting the copy for the original that he carried off to his ducal lord. Deputations were accordingly sent to the Duke Francesco I., of Este, who was at that time Lord of Correggio, and even the Pope was appealed to on the subject, but all to no avail. The monastery certainly received a grant of land, but the poor townsfolk never got back their altar-piece. How the picture came to disappear from the possession of the House of Este is not known, but undoubtedly the same composition in the Uffizi Gallery, that passes there for the original work, is only a copy. It is, however, no doubt, a faithful rendering of the original, and, as such, shows us at least the composition of the lost work. There are several other copies of it known, from one of which the engraving has been prepared, but even the substitution copy by Boulanger has now disappeared from the forlorn Franciscan church at Correggio.

The picture-dealer, Giuseppe Vallardi, claimed in 1830 to possess an original replica, but probably this was only one of the copies. Painted in 1515 or 1516.

2. TRIPTYCH: GOD THE FATHER BETWEEN THE YOUTHFUL S. JOHN WITH A CROSS AND S. BARTHOLOMEW. This was painted

for the brotherhood of the hospital of S. Maria della Misericordia at Correggio. The centre picture of God the Father in a glory of angels' heads has sometimes been held to be the Son.

Pungileoni quotes the deed of sale by which on the 23rd of November, 1613, this work passed from the possession of the brotherhood of the hospital into that of Don Siro of Austria, the last Lord of Correggio, for the sum of 300 ducats. The subject was described as "Tres imagines seu effigies pictas manu qu. egregii Viri Antonii de Corrigio Pictoris famosissimi, S. Dei Patris Omnipotentis, S. Johannes, and S. Bartholomaei," the three parts of the altar-piece being reckoned as three pictures. The picture was properly valued by the painter Jacopo Barboni of Novellara, and the sale conducted according to rule and order, so that there can be no question here of robbery. A copy was also given to the brotherhood by Don Siro. It is not known what has become of this work. Tiraboschi believes that Don Siro took it with him to Mantua, and that it perished in the sack of that town by the Imperial army in 1630, but Don Siro gave some pictures by Correggio into the care of the Count Gonzaga di Novellara in 1634 or 1635, and probably this was among them. A picture corresponding to the middle portion was considered in the seventeenth century to be genuine. It was then in the possession of the painter Niccolò Renieri, but it was probably only a copy. That in the Vatican in which the Saviour is standing on the rainbow has also been considered the original centre portion of this triptych, but it is only a copy, very likely the above-named copy by Barboni, or that belonging to Renieri. 1516?

3. BIRTH OF THE VIRGIN. Altar-piece for the Church of Albinea. Respecting the origin of this picture see page 100. Francesco I. of Este, Duke of Modena, who, as before stated, had already managed to steal away a work of Correggio's from the Franciscan Church at Correggio, as well as "Il Notte" from S. Prospero at Reggio, contrived to gain possession of this picture also. He went to the elders of the town council of Albinea, and found them ready to treat with him about it, only a priest named Don Claudio Ghedini would not give his consent. As this was needed, a groundless charge was brought against him of having spoken ill of the duke, and he was imprisoned for six months. Meanwhile the elders "with armed hands" took the picture out of the

church and gave it to the duke. In consideration of this the commonalty were released from certain obligations. According to Pungileoni a sum of 7,476 lire, that the citizens owed to the duke as a wedding present, was to be paid to the Church instead. But this was not paid, and the strife between the town and the Church still went on, and at last in 1706 the town was laid under an interdict. It was not until 1758 that a compromise was effected whereby each party received 50 zechins, and the duke, as he had done in the case of the " Notte," undertook to have a copy of the picture executed by his court painter Giovanni Boulanger hung in the church. If this was done the copy also must soon have disappeared ; for the copy that Pungileoni and Venturi took for it, was certainly a copy of a picture by Correggio, but not of this one. It represented the Madonna between SS. Magdalen and Lucia.

The original disappeared at an early date. It was no longer in the Modena Gallery when its Correggios were removed to Dresden. It has been found that Alfonso II. of Modena at the beginning of his reign made a present to the Emperor Leopold of some beautiful horses and " several paintings by the divine Correggio." It is possible that the " Birth of the Virgin " was one of these, but such a picture is never mentioned as being in the Vienna Gallery or in the Imperial collection.

APPENDIX D.

PAINTINGS THAT THERE ARE GOOD REASONS FOR CONSIDERING AUTHENTIC.

I.

MARRIAGE OF ST. CATHERINE in the Louvre. This has always been accepted as an undoubted Correggio, although its original destination and its first possessor are not known. According to Vasari, the Doctor Francesco Grillenzoni, who lived in Modena and was on intimate terms with Correggio, had such a picture in his possession about the year 1530 or 1535. This he mentions in his life of Girolamo da Carpi, who copied

the said picture. In his life of Correggio, Vasari merely states that he painted a picture of the Virgin at Modena, but there is no indication that the same picture is meant in both places. Bottari in his edition of Vasari speaks of another origin that is perfectly impossible; namely, that Correggio painted it for Bastiano, a lay brother of the convent of S. Pietro Martire, whose wife was named Catherine, because this Bastiano had procured for him the commission to paint the " S. George" for the convent. But the " S. George" was painted twelve years after the " Marriage of S. Catherine," so this could hardly be. Bottari further remarks that this work passed from the possession of Grillenzoni into that of the Cardinal Luigi d'Este, and from thence into that of the Countess of Santa Fiora. It certainly belonged to the latter family at the end of the sixteenth century, for a report of the Imperial Vice Chamberlain Coradusz to the Emperor Rudolf II. in 1595, mentions, among other works of art that might be bought in Rome, " A Madonna with S. Catherine and S. Sebastian by Correggio," in the possession of the Countess of Santa Fiora. There can be little doubt that this was the Louvre picture. It passed next into the hands of the Cardinal Francesco Sforza di S. Fiora, and when he died in 1624, according to Tiraboschi it passed to the Cardinal Ant. Barberini ; but Sandrart affirms that he saw it in Rome in 1634 in the house of the Cardinal Scipio Borghese. It could not have been in the cardinal's possession, however, at this time, for he had died in 1633, but it might have remained in his house for some time after his death. Sandrart furthermore relates that he wished to buy the picture for 6,000 scudi, but could not obtain it at that price. According to him a certain countess (probably she of Santa Fiora) brought it with other master-works to Rome. There is no doubt that the question is throughout of the same picture. Perhaps Cardinal Borghese had it before it came to Cardinal Barberini, to whom it certainly belonged in the year 1650. The latter cardinal took it with him to Paris, and there made a present of it, as it would appear, to Cardinal Mazarin. In the inventory of Mazarin's effects it was valued at 15,000 livres, and was sold by his heirs to Louis XIV.

The " Marriage of S. Catherine" has been often copied. In the catalogue of the pictures of Charles I. of England, an old copy is mentioned (possibly that now in the Bridgewater Gallery) as being by

Lodovico Carracci. Annibale and Agostino also both copied it. Painted 1517—1519?

2. MARRIAGE OF S. CATHERINE in the Naples Gallery. Small figures. Somewhat different in composition to the picture in the Louvre. (See text, p. 97.) In the catalogue of the old Farnese Gallery that was afterwards removed to Naples, it is described as a *Piccolo sposalizio di S. Catterina,* and assigned to Correggio, while another picture of the same subject is marked as a copy. This was probably the one painted from the larger picture in Paris by Annibale Carracci. Scannelli saw both pictures in the gallery of the Duke of Parma in 1670. 1517—1519?

3. THE VIRGIN ADORING THE CHILD, in the Uffizi, Florence. Small figures painted on canvas. Although the origin of this picture is not known, its authenticity is not doubted, on account of the playful mode of representation of the subject, and the entirely Correggesque style of the painting. Even the very hands betray the touch of the master in their wonderful grace, and the life that seems to move in each single finger.

According to the catalogue of the Uffizi, this picture was a present from the Duke of Mantua to Cosmo II. di Medici, and was placed, in 1617, in the Florentine Gallery. How the Duke of Mantua obtained it is not stated. There used formerly to be an old copy in Vienna that passed for an original repetition. 1519?

4. MADONNA DELLA CESTA. *Vierge au Panier,* in the National Gallery. Painted on wood. Formerly in the Gallery at Madrid. Vasari, in his life of Girolamo da Carpi, speaks of a "wonderfully beautiful" picture representing the Virgin putting a little shirt on to the Child, that belonged to the Cavalier Bajardo, of Parma, and was copied by Girolamo da Carpi. Probably this is the London picture. In the same place, however, Vasari mentions a painting by Parmigiano, in the Certosa at Pavia ; and Bottari is of opinion that he confused the whereabouts of the two paintings, and that it was really Correggio's that was at Pavia, and passed from thence into Spain ; only it is not clear how a picture by Correggio could have got to Pavia at that early date.

The "Vierge au Panier" was, at all events, at one time in the royal collection at Madrid, and was given by Charles IV. of Spain to his minister, Don Manuel Godoz, Prince of the Peace. After falling into

various hands during the French invasion of Spain, it was bought, in 1825, by M. Nieuwenhuys, at the sale of the Lapeyriere collection in Paris, and sold by him soon after to the National Gallery for £3,800. Waagen is inclined to place this work in the later time of the master, on account of the exquisite smile of the Madonna, and the breaking up of the local colours; but we have seen how soon Correggio perfected himself in his art, and there are no especial features in this picture that point to a late date. Small alterations appear to have been made in it by Correggio himself. Possibly the unskilful position of the right hand of the Madonna results from these. Moreover, the right arm and leg of the Child have suffered materially. Besides the copy by Carpi, there are several others—one by A. Carracci, and another old one in the Dresden Gallery. Girolamo Mazzola also mentions one in the Boscoli collection. 1520?

5. The ZINGARELLA, or MADONNA DEL CONIGLIO. The Virgin with the sleeping Child, under a palm-tree. In the Naples Gallery; to which it was brought, with 100 other pictures, from the Farnese collection at Parma, by Charles III. of Naples, in 1740, or soon after.

In 1587 this picture is mentioned in a catalogue of the effects of the Duke Ranuccio Farnese, and in the testament of this prince, dated July, 1607, he bequeaths it as a legacy to his sister, Donna Maura, in the following words:—"Eidemque serenissimæ Donnæ sorori meæ lego, et jure legati relinquo in signum dilectionis quam in ipsam sororem meam semper habui, et habeo, Tabellam, vulgo dictam un quadretto, cum Imagine Beatissimæ Virginis Mariæ, pictam manu Antonii Corrigii, jam pictoris celeberrimi, nuncupatam la Cingara, quæ nunc reperitur custodita inter omnia bona mea mobilia penes Equitem Flaminium Zunthium."

The picture must nevertheless have remained at Parma in the Farnese collection, for it is mentioned after this in a manuscript catalogue, and also the painter Giacomo Barri saw it there when he wrote his "Viaggio pittoresco." The statement of Richardson, that it was originally painted for a cardinal of the house of Farnese, is a mere unsupported supposition. It has suffered in places from over-painting. Richardson and Mengs both assert that they found it in an utterly spoiled condition, but such is not the case. Probably a part of the over-painting has been removed since their time. There are a great number

THE MADONNA IN GLORY.

S. JEROME, S. JAMES, AND THE DONOR.

In the Munich Gallery.

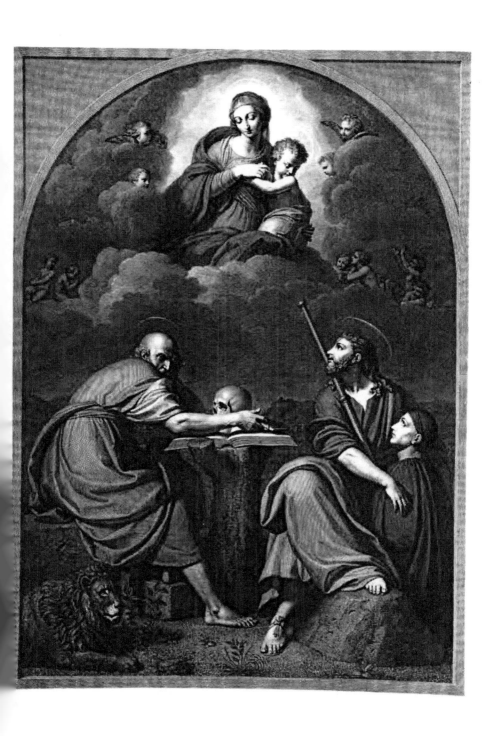

of copies of this work, several of which have passed as repetitions. One ascribed to Annibale Carracci was formerly in the Richardson collection, and another in gouach that passed for a long time as an original sketch was formerly in the Sylvestre cabinet in Paris. 1520?

6. MADONNA HUSHING THE INFANT JESUS. The original probably in possession of the Prince Torlonia, at Rome. In this picture either an angel or a little S. John the Baptist offers the Child fruit. It is described in an old treatise on painting, of the year 1652, (*Odomenigo Lelonetti, Trattato della Pittura,*) as a "Madonna by Correggio hushing the infant Jesus, who stretches out his hands towards some fruit that is offered to him by an angel." In the example now known, the Child only stretches forth one hand, and holds its mother's breast with the other, but no doubt the same work is meant, though which of the three examples was seen by this writer is not easy to make out, as all traces of the work in question seem to have disappeared since the end of the seventeenth century. Lelonetti, or Ottonelli, as he is more correctly called, affirms that it was in the possession of the Cardinal Aldobrandini in the time of Clement VIII. (1592—1605), that it then passed to his nephew, Cardinal Ippolito, from whom it was inherited by the Prince Rossano, who gave it to the cardinal of S. Giorgio, at whose death it was sold for 1,300 scudi to a certain Gotifredo Periberti, who was its possessor in Ottonelli's time.

Pater Resta speaks of two pictures of this subject, and affirms that one was in the possession of the Marchese del Carpio, a fact that is confirmed by an engraving of it having been executed by Teresa del Po for the marquis; the other Pater Resta himself bought from an old Roman family, and then gave up to the Marchese Corbella, of Milan. Resta likewise states that he possessed a drawing of this subject. The del Carpio example is doubtless the one that passed into Spain and afterwards to St. Petersburg. Whether the second example he mentions has disappeared, or is one of those still in existence, is impossible to say. Possibly it is the Roman example that Mündler mentions in 1844 as being in the possession of the Count Cabral. It is painted on canvas, and now belongs, we believe, to Prince Torlonia.

7. THE SAME REPRESENTATION is to be found in the Esterhazy Gallery at Pesth; only here, instead of S. John the Baptist, it is a little

angel who offers fruit to the Child. It is painted on canvas, and is somewhat injured.

8. THE SAME REPRESENTATION, in the Hermitage at St. Petersburg. On wood. Not thoroughly authenticated, but bearing such strong indications of the master's character and hand that it is difficult to suppose that it can be by a follower. According to Waagen, this example was formerly in the possession of Charles IV. of Spain, but this is not possible, as in Charles's time it had already, Mengs affirms, reached Russia, and was in the hands of the Empress Katherine II. There are various other accounts given of the history of this picture, but none seem thoroughly authenticated.

9. CHRIST IN THE GARDEN OF GETHSEMANE. Small picture on wood, in the possession of the Duke of Wellington, at Apsley House. This picture is often mentioned, even by writers of the sixteenth and seventeenth centuries. For the tradition respecting its origin, see p. 136. A totally different account is given in a letter of the painter Lodovico David (published by Campori, "Lettere artistiche inedite"), who, as before stated, made researches into the facts of Correggio's life at the beginning of the eighteenth century. In this he says that he had found in an old account book belonging to the Count Claudio Rangoni of the end of the sixteenth century, an entry stating that the said count had given 45 Modena lire for a picture by Correggio, of the year 1520, representing "Cristo nell' orto," that is to say—in the Garden of Gethsemane, and according to the wording of the entry it would seem as if Rangoni had bought this work from the master himself. It is not stated, unfortunately, where the Rangoni family resided—whether in Reggio or Parma ; and as the reply to David has not been preserved, and the papers of the family dispersed, it is impossible now to come at the rights of the matter. The date, 1520, appears suspicious, as well as the circumstance that an account of the end of the century should contain an entry of such a much earlier date. Lomazzo, who relates the anecdote of the apothecary, says that "during the last years"—that is before 1590—"it was bought by Pirro Visconti for 400 scudi." Scannelli further affirms, on the authority of the painter, Luigi Scaramuccia, that such a work was recently bought (before 1650) from Count Pirro Visconti by the Marquis of Carazena, of Milan, for 750 Spanish doubloons. If so, it

must have increased sixfold in price. Mengs and Tiraboschi add to
this that Carazena bought it as a commission from Philip IV. of Spain,
but Scannelli says nothing of this. The information appears to rest with
Pater Resta, at least it is first mentioned in one of his letters. He
relates that Philip IV. bought the picture for 750 doubloons, which sum
was really paid by the Marquis Serra, although the Marquis Carazena
appeared to conduct the transaction. Resta's father transacted the
business of changing the Spanish money into Italian coinage. Possibly
this roundabout way of proceeding was in order to get the picture
cheaper by only letting Carazena appear as the purchaser. At any rate,
the picture now in England was, in the second half of the eighteenth
century, in the royal palace at Madrid in a cabinet of the Princess of
Asturias. In the Spanish and French war, after the battle of Vittoria,
it was taken by the English from the carriage of Joseph Buonaparte,
who was making off with it. The Duke of Wellington restored it to
Ferdinand VII., but that monarch sent it back again as a present to the
victorious general. Hence its present abode at Apsley House.

There are innumerable copies of this celebrated picture, some of
which have formerly been passed off as repetitions. One old copy is in
the Uffizi at Florence, another at St. Petersburg, and a third in the
National Gallery. This last formed part of the Angerstein collection,
and was bought as an original for £2,000. 1519—1525.

10. THE READING MAGDALEN. At Dresden. Painted on copper.
No kind of information respecting its origin and first destination.
Baldinucci in his life of Christofano Allori describes an entirely similar
painting, "A Mary Magdalen in the desert almost covered with a blue
robe," as being in the collection of the Cavaliere Nicolò de Gaddi at
Florence about 1600. It was then considered an original work of
Correggio's, and as such was copied by Cristofano Allori. Very possibly
it was ; only in that case it must have passed into the possession of the
Duke of Modena early in the seventeenth century, for he undoubtedly
possessed the original work. In the eighteenth century it was most
carefully kept in the so-called golden chamber of the castle at Modena,
where it was set in a costly silver frame ornamented with precious stones,
and inclosed in a case that was only opened on state occasions. It owes
its excellent state of preservation to this extreme care. It was among

the pictures bought of the Duke of Modena for Dresden in 1745-1746, and was valued by itself at 27,000 scudi. It appears to have been sold in its costly frame. In 1788 it was stolen from the Dresden Gallery by a burglar named Wogaz, but was discovered in his house, and placed again in the gallery, where it has remained ever since, only without its original frame.

Old copy that formerly passed for an original in the possession of Lord Ward in London.

Copy by Christofano Allori in the Uffizi. Other copies. Painted probably between 1530 and 1533.

11. JUPITER AND ANTIOPE. In the Louvre. Almost life size. This title was only given to it in recent times. It used to be called a " Sleeping Venus, with Love and a Satyr." It is first mentioned in a catalogue of the art treasures of the Gongaza collection in 1627 without the name of the master, so at that time it could not have been known for certainty that it was a work by Correggio. This speaks against the supposition that it was painted for Federigo of Mantua by our master ; in such a case it would certainly have been known as Correggio's. In 1630 it was in the possession of Charles I. of England, to whom it came with the greater part of the Gonzaga collection, that was sold according to Waagen (" Treasures of Art in Great Britain ") to the Duke of Buckingham for the king, for the sum of £80,000. This purchase, however, could not have taken place as Waagen considers in 1629, for the Duke of Buckingham was murdered in 1628. Some newly discovered documents also give a different account of the purchase of these pictures.[1] According to these papers, it was Nicholas Lenier, the learned music-master of Charles I., who concluded the purchase, in conjunction with the French picture-dealer Daniel Nys. In a letter from Nys to Lenier of the 27th of April, 1628, he tells his correspondent that he, Nys, had concluded the purchase of a large number of pictures from the Duke Vincenzo II. of Gonzaga, and that amongst them was a " S. Katherine" and a " Venus with Mercury and Cupid " by Correggio, and other works. Nys further relates that when the people of Mantua heard of this sale they were so angry

[1] Noel Sainsbury. "Original Unpublished Papers Illustrative of the Life of Sir Peter Paul Rubens as an Artist and Diplomatist." London, 1859.

and excited that the duke would have paid double to get his pictures back again. His subjects also would willingly have borne the cost of so doing. They were however shipped to England in 1628 in the Margherita, commanded by a certain Thomas Browne, Nys having settled the matter by the payment of 68,000 scudi.

The "Marriage of S. Catherine" alluded to was probably only a copy of the work in the Louvre, but amongst the "other works" was no doubt the "Jupiter and Antiope."

At the public auction of the art collection of Charles I. that was held by the Parliament after the king's death, this picture was bought by the well-known connoisseur, the banker Jabach of Cologne, then living in Paris. It had been valued in the catalogue of the sale at £1,000. It passed from Jabach's collection to Cardinal Mazarin, and finally into the possession of Louis XIV. It is one of the best preserved pictures of the master, although it has been transferred to canvas, and the impasto by this means somewhat injured. 1521-1522?

12. THE SCHOOL OF LOVE, OR EDUCATION OF CUPID. In the National Gallery in London. Mercury sits in a landscape teaching the youthful God of Love to read. A winged Venus stands beside him. Origin unknown. This work is first mentioned in the Gongaza inventory of 1627, already quoted regarding the "Jupiter and Antiope," and passed in the same way into the possession of Charles I. It fetched £800 at the sale of the king's collection, and was afterwards bought either by Don Alonso de Cardenas, Spanish Ambassador from Philip IV., or, as the National Gallery catalogue states, by the Duke of Alva. It subsequently became the property of the Prince of Peace, in whose collection it was at the time of the occupation of Madrid by the French. Murat, afterwards King of Naples, then got possession of it and took it with him to Naples, and after his death it was sold, together with the "Ecce Homo," by his widow, the ex-Queen of Naples, to the Marquis, who in his turn sold it to the National Gallery in 1834 for £11,500. The "School of Love" is considerably damaged. Even in Mengs' time it was already in a bad condition, and has grown worse rather than better since it came to England. Besides the smaller re-touches that let the original colour be seen through them, there has been a great amount of re-painting on the right leg of Venus, and on her

face, under the nose, and on the right side and both legs of the Mercury.
Waagen is of opinion that if these re-touches were removed the picture
would be greatly improved.

Four known copies of this work in various collections. 1522-1525?

13. GANYMEDE BORNE ON AN EAGLE TO OLYMPUS. In the Belve-
dere at Vienna. On canvas. This picture has greatly suffered, espe-
cially in the landscape. It probably came to Vienna from Spain, for
towards the end of the sixteenth century it formed part of the rich
collection of the Spanish Secretary of State, Antonio Perez. When,
however, Perez, the favourite of Philip II., fell from royal favour, his
possessions passed into the royal treasury, his pictures as well as the
rest. Rudolf II. of Austria appears, however, to have been in treaty
before this for the purchase of the "Leda" and the "Ganymede," and
his ambassador, Graf Khevenkiller, succeeded in gaining possession of
them for him in 1603. Their arrival in Prague, however, is not noted,
nor do we find the "Ganymede" in the catalogue of the art treasures of
Prague at the beginning of the seventeenth century. Perhaps this was
because it was at once taken to Vienna, for the "Leda" that came with
it from Spain is quoted.

In 1702 a "piece by Correggio representing the rape of Ganymede"
is mentioned as being in the Schatzkammer at Vienna. It is evident,
therefore, that it always passed at Vienna as a work by Correggio, though
while it was in Spain it was assigned to Parmigiano. It is not a very
characteristic work of Correggio, and therefore might easily have got
attributed to Parmigiano, who in his good pictures greatly resembled
our master.

How the picture came into the possession of Perez is not known.
Probably it was a present of Philip II. to his influential favourite. It is
possible that it had belonged to Charles V., but there is no certain
foundation for asserting that it did.

14. IO EMBRACED BY JUPITER IN A CLOUD. In the Belvedere at
Vienna. Life size. On canvas. The picture in the Berlin Museum is
only a good old copy. Whether this picture was originally painted for
the Emperor Charles V., like the two following ones, is not clearly
ascertained. Lomazzo affirms that the sculptor Leone Leoni of Milan
possessed "two pictures by Antonio da Correggio, distinguished by their

wonderful effects of light—'Io with Jupiter in a Cloud,' and 'Danae;'" these had been sent Leoni from Spain by his son Pompeo, who was likewise a sculptor, and greatly employed by the Spanish Court. The painter Lomazzo was a contemporary of Leoni's and had seen the paintings in his possession, and undoubtedly held them as genuine, for he wrote an enthusiastic sonnet in their praise.[1]

Leoni was himself for a long time in Spain in the service of Charles V. and Philip II., and was regarded by the first with great favour. It is possible that the pictures may have been given to him or his son as a mark of regard by the emperor. It seems certain, at all events, that Leoni possessed the originals, and that they were bought from his son Pompeo Leoni by the same imperial ambassador, Graf Khevenkiller, who had negotiated the purchase of the "Leda" and "Ganymede."

Khevenkiller writes to his master from Madrid, on the 7th of July, 1600:—"I will treat with Don Pompeo Leoni for his pictures on the first opportunity, and as if they were for myself," adding, "they are now at Milan." Pompeo wanted 800 ducats for them, which Khevenkiller refused to give. The transaction, however, must have been satisfactorily settled, for we find the "Danae" mentioned in the Prague catalogue at the beginning of the seventeenth century. The "Io" does not appear, but that had probably been taken to Vienna. It is, indeed, mentioned by Tolmer as being in the Schatzkammer there. It is considerably damaged, especially the left hip of "Io."

An old copy is in the possession of Count Gongaza di Novellara that formerly passed as an original. It is called in the catalogue "A Dream" (*Sogno*). 1530-1532?

15. LEDA SURPRISED BY SWANS WHILE BATHING WITH HER COMPANIONS. In the Berlin Museum. On canvas. Most probably painted as a commission from the Duke of Mantua, Federigo II., for a present to the Emperor Charles V., as well as the following picture, the "Danae." As there was no exact information as to how these pictures came into

[1] "Trattato della pittura." The sonnet is in the seventh book of the Trattato, with other poetical effusions relating to painting. It especially extols the colouring of the paintings. Other masters may be greater, he says, than Correggio, but there is no escaping the effect of his pictures.

Germany, it was long supposed that the above account was a myth, and that they remained in the possession of the Duke of Mantua until his town was taken by the Imperialists in 1630, and the Gongaza collection dispersed, when they passed into the hands of Christina, Queen of Sweden. But in the before-mentioned catalogue of the pictures of the Gongaza family in 1627 these works are not enumerated, nor do we find them in the small choice collection of Isabella Gongaza. No mention is made of them, indeed, in Italy since the time of Vasari until the second half of the seventeenth century, with the exception of Lomazzo's notice of the "Io" and "Danae" at Milan. This seems clearly to prove that they could not have remained in Italy. Furthermore, recent researches have proved that they passed into Germany at an early date. As before remarked under the "Ganymede" (No. 13), the "Leda" was at one time in the collection of Antonio Perez, and after his fall was bought with the "Ganymede" by Khevenkiller for Rudolf II. In the Prague catalogue of about the year 1621 it is designated "Leda with several women bathing, an excellent piece by Correggio." Doubtless when Prague was taken in 1648 by the Swedes it was carried off as booty to Stockholm. In a manuscript catalogue of the collection of Queen Christina preserved at Stockholm, it is quoted as "un grand tableau avec plusieurs femmes dont l'une tient un cigne entre ses bras." An absurd story is told, that this picture and the "Danea" while in Sweden were not thought of any value, and that Sebastian Bourdon, Court painter to the Queen Christina, discovered them set up in two windows of the royal stables and used as a protection against the weather. The whole relation is evidently false. In 1722 the queen's collection, after passing through several hands, came into the possession of the French Regent, Philippe of Orleans. Afterwards Louis the Pious, son of the Regent, incited thereunto by his father confessor, the Abbé de Saint Geneviève, was so greatly shocked at the expressive heads of the "Io" and the "Leda," that he had them both cut out of the pictures, and is said to have mutilated the "Leda" still further, so that many of its fragments were lost. It is even said that the pictures would have been burnt, but that fortunately they fell into the hands of Charles Coypel, the Duke's court painter. Either he contrived to save them secretly from their proposed fate, or else they were given to him as a present. Coypel, according to Landon, tried to get

both Van Loo and Boucher to restore the heads, but both these painters feared to meddle with a Correggio. At last Coypel himself, or a painter named Deslyen, painted them in. At the sale of Coypel's artistic effects after his death the "Leda" was bought by the collector Pasquier for 16,050 livres, and at Pasquier's sale in 1755 was bought by the Count Epinaille for Frederick the Great for 21,060 livres. In 1806 it was taken by the French out of the Palace of Sans-souci, but was restored to Germany in 1814, and has been in the Berlin Museum ever since 1830. As may be imagined, the picture was in a very bad state by the time it got back to Germany. It had been, for one thing, almost entirely repainted when in the possession of Frederick the Great, but it has been thoroughly cleaned and restored of late by Schlesinger, who has painted in a better head of Leda than it had before.

A repetition in the Palazzo Rospiglioso at Rome. 1530-1532.

16. DANAE LYING ON A COUCH, WITH LOVE AND TWO PUTTI. In the Borghese Gallery at Rome. On canvas. This picture had originally the same destination as the "Leda," and went with it to Spain. Afterwards it shared the fate of the "Io" and was taken to Prague, where it remained, while the "Io" in all probability was carried to Vienna. In the oft-quoted Prague catalogue it is designated "Danae in the golden rain, a beautiful piece by Correggio." In the Swedish catalogue of 1652 it is called "un grand tableau où est représenté une femme, un Cupidon, et deux petits garçons qui éprouvent de l'or."

How it escaped mutilation when it passed into the possession of Louis of Orleans is not clear. Perhaps the fanatic Louis and his modest father confessor did not observe it.

When the Orleans collection was sold it fetched 650 guineas, and in the year 1816 it was purchased by Henry Hope for £183; was afterwards sold in Paris for £285, and finally passed into the collection of the Prince Borghese at Rome, where it still remains. It has been skilfully cleaned and all the over-painting removed.

17 and 18. THE TRIUMPH OF VIRTUE, and VICE WITH THE PASSIONS. Two companion allegorical sketches in gouache or tempera on canvas. Now in the Louvre. Both these pictures are mentioned in the inventory of Isabella Gongaza in the middle of the sixteenth century, the first as "The Virtues of Justice, Moderation, and Fortitude

teaching a child, who is crowned with laurel and bears a palm, to measure time;" the second wrongly as "Apollo and Marsyas," both being " by the hand of Correggio." In 1628 they passed, most likely in the same way as the "Jupiter and Antiope," into the possession of Charles I. of England, and when his collection was sold in 1650, were bought by the banker Jabach. The "Vice" passed after his death into the collection of Cardinal Mazarin and thence into that of Louis XIV., the "Virtue" having been probably acquired previously by the king from Jabach himself.

19. THE TRIUMPH OF VIRTUE. A somewhat altered unfinished repetition of the Louvre "Virtue." In the Palazzo Doria at Rome. There is no information concerning the origin of this undoubtedly authentic picture.

20. GANYMEDE BORNE ON AN EAGLE TO THE FEET OF JUPITER. An octagonal fresco medallion, formerly on the ceiling of an apartment in the castle of the Count Gongaza at Novellara. The authenticity of this picture is not very satisfactorily made out, but it is thoroughly Correggesque in character.

It was transferred to canvas with the consent of Francesco IV., was restored by Guizzardi of Bologna, and was then placed on the ceiling of a room in the Gallery at Modena.

21. A NAKED BOY. Also a fragment transferred to canvas of the painting formerly on the ceiling of the Castle of Novellara. With the "Ganymede" now in the Gallery at Modena.

APPENDIX E.

DRAWINGS, SKETCHES, AND STUDIES.

ORREGGIO'S drawings have been no less sought after since the seventeenth century than his paintings, and as amongst the latter a large proportion are wrongly ascribed to him, so with the drawings also he is credited with a great many that possess at most some Correggesque motive or imitation of his style. Such falsely attributed drawings are to be found in almost every public collection. To enumerate them would be wearisome and useless. Original drawings by Correggio are extremely rare. It is, indeed, almost impos-

sible to determine with any great certainty the genuineness of works of this kind, all documentary evidence concerning them being utterly wanting. Mistakes and falsifications arose so early that the distinguished connoisseur Mariette gives it as his opinion that even the drawings for the Dome at Parma, that Vasari mentions as being in his possession, were not genuine. If such was the difficulty of arriving at the truth in Vasari's time, how much greater must it be now, when all external proofs fail and we can only judge by the internal character of the works themselves. Correggio's drawings are, for the most part, only light hasty sketches of single figures, mere studies and helps for painting. They lay no claim to be considered as independent expressions of artistic thought, and have none of the significance that we find, for example, in Dürer's sketches and drawings. Their author was essentially a painter, and expressed himself best in colour. He himself evidently attached little value to his drawings. Nevertheless, such of his drawings as may with some justice be considered original have a certain charm in their sketchy artistic treatment of the subject. They are to be met with in most important collections, and the value now attached to them is shown by the fact that at the auction of the late King of Holland's collection in 1850, the well known English dealer Woodburn gave 510 florins for one example and 1,100 florins for another.

Most of the collections formerly existing in Italy of any value have passed into England and France.

Of the twelve DRAWINGS IN THE UFFIZI AT FLORENCE, studies of Madonnas, Saints, &c., there is not one that can with any right be attributed to our master.

The five DRAWINGS IN THE GALLERY AT MODENA, studies of angels for the S. George, Putti, &c., are likewise very doubtful.

Also several STUDIES IN THE AMBROSIANA AT MILAN. Richardson, however, distinguishes two of these—the "Marriage of the Virgin" and a study for the "Notte."

A DRAWING FOR AN ALTAR AMONG THE ARCHIVES OF THE CHURCH OF THE STECCATA AT PARMA. Martini is of opinion that it may be the altar that Correggio appears to have been consulted about, and that therefore the drawing may be his.

Of the twenty-three DRAWINGS IN THE BRITISH MUSEUM may be

mentioned:—the "Marriage of S. Catherine," "Virgin and Child," and "Kneeling S. Catherine, with two angels flying in the air," red chalk and pencil. Signed *Ant. il Coregio*.

Large red chalk drawing of S. John with a lamb in his arms, for the dome at Parma.

Large coloured drawing of the head of a man. (This is the one given in the illustrations.)

Sketch for part of the dome at Parma. Red chalk outlined with pencil.

Study, or first rough sketch for the "Notte." Somewhat different in detail from the picture. Quite small.

Christ on the Mount of Olives. Red chalk, very faint.

Two small Madonna subjects, probably studies for "The Madonna of S. George."

IN THE DYCE COLLECTION, now in the South Kensington Museum, are five drawings ascribed to Correggio (two of these are given as illustrations). Four of them are apparently studies for the frescoes. They are from the Richardson collection.

IN THE ROYAL COLLECTION AT WINDSOR are nine drawings, among them a sketch for the "Jupiter and Antiope" of the Louvre.

IN THE DUKE OF DEVONSHIRE'S COLLECTION at Chatsworth are :—a drawing for an Altar in pencil, and colour sketch of God the Father with Angels, the Ascension of the Virgin, and three studies of children.

IN THE LOUVRE are twenty drawings ascribed to Correggio, mostly from the celebrated collections of Crozat and Mariette. Among them may be mentioned a first sketch for the "Martyrdom of SS. Placidus and Flavia," red chalk heightened with white.·

Rough sketch of the ascending Virgin in the dome at Parma. Very doubtful.

Sketch of S. John the Baptist for one of the figures in the dome. Figure of one of the Apostles; four drawings of foreshortened figures; four drawings of angels' heads; a Holy Family from the collection of William II. of Holland.

IN THE CABINET OF PRINTS AT BERLIN are nine drawings ascribed to our master, but only one of them, a Putto, is in the least like his style of drawing, and even this is not genuine.

HEAD OF A MAN.

In the British Museum.

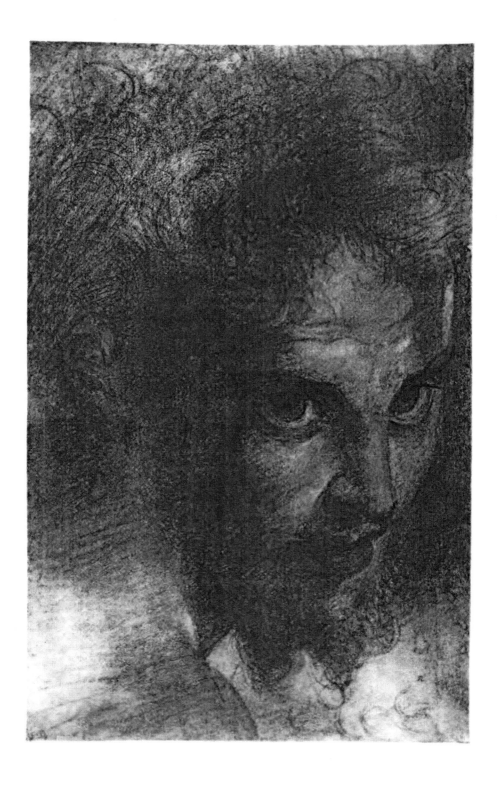

IN THE ALBERTINA AT VIENNA are twenty-six drawings, for the most part late works copied from the figures in his frescoes. Only one of them gives any impression of being genuine. It is a Holy Family with Elizabeth and a little S. John. In the background Joseph at work and a little angel. On the reverse side of the paper a sketch for a S. Jerome.

IN THE CABINET OF PRINTS AT DRESDEN are several studies or sketches for the S. George at Dresden. Also a study for the whole picture without the children, and two angels in red chalk. These are said to have come from the collection of the Duke of Modena, and may, perhaps, be the originals of the seven drawings at Munich; only one is of any importance. This represents the Virgin rising to meet Christ, surrounded with angels as in the dome at Parma, but even this masterly drawing is doubtful. It is in pencil washed with bistre.

APPENDIX F.

PICTURES OF DOUBTFUL AUTHENTICITY AND WORKS THAT HAVE DISAPPEARED.

MONG the former class Dr. Meyer reckons the "Noli me Tangere," of the Madrid Gallery, and the "Ecce Homo" of our National Gallery, both of which are considered genuine by the greater number of critics.

A picture by Correggio of Christ appearing as the gardener to Mary Magdalen, undoubtedly existed at one time. Vasari speaks of it as being in the possession of the Counts Ercolani at Bologna, but its history cannot be traced satisfactorily in the seventeenth century. It is, however, almost universally believed to be by Correggio. No doubt is thrown upon it in the carefully prepared new catalogue of the Madrid Museum. The over-painting which formerly hid its beauty has lately been skilfully removed.

With regard to the "Ecce Homo," its authenticity has never been questioned until quite recently. Careful research has, however, elicited that even as early as the sixteenth century there were two examples in existence of this celebrated work. One was engraved by Agostino

Carracci in 1587, and was then most assuredly in the possession of the Counts Prati of Parma. The other is mentioned by Bocchi (*Bellezzi di Fiorenza*), in 1591, as belonging to the Salviati family in Florence. This could not have been the same work as that engraved by A. Carracci, for Scannelli also mentions it, and adds that it was smaller than the Prati picture. It is this Salviati example that Dr. Meyer considers passed by marriage into the Colonna family, and was taken to Rome, from which time its history can be accurately traced. What became of the Prati example is by no means so clear. Pungileoni thinks it was sold by the Counts of Prati to the Colonna family in payment of a debt of 5,000 or 6,000 scudi. If so, both examples must have been at one time in the Colonna Palace at Rome, but this is a mere loose statement without any proof, and cannot be accepted. According to Tiraboschi, the Prati picture passed by inheritance into the family of the Marchesi dalla Rosa, and was sold by them to Louis XIV., but this statement also is doubtful, for no trace of such a work by Correggio can be found in France. In the notice in the National Gallery Catalogue, it is affirmed that the "Ecce Homo" of the National collection is the picture that was formerly in the possession of the Counts Prati of Parma, for whom Correggio might well have painted it, and that also it is the same work that was subsequently long in the Colonna Palace at Rome. This identity is, however, as we have seen, by no means sure, and it must be owned that the picture in the Colonna Palace might have been only an old copy of the Prati original. It is more probable, however, considering the excellence in some points of the picture, that Correggio painted two examples of it. The one in the National Gallery was purchased of the Colonna family by Sir Simon Clarke, who sold it to Murat, then King of Naples, from whose widow, the ex-queen, the Marquis of Londonderry purchased it together with the "Education of Cupid." In 1834 the Marquis sold both these works to the National Gallery for the large sum of eleven thousand guineas.

MADONNA AND CHILD BETWEEN S. LUCIA AND THE MAGDALEN. There are four copies existing of this picture, which would seem to prove that Correggio must at one time have painted such a composition, but no information concerning it exists.

THE YOUTH WHO FLED ON THE MOUNT OF OLIVES. Correggio appears to have painted this subject in his youth, and there are several copies existing of it, and a supposed original sketch. According to

Mengs the original was at one time in the Casa Barberini at Rome, from whence it was brought to England. It has now disappeared.

ALTAR-PIECE IN THE FRANCISCAN CHURCH OF S. NICCOLO AT CARPI. According to Tiraboschi an original document at Carpi stated that a " Virgin and Child" by Correggio was placed in the chapel of the Alessandrini family in that church, but this document is now lost, and the picture itself, if it ever existed, has long since disappeared.

ALTAR-PIECE OF S. MARTHA, painted for the Oratory of S. Maria della Misericordia at Correggio. For the history of this picture see text, page 95. Whether the picture in Lord Ashburton's collection is the original work is very doubtful. A copy of this composition was, and probably still is, existing in Correggio, in which "The Magdalen" is changed into a "S. Ursula." The copy is by Orazio Capretti.

S. BENEDICT IN A CHOIR OF ANGELS. A fresco in a small cupola in the passage to the dormitories at S. Giovanni at Parma. Four statues in the corners of this hall were executed by Begarelli, with whom, as we have seen, Correggio was on terms of friendship. It is not unlikely, therefore, that the frescoes on the ceiling should have been executed by our master. But in the eighteenth century only ruined portions of this painting remained, and even these have now quite disappeared.

THE MAGDALEN KNEELING AND PRAYING IN A CAVE. The only information we possess regarding this work is in the letter of Veronica Gambara already quoted (see page 205). It is not probable that a Magdalen with a crucifix in her hand mentioned in the inventory of the pictures of the Count of Novellara was the same work, for in the letter it is stated that her hands were folded. Another Magdalen also ascribed to Correggio does not answer to this description.

MADONNA AND CHILD AND S. GEORGE. A different composition to that at Dresden. Bulbarini affirms that such a picture existed in the church at Rio, a village near Correggio, and Brunario also gives a detailed description of it. In his time (1716) it had been replaced by a copy in the church at Rio, and the original removed to the gallery at Modena. No mention, however, is made of it in the old catalogue of the Modena Gallery.

Nevertheless, in the archives of the church the copy of the celebrated picture of "S. George" is twice mentioned, once as being in the old frame from which the original had been taken by his highness the Duke

of Modena. Pungileoni considers the copy as undoubtedly taken from an original work by Correggio.

Vasari speaks of "another admirable and delightful work" by Correggio as being formerly at Reggio, where it attracted the attention of Luciano Pallavicino, "a great admirer of fine paintings, who without regard to the cost bought it as some precious jewel, and despatched it to his house in Genoa." Unfortunately Vasari does not specify the subject of this painting, and all knowledge of it has been lost.

APPENDIX G.

Topographical Catalogue of Correggio's Works.

Parma.

FRESCOES in the Cathedral.

 Frescoes in S. Giovanni.

 Frescoes in S. Paolo.

 Annunciation in S. Annunziata.

Remains of Frescoes in a room in the Monastery of S. Giovanni. Doubtful.

Remains of Frescoes in the Abbey Torchiari near Parma. Doubtful.

Coronation of the Virgin. Fresco in the Library.

Madonna della Scala. Fresco in the Gallery.

Madonna della Scodella. Fresco in the Gallery.

S. Jerome, or Il Giorno. Fresco in the Gallery.

Martyrdom of SS. Placidus and Flavia. Fresco in the Gallery.

Pietà, or Descent from the Cross. Fresco in the Gallery.

Christ bearing the Cross. Fresco in the Gallery. Not by Correggio.

Portrait. Fresco in the Gallery. Not by Correggio.

Rome.

Christ in Glory. In the Vatican. Not by Correggio.

Danae. In the Palazzo Borghese.

Triumph of Virtue. In the Palazzo Doria Pamfili.

Madonna nursing the Child. Probably still in the possession of the Prince Torlonia.

Leda and her Companions. In the Palazzo Rospigliosi. Copy.

FLORENCE.

Madonna in Adoration. Uffizi.

Flight into Egypt, with S. Francis. Uffizi. Copy.

Head of John the Baptist in a dish. Uffizi. Not by Correggio.

Study of Children's Heads. Uffizi. Doubtful.

Boy's Head. In the Pitti Palace. Probably copy.

NAPLES.

Zingarella. In the Museum.

Marriage of S. Catherine. In the Museum.

Madonna and Child. In the Museum. Not by Correggio.

Sketch for Nativity. In the Museum. Very doubtful.

Sketch for Descent from Cross. In the Museum. Not by Correggio.

Four studies for the Cupola at Parma. In the Museum. Probably old copies.

MODENA.

Rape of Ganymede. Fresco. In the Gallery. Perhaps genuine.

Naked Boy. Fresco. In the Gallery. Perhaps genuine.

Angel's Head. Fresco. In the Gallery. Perhaps genuine.

Madonna and Child, ascribed to Correggio, in the possession of the Marchese C. Campori.

MILAN.

Madonna with Saints. In the Brera. Old copy.

Madonna and Child and S. John the Baptist. In the Ambrosiana. Doubtful.

Portrait in the Ambrosiana. Not by Correggio.

Madonna with the Patron Saints of Parma. Ascribed to Correggio. In the possession of the Melzi family.

BERGAMO.

Head of an Old Man. In the Gallery. Not by Correggio.

Head of a Dead Woman. In the Gallery. Not by Correggio.

Sketches for Annunciation and a Pietà. In the Gallery. Not by Correggio.

TURIN.

Head of Christ. In the Gallery. Not by Correggio.

MANTUA.

Madonna and Child and S. John the Baptist. In the possession of the heirs of Aless. Nievo. Not likely to be by Correggio.

BOLOGNA.

S. John. In the possession of G. G. Bianconi. Very doubtful.

Madonna and Child. In the possession of G. G. Bianconi. Very doubtful.

Six studies for Cupola at Parma. Count Aldovrandi. Doubtful.

MADRID.

Noli me tangere. Royal Museum. Not beyond doubt.

Madonna and Child and S. John the Baptist. Royal Museum. Not by Correggio.

Pietà. Royal Museum. Copy.

Martyrdom of SS. Placidus and Flavia. Royal Museum. Copy.

PARIS.

Marriage of S. Catherine. Louvre.

Jupiter and Antiope. Louvre.

Triumph of Virtue. Louvre.

Vice and the Passions. Louvre.

In one of the cabinets of the Louvre are also—

A Holy Family with a little S. John the Baptist giving the infant Jesus a cross; a sketch for the S. Jerome in Parma, and a S. Jerome doing Penance. The Youth on the Mount of Olives. In the possession of M. de Foyes.

· IN ENGLAND.

Madonna della Cesta (*Vierge au Panier*). In the National Gallery.

School of Love, or Education of Cupid. In the National Gallery.

Ecce Homo. In the National Gallery. Not beyond doubt.

Two studies for the Cupola at Parma. In the National Gallery. Copies.

Two fragments of Frescoes from the Tribune of S. Giovanni in Parma. In Lord Ward's Collection.

Reading Magdalen. In Lord Ward's Collection. Copy.

Christ in the Garden of Gethsemane. Duke of Wellington's Collection, Apsley House.

Madonna kissing the Child. Lord Carlisle's Collection. Ascribed to Correggio.

S. John. Same collection. Not by Correggio.

Portrait in Hampton Court. Not by Correggio.

Madonna della Cesta. Lord Ellesmere's Collection. Copy.

Portrait. Mr. Hope's Collection. Not by Correggio.

The Youth who fled on the Mount of Olives. Mr. Sikes' Collection. Copy (?)

S. Martha with three other Saints. Lord Ashburton's Collection.

The Muleteer. Inn sign. Duke of Sutherland's Collection, Stafford House. Doubtful.

Madonna and Child and S. Joseph. Petsworth. Doubtful.

Christ and Child and S. Catherine. Brocklesby. Not by Correggio.

Ecce Homo. Panshanger. Doubtful.

Venus arming Love. Longford Castle. Not by Correggio.

Fall of Phaeton. Corsham Court. Not by Correggio.

Allegory. Beechwood. Probably copy.

Madonna and Child. Somerley. Not by Correggio.

ST. PETERSBURG.

Madonna hushing the Child. In the Hermitage.

Marriage of S. Catherine. In the Hermitage. Not by Correggio.

Apollo and Marsyas. In the Hermitage. Not by Correggio.

Portrait. In the Hermitage. Not by Correggio.

Sketch for the Cupola in Parma. In the Hermitage. Possibly genuine.

The Madonna in Adoration. In the Leuchtenberg Gallery. Copy.

Christ on the Cross. In the possession of Count Paul Stroganoff. Doubtful.

Sketch of Nativity. In the possession of Count Serger Strommoff. Doubtful.

IN VIENNA.

Ganymede. In the Belvedere.

Io. In the Belvedere.

Christ Crowned with Thorns. In the Belvedere. Doubtful.

Christ in the Temple. In the Belvedere. Not by Correggio.

Madonna and Child. In the Belvedere. Copy.

S. Sebastian. In the Belvedere. Not by Correggio.

Flight into Egypt. Sketch. In the Academy. Not by Correggio.

Venus, with Loves. In the Liechtenstein Gallery. Not by Correggio.

Madonna and Child. In the Liechtenstein Gallery. Not by Correggio.

Christ bearing the Cross. In the Liechtenstein Gallery. Not by Correggio.

Madonna and Child. Harrach Collection. Not by Correggio.

IN PESTH.

Madonna hushing the Child. In the Esterhazy Gallery.

Correggio's Portrait. In the Esterhazy Gallery. Not by Correggio.

Two studies of Angels' Heads. In the Esterhazy Gallery. Old copy.

KRAIN.

Madonna and Child. In the possession of Count Gallenberg. Doubtful.

BERLIN.

Leda. In the Gallery.

Portrait of Christ. In the Gallery. Not by Correggio.

Io. In the Gallery. Copy.

DRESDEN.

Madonna and S. Francis. Gallery.

La Notte. Holy Night. Gallery.

Madonna and S. Sebastian. Gallery.

Madonna and S. George. Gallery.

Reading Magdalen. Gallery.

Portrait of a Doctor. Gallery. Not by Correggio.

MUNICH.

Madonna and Saints. Pinakothek. Not by Correggio.

Madonna and Saints and donor. Pinakothek. Not by Correggio.

Ecce Homo and donor. Pinakothek. Not by Correggio.

Head of Faun and donor. Pinakothek. Not by Correggio.

Angel's Head Fresco. Pinakothek. Doubtful.

LUBECK.

Naked Boy. In the possession of Dr. Gædertz. Ascribed to Correggio, and considered genuine by Rumohr.

POTSDAM.

Madonna and Child and S. Anthony. Castle of Sans souci.

Several other works ascribed to Correggio in same place. None of them genuine.

CHISWICK PRESS :—PRINTED BY WHITTINGHAM AND WILKINS,
TOOKS COURT, CHANCERY LANE.

CPSIA information can be obtained at www.ICGtesting.com
Printed in the USA
BVOW03s2359050715

407378BV00007B/11/P